Desperate Prayers

Desperate Prayers

A Quest for Sense
in a
Senseless Time

Daniel Dancer

Illustrated by
Jocelyn Slack
and
Lori Thompson

Cover photograph: Death Reflection Circle
Eureka Dunes, Death Valley, California
© Daniel Dancer

Author photograph by Carola Stepper

Note for Librarians: A cataloguing record for this book is available from Library and Archives Canada at www.collectionscanada.ca/amicus/index-e.html
ISBN 1-4251-0224-7

PUBLISHING

Offices in Canada, USA, Ireland and UK

Book sales for North America and international:
Trafford Publishing, 6E–2333 Government St.,
Victoria, BC V8T 4P4 CANADA
phone 250 383 6864 (toll-free 1 888 232 4444)
fax 250 383 6804; email to orders@trafford.com
Book sales in Europe:
Trafford Publishing (UK) Limited, 9 Park End Street, 2nd Floor
Oxford, UK OX1 1HH UNITED KINGDOM
phone +44 (0)1865 722 113 (local rate 0845 230 9601)
facsimile +44 (0)1865 722 868; info.uk@trafford.com
Order online at:
trafford.com/06-1981

10 9 8 7 6 5 4 3 2

"May you be alive at the end of history."
—old Irish prayer

Earthfound
Born lost
with a wild heart
We are beckoned
now
to stop pretending
to call home the shards
to find and name the unnamable
to witness and bless each one
and bring them to the center
and there
with the help of whom we call God
fashion wholeness and beauty
and from there
radiate
truth, healing and resurrection
for ourselves
for each other
for the world

And we must do it again and again and again

Contents

For Sierra and Nick,
the unknown and
wherever wildness
endures.

Acknowledgements

A book is like a river. One can follow it to its headwaters which may be a lake, a glacier, or a valley at the base of a mountain. If it is a long river, there will be significant watersheds that contribute to its flow as well as small creeks, springs from Earth and rain from sky. The river's flow finds completion when it reaches its confluence with a larger river, lake, or the ocean. A book reaches completion as it pours out into the world to join in confluence with the great written sea of information. Every author hopes that the river of his or her particular book will be interesting and beautiful enough to inspire many visits, tales, sharing with others, and little epiphanies; that its particular configuration and look will inspire change. Like a river, a book is contoured by what shapes and flows into it. Here I wish to thank all that has.

The headwaters of *Desperate Prayers* came from the twin peaks of my father and mother. From the beginning my dad showed me that "wild is the way," and through fifty-one years of marriage that ended with his death in 1999, my mother supported his teachings on continuous family adventures in nature. I thank them deeply for the height and breadth of their support throughout my life. Christine Meade, the mother of my children, was a canyon that allowed me to flow freely with my vision for many years and I thank her deeply as well. Two watersheds contributed hugely to the flow and inspiration of this book. I thank Interspecies artist and writer Jim Nollman and educator-activist Gigi Coyle for the stimulation, encouragement, and space they provided for my experimentation. Kansas crop artist Stan Herd was a significant river that flowed into mine and I thank him greatly for his friendship and collaborative adventures in earth art.

I thank my daughter Sierra and son, Nick, for the constant joy and inspiration they breathe upon my life and for their patience during periods of writing and absence when they could not claim my presence.

11

Desperate Prayers

Will Nixon, Dave Thomas, Andrea Glenn, Grant Abert, Teton Campbell, Judy Rudiger, Sera Klein, Lynda Sacamano, Ray Mitchell, Kimm Burkland, Jay Letto, Lee Christie, Doug Tompkins, Joan Halifax, Chief Johnny Jackson, Michael Jones, Rick Klein, Kaya, Tom Dancer, Michael Stewart, Nancy Goddard, Sister Miriam MacGillis, Tina Hodge, Martín Prechtel, Diane Harvey, Arlene Burns, Jack and Nancy Methvin and Exhibits USA were all springs and rain that invigorated and encouraged the flow of my work in various ways. A special thanks to Kathy Glass for her early editing, enthusiasm, and final proofing of my work. There are authors that I will never know whose rivers have contributed to the flow of my own and I wish to thank all those whose words appear in this book and many, many others for their wisdom.

Down the home stretch two people deserve special thanks, both of whom found me through one of the wonderful "watersheds" of our time: Julia Butterfly. My association with Julia via my creation of her web site led them to me. I wish to thank Lori Thompson for the magic and inspiration that helped me resurrect certain things lost and bring the book to its appropriate conclusion. I thank her for her lovely illustrations as well. Things often appear when you need them the most and in this regard I wholeheartedly thank Carol Harley for supplying her superior effort, wisdom, friendship, and guidance as editor for this book; she was wonderful to work with. Special thanks to Jim Bisakowski for his care and diligence in the design and preparation of this book.

I wish also to thank Jocelyn Slack for her wonderful drawings. She was a joy to work with and continuously amazed me with the depth of her talent. The good people at Trafford Publications were a pleasure to work with as well and I thank them for their enthusiasm and care in the publishing of this book. Finally, I would like to thank Carola Stepper for her special support and encouragement during the final phases of this project as well as Jade Sherer during the second edition reworking of the book.

I reserve my greatest thanks for the wild places and all their species that flow from the watershed that feeds all life—Mother Gaia. They will forever guide me.

Foreword

Being a complete original is usually a plus for an artist although, iron-ically, it can also marginalize his or her work within a culture that thrives on categories and experts. What is it that Daniel Dancer does, precisely? He's an artist, of course; a guy who prefers natural and man-made found materials, whose "pieces" are often ephemeral, lingering only as photographic documents of long-gone artworks.

On an expedition to the Canadian Arctic, I once watched Dancer spend hours and hours constructing a compass out of feathers, cotton grass, and sticks. A good puff of wind destroyed it a few hours after he was done. But he'd taken his photos and said his prayers. This descrip-tion makes it sound as if Dancer might be pegged alongside other so-called "Earth artists" like Andy Goldsworthy, Robert Smithson, or Stan Herd. Unlike these others, he does not easily fit the mainstream art tra-dition that employs aesthetics as an end to itself.

During that same Arctic expedition, I remember Dancer spending days constructing a mobile out of two beluga whale skeletons burgeoning from a common midpoint. He hung the bones from a goalpost-shaped rack used by the local Inuit to dry beluga meat. When the wind came up, the skeletons would sway, always eerily, and occasionally like two whales working earnestly to swim off that drying rack and back into the Beaufort Sea. Inuit beluga hunters drove their boats past the persuasive mobile and interpreted it, not as art—never as art—but as black magic, a true communication to the whales warning them to evade the hunters. Was it just coincidence that all the local belugas had just departed the river estuary, two weeks early? A few days after we left the site, travel-ing west along the coast, we were threatened by hunters carrying guns. When we escaped into the teeth of a gale, Dancer said something I'll never forget. "I've had my art shown in many galleries, but no one's ever taken it as seriously as these hunters. Makes you think."

Daniel Dancer's earth art springs from the same polemic mold of realigning perceptions and invoking metaphors that alter our general relationship to nature. He digs deep into the sculptural grammar of material, shape, mass, symbolism, and kinetics to meet the ecosystem halfway. He shows us how a human artist and an ecosystem can learn to collaborate, to make art together. The symbolism of this mutable bond is at least as powerful as the art produced. Earth art flirts with environmental activism, myth, politics, geology, shamanism, and erosion as much as it flirts with sculpture.

Imagine building a medicine wheel out of garbage on a Mexican beach, then bagging up the contents and being so brash as to carry it through Customs. Dancer did that, and described it as a metaphor promoting ecological sanity in this insane time. Hearing that, it would be easy to depict him as an environmental activist with an original shtick for getting the world's attention at a time when we're too often inundated by bad news. But that would also be incorrect. The activist's tone simply doesn't fit the man. Dancer's work is symbolic, never blatant, rarely explicit, and always transcends politics. We're stuck categorizing Dancer as someone who makes art/socio-political statements in defense of the Earth (try using that on a grant application).

People whose job descriptions fall through the cracks are the ones we should be listening to most mindfully. That's the Daniel Dancer I know. A man of indefinable grit. Enjoy his book. Let it inspire you to spend hours constructing a little something out of feathers that's going to get blown away by the first gust. Or, go build hexes to protect the whales. Take garbage through Customs. Perceive the world as sacred.

—Jim Nollman,
 Friday Harbor, WA, April 2000

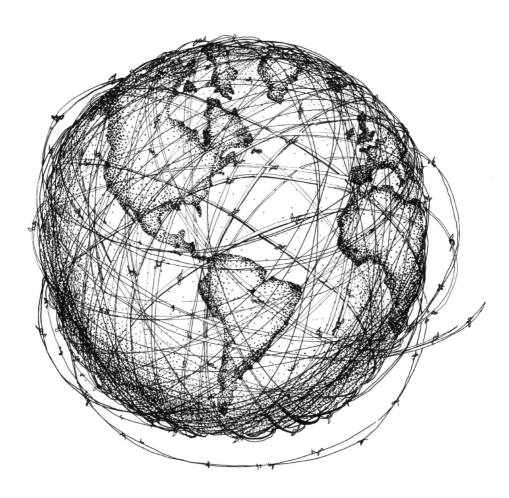

Preface

"Beauty will save the world."
—Fydor Dostoyevski

ast week I wrapped 200 yards of rusty barbed wire around a world globe. Tearing down the fences that once crisscrossed the land where I live and rolling them up into large balls has given me great joy. Numerous "rust-in-peace" barbed-wire-ball shrines now dot the woods and meadows—testimony to the cow-free-fence-free vision of my community. I reserved the last stretch of fencing for the globe that I purchased for a dollar at the local Salvation Army store. It seemed an artful metaphor for the state of things and a good way to mark the ending of the twelve years it took to collect the stories for this book.

Barbed wire was how the Industrial Revolution played out in rural america. It allowed for land to be easily divided, fenced, grazed and sold. And nothing quite compares to removing a stretch of it, of seeing after a few hours work, a lovely meadow suddenly unburdened by what had divided it for years. With the rusty ball of barbed steel beside me I surveyed the scene and drew in my breath in awe. I found an uncommon stillness. True beauty has this affect. It arrests motion. An eagle suddenly spied against a stormy sky, the shy smile of a young girl playing in the woods, an emerald-green meadow suddenly fence free: all stimulate a quick intake of the breath and then a long "ahhhhhhhh" as we relax into what we have seen, This sudden intake of breath is the very root meaning of the word aesthetics. "Rose O Rose" wrote Rilke. The "O" is the arrested moment, the still point, the abode of beauty. The rose is beautiful because of the

stopping "O". The re-specting, the re-treat to see again . . . this is the only motion possible to recapture the fleeting epiphany.

"Gaia O Gaia." We are at a point in human history where the entire world needs to get how beautiful it is . . . pause . . . and then begin anew, refreshed by the power of this understanding. Beauty is the "reset button" craftily cloaked in the wasteland of techno culture. If there is a holy grail at this point in human history, B E A U T Y is it. And if we do not make this discovery, Mother Earth will step in and reset things in her own ancient way which will result in human suffering and catastrophe the likes of which we can not imagine. By the looks of the data from nearly every conceivable index; climate change to the warming of the oceans . . . over population to resource depletion— the knowing "finger" of Earth, which has been regulating itself for 3.5 billion years, has already begun to press down.

There is such a wealth of metaphor in a fence that the simple act of removing it is as fresh and healing for ourselves as it is beauty making for a meadow, a forest, or a prairie. When my friend Carola and I finished the wire wrapped globe, it was after sunset. Looking at our bizarre creation, I was immediately struck by the parallel between the orbits of barbed-wire circling the globe and the thousands of communication and spy satellites circling the Earth at that very moment, not to mention the millions of miles of fencing, pipes, electric lines, asphalt, cars, trains, and ships also circling her.

In the fading light we rolled the ball through the grass to a beautiful stand of old oaks and maples where our community holds its biannual meetings. The largest oak on the land, in fact in the entire region, dominates the setting at the head of a big sloping meadow where elk are sometimes seen. A dark circle of river stones lies under her boughs. We call this old one "the Queen" and she is symbolic to me of the "Tree of Life".

Nearby, two battered and twisted apple trees from the homestead of 100 years past rose improbably in the meadow grass. The trees had lost their leaves, and the few apples clinging to their branches shone like jewels in the twilight. Deer and elk had eaten all the windfallen fruit and any within reach. With a broken branch we managed to reach up and dislodge a few apples, each one with a worm hole—guaranteed organic. We munched them and considered the nature of this act: in "the garden," eating apples from the "Tree of Knowledge of Good and Evil," the great biblical moment of antiquity that led to our expulsion from Eden. Blaming the fall on the perfectly natural act of eating a beautiful apple always seemed ridiculous to me. Myths are important though. They just need to be updated from time to time. Thus I prefer Mark Twain's ver-

sion of the story which is much more relevant to our time. He lays the blame for our eviction on a bad joke made in the garden by Adam . . . a joke at nature's expense. [1]

After removing the fence which divided our Eden, we joyfully imagined that by eating the fruit from the Tree a second time we had broken the spell. This was the beginning of a whole new relationship with nature. "Why not?" I thought. Maybe Eve stopped too soon; maybe our relationship to the Earth would be more balanced if she would have eaten a second time, a third, again and again coming eventually to the heartfelt understanding that *they and the tree were One,* that there is no separation. For the writers of this legend however, separation was an important myth to cultivate. When people feel separate from nature it is much easier for the powers in charge to plunder the Earth's resources. And thus we have an environmental crisis of apocalyptic proportion.

If we accept the Gaia hypothesis, that we and the Earth are one whole living system, then after five billion years of planetary evolution we are the beings in whom the Earth has become conscious of itself. In this recognition we are invited to eat, have always been invited to eat in a *sacred way*, from the Tree.

If there is a future for the human species, then certainly at its heart is the transformation of old, worn-out myths that have led us to a place of extreme peril . . . into new ones. So let us each hold council with the special trees and places in our own corners of Eden, bow before them, and ask to be shown the gift we have to offer Gaia and one another during this critical time in history. And then let's use our gifts to unravel that which ties and binds the Earth—a mind-set, a trance, a cultural addiction—and help manifest *The Great Pause*. Lets invite something so beautiful the whole world will have no choice but to simply stop, breathe in a great . . . "ahhhhhh" and then chart a vigorous new course.

—Daniel Dancer
Mosier, Oregon 2006

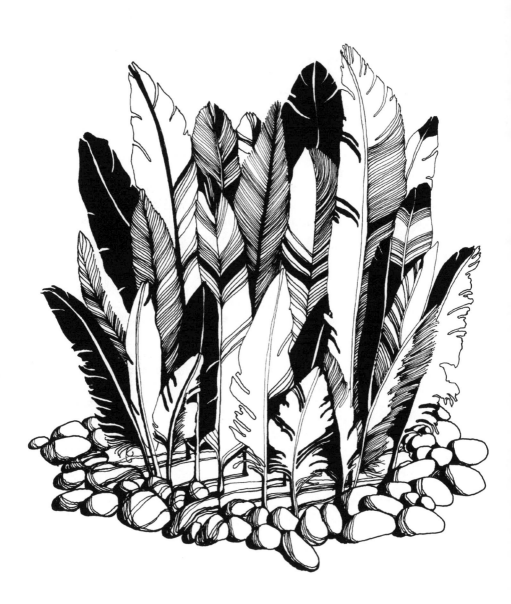

Introduction

"As you start on the way, the Way appears."

—Rumi

n a cold February morning while walking along the beach of the isolated Quinault Indian Reservation on Washington's Olympic peninsula, I made a discovery that altered the course of my life.

Dimly lit, in a swirling fog, was a group of tall multi-colored feathers rising from the sand, set within a circle of smooth, wave-tumbled stones. The beach was completely deserted—no people, no birds, the only sound the rhythmic crashing of the incoming waves. Set high above the surf line, the arrangement offered no evidence as to when it had been crafted. My golden retriever sniffed the feathers, while I sat beside the circle watching waves roll in and recede in the gathering dawn. Was there any sound, I wondered, more ancient than the tidal pulse of waves breaking upon the shoreline, the gentle heave and swish of the waters sliding back into the sea? Was there any shape more ancient than the circle beside me?

I made a photograph in black and white, and months later tacked the print above my desk. Gradually I became enchanted by the power that seemed to emanate from that circle, a power that went on and on undiminished. For me, this handmade stone-and-feather symbol of wholeness seemed to hold the intent of our species, something lost and ancient—something from the source.

The photograph loomed above my desk and continually stirred what poet Gary Snyder calls our "native myth-mind"—something "perennially within us, dormant as a hard-shelled seed."[1] Over time, the image of that simple beach shrine helped to dissolve my Judeo-Christian layers,

thickened from nearly five decades of living in America. Contrived over thousands of years of nature-denying detribalization by our ancestors, these layers conceal much of our native selves.

Underneath the photograph, I tacked an old Irish prayer, "May you be alive at the end of history." The little stone-and-feather beach shrine seemed to call forth a transformation, for I knew I was alive in a time of endings.

The notion that the end of history might be desirable may at first be shocking. History, however, is not synonymous with human life. In fact, one might conclude the opposite. "History is an invention of Western Civilization whose guiding theme has been the rejection of habitat," writes human ecologist Paul Sheppard.[2] It is simply, to quote Voltaire, "the lie commonly agreed upon." In essence, it is *his story*—an anti-mythological record put forth by winning/ruling political entities, of an 8,000-year assault on nature that began with the destruction of Earth-based pagan religions and led to our Age of Toxic Man.

Humanity, in its historical mode, is fed by the devastation of the ecology that supports us. We are alive in the midst of a holocaust. On the deepest level we know this, but the anguish of facing the truth is overwhelming. Taboos constructed by society against the expression and communication of such distress shield us from acknowledging the reality of our situation. We have essentially been silenced.

Writer Derrick Jensen eloquently echoes ecofeminist thinkers in his book *A Language Older Than Words*: "The staunch refusal to hear the voices of those we exploit is crucial to our domination of them. Religion, science, philosophy, politics, education, psychology, medicine, literature, linguistics, and art have all been pressed into service as tools to rationalize the silencing and degradation of women, children, other races, other cultures, the natural world and its members, our emotions, our consciences, our experiences, and our cultural and personal histories."[3]

What would it feel like to be an agent of awakening in a society where the collective urge to pretend runs so deep? Dare we risk holding up a mirror to the world and to ourselves? It takes courage to look at truly what is and refuse to be silenced. Dare we speak the truth?

The truth may be that the collapse of Western Civilization is necessary, even natural—as natural as an insect-ridden tree falling to the forest floor. Such a falling is prophesied by ancient wisdom keepers and their modern counterparts as well, including respected scientists across the planet. The elders of indigenous cultures around the world tell us that this time, this Great Turning, has begun. They say that it is a time to welcome, perhaps even to celebrate as the best time to be alive.

Was the rock-and-feather shrine a simple act in response to the plan-

etary assault in which we all participate to some degree? Was it an expression, perhaps, of the grief that comes with the recognition of our complicity? About the time I found it, the Quinault Indians had just finished clearcutting their entire reservation—all of it pristine, ancient rainforest. They left only a thin strip along the beach. To me, the stone-and-feather circle was an artistic, prayerful act, a way to help dispel the techno-trance that grips the world. In a sense, it may have been the planet responding to its pain through the holy imagination of one in touch with her or his Earth-mind. In a far-reaching way, perhaps the Earth was treating herself much as one might heal an ailment by using herbs, acupuncture, or visualization. Though I may never learn the origin of that organic, oceanside mandala, its image still radiates magic above my desk, and I am grateful to its creator.

Breaking the Spell

Weary of sadness and loss, in shock perhaps, isn't it easy to simply pretend that all is well? Billions of dollars are spent to shield us from the truth, to support the very structures that blind us to what is truly happening in America. Modern technological culture feeds on the memory loss of our origins, and it is not easy to fight our way back upstream. And what's more, our forgetting has been so purposeful and systematic that we forget that we have forgotten! Ironically, in our Age of Information we are missing the information most vitally important to us: how to dwell in community with each other and the natural world.

Studies within the burgeoning field of ecopsychology can help tremendously in identifying the impacts of our dysfunctional relationship with nature—a relationship that has been building to a crescendo since the Industrial Revolution. The basic tenet of ecopsychology is that the vast majority of the psychoses and neuroses afflicting the modern human are a reflection of our fragmented relationship with nature. The state of our environment continually mirrors itself in our interior lives, in ways that are difficult to recognize. We then perpetuate the crisis with self-destructive behavior, because we feel so terrible under the surface of our lives. Any "cure" to this vicious circle lies within our ability to break free by developing a more reciprocal relationship with the natural world. For this to happen, our definition of sanity must literally be redefined. This the goal of ecopsychology.

"What we do to the Earth, we do to ourselves." These words attributed to northwest native elder Chief Seattle have always been a beacon

for our recovery and can lead us away from the addictive compulsions of an unsustainable society.

As we try to patch together the shards of our distorted relationship with nature, "we often regress, slipping away from the world, hiding and peering from the very crack that initiates recovery," writes ecopsychologist Laura Sewell in *Sight and Sensibility: The Ecopsychology of Perception*.[4] It hurts to awaken to the outrage and trauma of what is happening to Earth. It hurts to acknowledge our unwitting complicity in the undoing of Mother Gaia and the shame that comes with it. Our sensory systems are highly evolved and the pain of it all is extremely difficult to bear (one reason anti-depressants are so widely prescribed). Through it all, it is important that we have compassion for ourselves and our need to protect our spirit from the terror of what is happening. Always, we must forgive ourselves and then, look a second time. We must look again and again and muster the courage to stop pretending, to face despair and resist the urge to give in sleepily to the seductions and superficial comforts of modern society.

Many of us are afraid to feel despair, thinking that if we do we will be sucked down into a dark hole of never ending misery from which we will never escape. And yet, isn't despair entirely appropriate given the direction of pending global environmental collapse in which we are heading? Despair is perhaps fearful to us because if we truly open up to how desperate things are we may be forced to take action. For so many of us in the western world, the ones with the time and wherewithal to really make a difference, our lives are just so darn busy and comfortable. And thus . . . the howling wolf of despair is continually beaten back from the door, made easier I suppose by appearing to us a softly scratching annoying poodle. I suggest it is better to invite the wolf inside (poodle form if that helps), sit down with it, embrace what is happening, and not leave the hard work of change to others.

"Fear of despair," writes deep ecologist Joanna Macy in *World as Lover, World as Self*, "can erect an invisible screen selectively filtering out anxiety-provoking data. In a world where organisms require feedback in order to adapt and survive, this is suicidal." The pain we carry for our imperiled world is only dysfunctional when we refuse to own it. In the not-so-very-long run, it is our wakefulness, our facing of what haunts us, that contains our brightest chance as a species. "In despair, if we digest it, is authenticity and joy to fuel our dreams."[5]

In the midst of these apocalyptic times, we must learn to dwell with an open heart—with eyes and ears and spirits wide open. To stay present amid ecological ruin and numbing propaganda is a spiritual disci-

pline. Hope for ourselves and the world resides in this practice. Any chance of influencing the human outcome rises first from accepting the truth. When we honor our grief for the world, we approach the wisdom and joyful fit that is our birthright—a deep and soulful recognition of our oneness with Earth. Is this the intent behind the old Irish prayer to be alive at the end of history? May you be alive when the spell is broken, at the beginning of *our* story—a time when humanity has rediscovered how to live in balance with Earth and each other. And most importantly, the prayer seems to say, *"Realize the special gift that you have to offer the world and learn to wield it."*

How can we unearth the unique gifts that we each have to offer the world at this critical time? How do we maintain our courage? How do we balance the joy and rage inherent in the awareness of being "alive at the end of history"? We each must find a way, or risk slipping back into the alure of the pretending spell. In her lectures and workshops, spiritual ecologist Sister Miriam MacGillis offers a profound solution. "What can help us," she says, "is that instead of asking what we can do to change the world, we must ask as well, *what can we do to bless it.*"[6] Here, I believe, lies the secret of real change: grounding our actions with direct and personal displays of our devotion to Earth. The surfside, rock-and-feather offering signaled my way.

Putting Prayer Into Form

As children, many of us were "Earth artists," arranging rocks, sand, sticks, and such materials in various spontaneous forms. Why we did it, who can say? It just seemed necessary, like breathing. It was an instinctive way, perhaps, of maintaining our connection to the sacred circle of life. On a very simplistic and organic level we were engaged in mandala making.

"Mandala" is the Sanskrit word for "circle" and is defined by psychologist Judith Cornell as "a concrete symbol of its creator's absorption into a sacred center."[7] Mandalas serve as artistic tools for healing and transformation in Native American sand painting, Hindu and Tibetan Buddhist rituals, and in modern psychotherapy. Indigenous cultures were often compelled to create mandala-like patterns on the Earth. The Nazca Indians of Peru and the Pueblos of the Southwest, for example, arranged stones and carved ditches to make elaborate symbols upon Earth, some of them now thousands of years old.[8] For them and for us, creating symbolic mandala patterns is a way to make the invisible visible. Noted historian and anthropologist Mircea Eliade writes that "the

discovery or projection of a fixed point—the center—is equivalent to the creation of the world."[9] In essence, we recreate or hold up the world and our place in it each time we consciously set our intentions and project them in a sacred way through art or ceremony that radiates wholeness.

Art crafted in a sacred manner upon Earth's surface may function as a kind of personal and planetary acupuncture, medicine for ourselves and for Earth. This book is an articulation of my experiences with making such art in the degraded eco-regions I've encountered on my journeys. There was no technique really, only an effort to blend with the imagination of the wild in the places I visited and let nature's voice play an equal part in the creation of each work. In this manner, each earthwork shaped itself through the natural unfolding of synchronicities and events, shapes and animals, and with the organic and human-made shards found along the way. A kind of alchemy always seemed to occur. In each instance these "co-creations" with Earth became a deep and ceremonial way to be present with Nature, to help atone for its abuse by our species and perhaps inspire a positive outcome. The resulting earthly collaborations, what I have termed eco-mandalas, are the deepest ways I have experienced to bless and give thanks for the beauty which surrounds me, for indeed, hope resides in beauty. "Beauty will save the world," said Dostoyevsky—a simple affirmation worth repeating daily! [10]

Beautiful or devastated, each place I chose to work had a story embedded within it—a story that, were it not for this way of art, might otherwise have escaped notice. By putting prayer into form, partnering with Earth, I hoped in some way to create space for a miracle to occur. Is this not the wish of all artists? Upon Earth's body, blending with my own hands the elements and objects found in each place, guided by nature, the outcome of such a wish felt almost palpable at times. On polluted beaches, clearcuts, plowed prairies, and other defiled places in nature, each work was a kind of corrective ritual, an offering to the wild—to the geological-biological-spiritual web of life, a desperate prayer.

Over the years, something surprising took shape. With the creation of each additional work, I came slowly to believe that this form of art can sometimes function as a kind of earthly oracle, providing a reading not only of the forces affecting a particular ecosystem and place in time, but also of the forces affecting one's own life in that moment. By engaging my mindfulness and setting my intentions, each item collected and each event observed gained a voice, serving as metaphor for current issues swirling in my life. When these shards and elements were brought into an artistic the wholeness the healing was often profound.

Introduction

Shards and Circles

From remote, wild shorelines to clearcut forests, the shards of industrial culture abound in tangled lengths of wire, tattered fabrics, oil drums, tires, plastic utensils, broken glass, pop tops, rusted engine parts, and the like. But the organic shards of nature still predominate (except in urban areas where their presence is muted) and I derive considerable hope from this. Stones and feathers, seeds and shells, bits of wood and bone, ash and silica, the scat of animals and the leaves of trees: of this we are born and in this we dwell.

And of this we breathe, as well. There are "many hundreds of particles in each breath we take," says Oxford writer David Bodanis. "Air routinely carries intimate fragments of rug, dung, carcasses, leaves and leaf hairs, coral, coal, skin, sweat, soap, silt, pollen, algae, bacteria, spores, soot, ammonia, and spit, as well as salt crystals from ocean white caps, dust scraped off distant mountains, micro bits of cooled magma blown from volcanoes and charred microfragments from tropical forest fires."[11] Moment by moment we breathe into our body tiny shards of Earth.

According to modern physics as well as ancient Buddhism, everything we see is nothing more than space and molecules. Every atom in each of us existed before organic life emerged four billion years ago. Just as we are the progeny of minerals and lava, so will something unimaginable surely arise from the detritus of our industrial world. Gathering natural and human-made shards found on the land—shards representing the *yin and yang*, night and day, feminine and masculine, inner and outer, heart and head—into an artful, holistic relationship on Earth's surface has always made perfect spiritual and intuitive sense to me. "Out of the Tao comes unity;" wrote Lao Tzu, "out of unity comes two; from two comes three; from three all things come."[12] For me, each eco-mandala held the possibility of becoming the divine third, the magical point where all great healing springs forth.

"The power of the world always works in circles," declared Black Elk.[13] Or holograms, many modern physicists would assert. Animate or inanimate or inorganic; all dance with us and are inseparably interwoven and enfolded throughout the totality of the universe. For cutting-edge quantum physics researchers like David Bohm, this means that if we knew how to access it we could find the Milky Way in a pinecone, a pottery shard, or the palm of our hand! Unification. Consolidation. Wholeness. These are old and hopeful notions, and in my own way I struggle to activate them.

One of the most difficult aspects of this struggle has been to own my "Americanism," my citizenship in a nation that seems bent on setting the pattern for the modern fragmentation and devouring of Earth. I am part of a society whose guiding mythology is a distortion called "progress," a distortion that is genocidal when practiced on a global scale. Lacking few real traditions of Earth communion, I have had to reach way back, eclecticising my philosophy and way of being from Native Americans, Buddhists, poets, artists and quantum physicists. Books have been my elders, and the places I have dwelled and walked, my greatest teachers. Nature has been my loyal guide through the spiritual chaos which confronts any modern seeker of "the truth."

Perhaps I would not have embarked on this path were it not for my father who taught biology and sought wholeheartedly to instill in me a deep appreciation and respect for wild nature. From him I learned the lesson painted boldly on the beam above my desk: "Wild is the Way." To him and to all who have brightened my path, I am deeply grateful.

The contents of this book record a quest to recast our place in the sacred circle and resurrect what has been lost—a way to help heal the *anima mundi*—the soul of the body of the world. By attempting to reassemble the long scattered shards of the ancient compact between human and Earth, I have sought to *come home* in the most profound sense. While at times it has seemed a lonely endeavor, I have taken comfort in the increasing numbers of those practicing in a similar spirit across the planet. There is a gathering momentum. Something wondrous is coming ashore.

Author's note:

Every story in this book is true just as it is written. All events occurred between 1988 and 2005, a period of time that spanned the cycle of my marriage, and homes in Kansas, Washington, and Oregon. Each adventure was documented with journal entries and photographs. Pen-and-ink drawings were chosen to illustrate these pages because of my personal belief that photographs in this context would steal the magic and flow of the reader's imagination, and because drawings make this book more accessible. A small book of photographs may be forthcoming. This book was previously published with the title: *Shards and Circles: Artistic Adventures in Spirit and Ecology.*

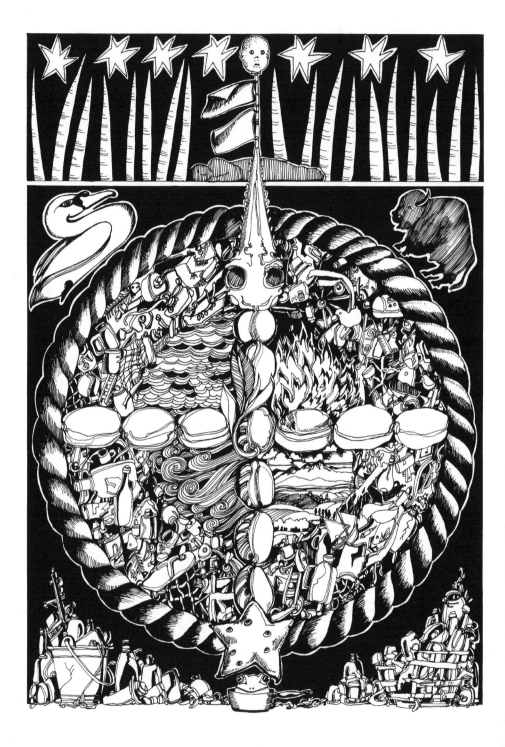

Chapter One

A Wheel for Toxic Man

"It's too late for anything but magic."
— Starhawk

ethal yellow disease had decimated most of the coconut palms, and their naked trunks pierced the sky like toothpicks. The area resembled Iwo Jima after World War II. But at least there were no tourists—the reason I had driven so far from the crowded, glitzy beaches of Cancún.

I turned off the rutted road onto a barely visible track that meandered toward the ocean. My rental car bottomed out as I edged into the overgrown desolation of a small, abandoned copra ranch. Sun-bleached coconut shells littered the ground between the dilapidated, vine-covered buildings. I parked in the shade under a cluster of Malaysian palms.

After finding an old cistern containing a foot or so of rainwater, I decided to call the place home for a few days. Hot and dusty, I headed to the beach for a swim. Not a soul as far as I could see in either direction—perfection itself! Relieved that accessible wild beaches remained on the Yucatán Peninsula, I closed my eyes for a moment in silent appreciation.

After a few seconds of bliss, I opened my eyes to the plastic—tons of it. The shoreline was thickly strewn with refuse, as far as I could see. I walked up and down the beach in distress. My first reaction was to leave quickly and head back north. Although full of tourists, at least the Cancún beaches were relatively clean. I faced a difficult choice in the late afternoon sun on my violated idyllic beach. What would it be—tourists, or garbage?

It was January, 1990. I had come to Mexico on a mission for Lighthawk, the "Environmental Airforce." As an aerial photographer, I would help map two of the newest and largest biosphere reserves in

31

Latin America—Calakmul and Sian Ka'an. The Cessna would arrive in a few days, and meanwhile I decided to explore.

Sian Ka'an is a Mayan word meaning "where the sky is born." The reserve consists of one million acres of coastal wetlands, mangroves, tropical broadleaf forest, and part of the world's second-longest coral reef. It was a place I had assumed would be wild and clean. I should have known better. The casual Mexican attitude toward garbage disposal, combined with strong Caribbean currents that wash ocean-dumped trash onto shorelines, had created the thickly littered beach upon which I stood. Yet the wild quality I had sought did seem to be here.

Perhaps there was a lesson in my predicament. I looked again at the garbage everywhere before me. And again. "To 'look again' is a way of showing respect," writes Laura Sewall. "We know the word, but when we choose to truly live it—to look again with sincerity and depth—the heavy, dull sensation we call 'numb' slips away across the landscape like a cloud shadow in wind."[1] Opened and fully alive, when we show our respect for the world by looking closely, we invite revelations and synchronicity. As I examined the awful scene all about me, I nearly tripped over a dolphin skull half-buried in the sand. I decided to stay.

Now *this* was a find. I cherish the perfect architectural grace of an animal skull and how it reminds me that my body doesn't belong to me— it belongs to nature. Skulls reflect our impermanence. They teach us that nothing lasts, nothing is stable. Back home, I honored many skulls collected from peregrinations through the wilds, yet never had found a dolphin skull. This was truly a gift. With the luck of this find, I knew I had made the right choice; and what's more, I knew that I had work to do.

An Oceanside Mandala

As a way to process and transform feelings of environmental despair, and in a budding belief that art and ceremony can make a difference, I decided to build a healing sculpture on the beach. I thought that a creative gifting of myself might enable passage to the wild, sacred heart of this place—an opening that perhaps would normally be denied. On this degraded beach, my sculpture would be a prayer of forgiveness for the abuse so evident here. Transforming a bit of ugliness into something meaningful, perhaps beautiful, would be a way of appealing to the "higher powers" for help. Simply put, it was the only way I could think of to make a difference in the present moment. It was an Aikido tactic: Take the blow and redirect its energy.

A Wheel for Toxic Man

I found a long, thick, half-coiled piece of anchor rope that suggested a design. I would build a healing mandala, a kind of combined Mayan compass and Native American medicine wheel. To many North American tribes, the medicine wheel is a microcosm of the world, a place of prayer and ritual; in a sense, their church. While there has been much concern by Indians over white people co-opting their ways of relating to the Earth, I prayed that they would accept my intentions on the beach and perhaps welcome my creation. While I abhor the acts of my ancestors against them, by embracing their spiritual ecology and honoring their beliefs—something my own race as a whole does not do—I feel indigenous and more like them than not.

Native tribes divide the wheel into quarters. Each quadrant represents a direction and is designated by a color, an element, and an aspect. There is some variation among tribes in this respect. I was most familiar with the way of the plains Indians. North: white, air, wisdom. East: red, fire, illumination. South: yellow, water, innocence. West: black, earth, transformation.

In my wheel, the colors of the four directions would be formed from the multi-hued garbage that was dumped into the ocean to "disappear," only to wash up later on the beach. It would be a metaphor for our toxic times and separation from nature.

In essence, the wheel would be an oceanside mandala symbolic of the profound transformation that must arise from modern consumer society—a society in which, as social critic Lewis Mumford notes, "all but one of the seven deadly sins, sloth, has been transformed into a positive virtue."[2] Greed, avarice, envy, gluttony, luxury, and pride—all drive our economy, and their by-products coated the Sian Ka'an shoreline.

I chose a site on a raised area of beach near my camp. I made a hoop with the anchor rope, then collected twelve wave-tossed coconuts to divide the circle into quarters. With a discarded bucket and a broken laundry basket, I began to gather my colors. White and yellow were everywhere. Discarded styrofoam, six-pack rings, tangles of nylon netting, light bulbs, hypodermic syringes, and detergent containers quickly filled the north and east sections of the circle. Black and red were harder to find, but ocean dumping had provided them also in Texaco oil containers, old toys, fragments of garbage bags, and so on.

It was hard to imagine the tons of garbage before me being dumped by humans into the ocean, but it had been—and the impact went far beyond a mere assault on my aesthetic experience. One hundred thousand marine mammals die each year from entanglement and ingestion of plastics. For example, three pounds of plastic were found in the intes-

tines of a single twelve-pound sea turtle, washed up on a Hawaiian beach. Beads, a comb, a golf tee, a toy wheel, a piece of rope, a balloon, a toothpaste cap, bags, and a fake flower had all been swallowed by the turtle.[3] Each of these items was present in my wheel, as well.

For too long Earth's oceans have been treated as convenient places to put things we have created and don't know what else to do with—things infinitely more dangerous than plastic. "For years we have been dumping everything imaginable into the ocean," writes James Lovelock who, along with Lynn Margulis, champions the notion of Gaia. The Gaia hypothesis holds that Earth is a single organism continually making choices, regulating climate and the composition of the oceans and atmosphere in order to maintain the most ideal conditions for life. "We don't have any idea of the risk we are taking. If she dies, we die."[4] At present pollution rates, according to oceanographer Jacques Cousteau, by the year 2010 the phyto-plankton will be gone. This is an alarming prediction indeed, since these tiny organisms produce three-fourths of Earth's oxygen.[5]

Years later, I would learn of Richard Sowa, an artist living near my mandala site. Sowa transformed heaps of ocean garbage into a floating island home, in a two-year project with the help of friends, neighbors, and schoolchildren. He enclosed all the non-degradable items he collected, including 100,000 empty plastic bottles, in a webwork of nets. The Mexican government claimed this new land—complete with palm trees—as theirs, but Sowa's plan is to eventually float his island across the ocean.[6]

The Taste of Wholeness

More than once, while gathering the refuse that coated the shoreline, I felt my legs and arms burning from foreign liquids spilled upon my skin. In the shore break I washed off chemicals I could not name, and as I did so, I remembered that just like Earth, the human body is seventy percent salt water. With this memory, I suddenly felt *bodily* a concept that until then had been primarily intellectual—the ancient and newly rediscovered principle of Gaia. We and the Earth are alive as one whole living system. The dreadful pollution of this beach was a defilement of *my* body. The chemicals I washed "off" had not disappeared, they were still present in the salt water system that flows through the planet, through all living things—through me.

I became enraged. I could no longer contain the despair for all that was being lost. I screamed. I shed saltwater tears. Years of feeling the fabric of nature come apart around me—of watching ancient forests dis-

appear, of swimming in dying rivers, looking for endangered species, worrying about toxic waste and ozone holes—all poured out of me as I knelt in the shallows of the incoming tide. When I recovered, I was infused with a kind of peace unknown to me until that moment. I had released my grief for the world, and now empty, I could begin anew.

I felt the ocean flow into me and me into it. I tasted wholeness. It was salty, boundless, deep, and blue.

By sunset, I had collected enough material to complete the wheel. I unrolled my bag a few paces from the unfinished wheel, beside the trunk of a dead palm. As I settled in for the night, my eyes followed the tree's narrow column heavenward into the refreshing thicket of stars that greet a skygazer like an old friend. Arrow-like, the trunk pointed directly at the Pleiades, the closest cluster of stars to the Earth, five light years away. I stared at this nebula, which figures strongly in so many mythologies, and picked out its seven stars, two of which are only visible with good eyes from wild places far removed from city lights. The Caribbean night was a melodious blend of crooning crickets and the soft, tidal lapping of small waves on the beach. Studying the stars an unfathomable distance away, I wondered about the many years it took for their light to reach me. No doubt some of them are burned out by now. Which ones, I could not know. Yet, it was precisely this unknowing which made them all so beautiful.

Is not all life a bit the same—heartbreakingly beautiful, because it is so fleeting, so impermanent with a destiny unknown?

I was familiar with the haunting ecological metaphor of "ghostbears." This very descriptive term refers to increasing numbers of animal species whose populations are too small to maintain their viability much further into the future. They are the extremely endangered. Still alive today, as a species they are essentially the walking dead, their time on planet Earth nearly at an end. Ghost bears, ghost stars, ghost humans... we're all kin in this colossal experiment of life.

My thoughts wandered from stars to ocean. I thought of the many thousands of miles of drift nets set each day to "vacuum" the oceans. One third of all fish species are threatened with extinction.[7] Wild, sentient dolphins and thousands of "trash fish" were trapped and dying at this very instant. Feeling cozy in my sleeping bag, I stared up into the dark mystery of space. All life seemed an ephemeral sparkle, mirrored by the winking stars and the phosphorescence of the gathering tide's ebb and flow.

I considered my death. "Life's greatest adventure, that's why it comes last," I read once on a bathroom wall. "Our greatest teacher," counsels Carlos Castaneda's Don Juan. "The crowning and most glorious moment

of life," say the Buddhists. Sure, we are all alive and dying, but what can we learn from the premature death of the creatures we share this planet with? How awful to steal so callously, so needlessly the gift of another's life—animal, tree, or river—before its time! What one thing would I do, I thought, if I were a God or Gaia, to right this wrong?

Here's what: I would engineer the bio-psycho-mechanics of life such that we big-brained, conscious mammals received instantaneous feedback from our actions. What if every act of senseless pain humans inflict-

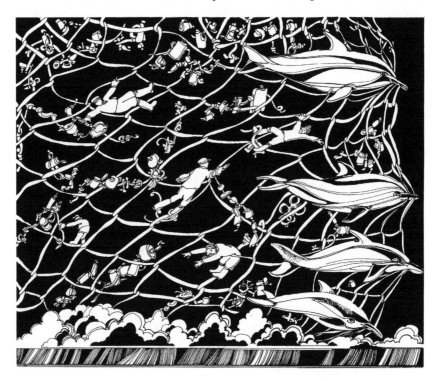

ed without thought or concern on one another—on fish, mammals, birds, trees, and Grandmother Earth herself—we felt ourselves? With this strategic bit of instant karma in place, our environmental crisis would dissolve in an instant!

"Are you listening out there, God?" I implored. "Please mutate us and make it so!"

I fell asleep imagining powerful teams of dolphins towing drift nets full of garbage to entrap fish miners in the "walls of death" that are their stock and trade—and then releasing them, of course, changed forever.

A Wheel for Toxic Man

At sunrise the next morning, I completed the wheel. In a weird, apocalyptic sort of way, I found it beautiful. Facing west, at the circle's edge, was a sun-baked starfish shot full of bullet holes. The dolphin skull lay on the east-west meridian facing the ocean and the morning sun. Two red flags on a bamboo pole, an old tattered marker from some fisherman's diving site perhaps, flew at the eastern point in front of the dolphin. On top of the pole, presiding over the healing wheel, was the smiling plastic head of a baby doll, one tiny blue eye still in place, representing the youngest generation—the inheritors of the toxic planet we have wrought.

From the mandalas and round dances of ancient peoples to the sacred hoop of Native Americans, the wheel reminds us that all is alive and turning, connected and interwoven. The Buddha used the wheel to explain his central teaching—the dependent co-arising of all things. Everything forever transforms and conditions everything. All is interdependent like the spokes of a wheel.[8] Staring at my creation, I wondered what would "co-arise" from the techno-beast that spawned *this* wheel? If this was the land where the sky was born, as the Mayan name for this place implied, then what was happening to the sky from the disrespect for its birthing ground?

I fasted on coconut meat and stayed near the wheel all that day and night, until the next morning. The wide variety of plastic trash that adorned it seemed to sum up industrial society. All our addictions were present—vanity, gluttony, convenience, speed—to name a few. Some items stood out with particular irony, like Baygon bug killer, Tropical Trade Winds air freshener, and Natural Brilliance hair conditioner. Our addictions have grown to mythic proportions and sadly, like alcoholics or drug addicts, we refuse change even when it becomes obvious that our body (in this case, our larger body, the Earth) is being destroyed. Like the addict whose "fix" permits momentary survival, we continue to crave that which may eventually make life impossible for our species. Like the alcoholic, we must concede that we have "hit bottom." Our salvation may reside in this acknowledgement.

Ghost Dancing

Our predicament is a bit like the science experiment that my father shared with me when I was ten. He taught high-school biology classes then, and while I knew—or at least hoped—that he never actually performed this experiment for his class, I figured someone must have done it. The experiment goes like this: If you take a frog and plop him into a

boiling pot of water, he will jump right out. If you take the same frog and put him in a pot of cool water, raising the temperature slowly, he will stay in the pot until he boils to death. To the frog, it is not the boiling water that is the apocalyptic event. It is the incremental changing of its environment that is below its biological threshold ability to recognize—in this case, the heat—that is the frog's demise.

The metaphor for the human species is an obvious one but still bears examining. Our environment is growing incrementally more toxic every day but of course, most Westerners are doing fine basking in the warm and entertaining comfort of modern technology. Writer and artist Dianne Harvey puts it well. "The dizzying flight of the techno-beast has left behind more than spoor and flattened undergrowth. It has left behind entire previous incarnations of itself, and these scraps are what we are using for building our huts, trading our baubles, and whiling away the long nights. Our entire civilization is now composed of pieces of a gargantuan broken eggshell, and very few of us are concerned about looking around for what on earth emerged. The majority of people find the leftover castings of technology so entirely entertaining and comfortable to dwell in that no thought of the morrow need apply. But of course tomorrow is already here, up there ahead, far in the distance, where techno-beast is up and running."[9] In other words, the boiling point is not far off.

And yet our dilemma is different than the frog's. All the frog has to do is jump out of the pot and he is back in his frog world doing fine. For us, however, all Earth is the pot. And since there is nowhere to jump to, we literally must figure out how to turn down the heat. We have advantages the frog doesn't have. Unlike the frog, we have thousands of scientists around the globe telling us to "jump." How many of us remember the "World Scientists' Warning To Humanity" that was issued in 1992?[10] If you do not, it is probably because it was buried on the back pages of our newspapers whose owners have deep financial interests in keeping the water warm. The U.S. Union of Concerned Scientists, in a statement endorsed by more than 100 Nobel laureates and 1,600 members of national science academies from around the world, proclaimed "that present rates of environmental assault and population increase could not continue without vast human misery and a planet so irretrievably mutilated that it will be unable to sustain life in the manner we now know." Certainly it is time we listen to our scientists and avoid the trap of the slowly boiled-to-death frog.

Born from seeds long dormant, sown scarred, and steeped in a fallen society that left the sacred wheel of life to create its own—my shoreline efforts were a desperate way to somehow, on some level, help us make the

collective "leap from the pot." The wheel I constructed was my own way of beginning to reclaim a once-sacred compact between human and Earth while there was still time. As the morning sun rose from the sea, I was moved to honor this relationship. I felt a ritual literacy locked in my DNA arise that morning as I circled the toxic wheel, focusing my intent on an appeal to the Great Mystery. I had read of the Mayan compass which added a fifth direction to the standard four. The color of the fifth direction was green. I found a sprouting coconut nearby and placed it at the wheel's hub, the green heart of the world.

"Hold on to the center," reminds the *Tao te Ching*. Is there any advice greater than this?

The vigorous palm shoots rose hopefully as The Tree of Life—an origin myth common to indigenous peoples across the planet. The young palm signaled "A Great Remembering" among our species and a rebirth of our reverence for nature. The restoration and protection of the sacred living systems that sustain us must begin.

"Help us to change, help us to change, help us to change," I chanted over and over as I stood facing the sun. "The Sun will help us if we ask," teaches Mayan elder Hunbatz Men.[11] I continued to circle the wheel until a growing self-consciousness ended my efforts. I had not yet broken the yoke of the industrial culture that shaped me—a society "denatured" and cut off from the ebb and flow of rites to celebrate life. We moderns are perhaps the only ones who have ever attempted to live without ceremony as an integral part of our lives, and it may prove to be a fatal flaw. Despite the fashion of my own awkward attempt, I felt a faint link to the Sioux ghost dancers at the end of the nineteenth century who danced a secret dance in a desperate attempt to rid the land of the white man's disease—to "dream back the buffalo and sing back the swan." The dance was potent medicine our government feared, for they were quick to turn the cannons upon the dancers.

For native cultures living in harmony with the Earth, Nature was the sacred language and they spoke it fluently. They honored the Circle of Life in conscious interbeing with the Earth. This has been our way for the majority of human time on Earth. Within this context, the last 4,000 years or so is merely an aberration—only a brief forgetting. Inwardly, we crave a world that each cell of our body remembers, a time when we lived within the circle in balance upon Earth. It is imprinted within each of us, coded in our DNA. Or is it? Have technology and modern life weaned us so completely from nature that we have lost the coding that has been with us since the beginning? Once wolves, have we become poodles with no way back? Personally, I can only hope this is not true, for certainly it

does not feel true for me. I have to believe that a sustainable human world in balance with nature can be regrown and nurtured within this one. I can only say "yes" and continue to push onward, seeking the way home through the frayed and straining network of a dying culture lost in fantasy and denial.

At sunrise the next morning, I took a few final photographs while lazy rain clouds traced their contents over the sea. The steadily blowing tradewinds pushed the clouds inland toward me as I stood before the toxic wheel one last time. Was I fooling myself in thinking that an act such as this could really make a difference? We cannot know such things, just as we cannot know that a letter to our congressional representative or recycling our garbage will make a difference. One can only know that doing nothing will *not* make a difference. "Fooling ourselves" might just be our greatest hope, I thought, and I vowed to continue my foolishness.

A bold rainbow stabbed downward from the north sky, connecting cloud to ocean. It was the only one I would see during my month-long stay in Mexico and seemed to confirm the importance of the wheel before me. I took one last look, bowed, and walked away without looking back.

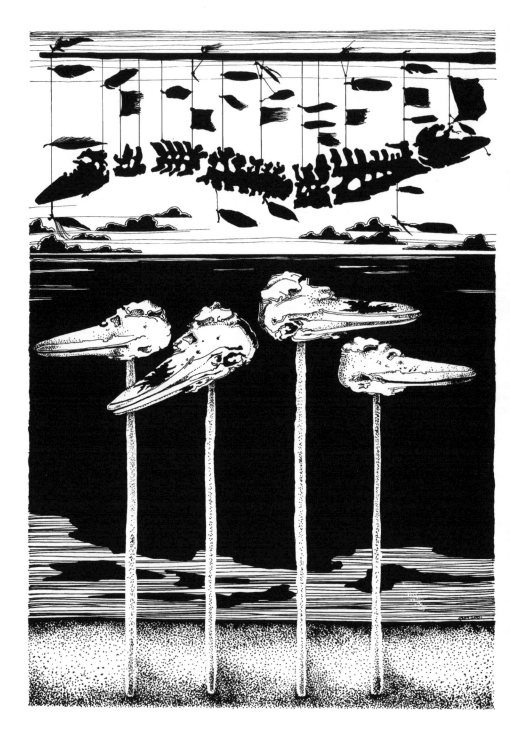

Chapter 2

The Beluga Peacemakers

"Living is a form of not being sure, not knowing what or how.
The moment you know how, you begin to die a little.
The artist never entirely knows. We guess. We may be wrong,
but we take leap after leap in the dark."

—Agnes de Mille

n a roundabout way, it was the valley coyotes that led me to the Arctic on a musical quest to communicate with the beluga whale. No music has ever enchanted me like the chorus of coyotes that sing in the valley of Sleeping Beauty Ranch—my home for many years. Adding howls, bamboo flute, or harmonica to nearby coyote vocals interested me in the possibility of interspecies communication. It interested me because sometimes, such a dialog seemed to happen.

The intimate shape and size of my valley home in northeast Kansas formed a natural amphitheater, creating an acoustic quality that transformed simple coyote howling into sheer magic. Almost nightly after sunset, different groups of coyotes would gather at opposite points of the valley at well-chosen spots to begin their concert. I knew these places from the copious amounts of scat the animals left there and surmised that over time, they must have learned that these were the best places to lift their muzzles to the stars and yip their song across the valley. The effect they produced is unlike anything I have ever heard. What transfigured their howling into such wild, beautiful music was the circular echo produced by this small valley. The animals would croon back and forth, here in falsetto, there in tremolo and countertremolo, all the time playing on the rising and falling crescendo of their echoing cries. On and on they would vocalize, delighting me always and amazing any friends that were able to join me. "Come listen to the music of God's dogs," I would suggest. The coyotes rarely disappointed us.

Sometimes a few herons from the colony atop the creek sycamores would join in, with their guttural squawks lending a distinct primordial

tone to this most surreal of symphonies. Combine all this with the common summer rumbling of Kansas thunder and celestial lightning displays, and you can imagine a concert of absolute mythic proportion!

It was the music of these coyotes that enabled me to find Jim Nollman, author and director of Interspecies Communication, Inc. Inspired by the coyotes, I picked up Nollman's first book, *Animal Dreaming* (now called *Dolphin Dreamtime* in its revised edition), which is about communication with animals. The boldness and beauty of Jim's adventures in seeking a musical intimacy with dolphins, buffalo, turkeys, spiders, and whales so moved me that I wrote my very first letter to an author. Jim wrote back, inviting me to an Interspecies Communication conference that would be held in Maui in several months. I went, and became enchanted by the stories, theories, and prospects of communication with animals. During the following summer, in 1990, I found myself on an arctic adventure I will never forget.

Our Interspecies traveling trio consisted of myself as photographer and flute player, Jonathan Churcher as keyboard player and frontman in Inuvik, and Jim Nollman as guitar player and project leader. We journeyed a great distance to be with beluga whales. Our jumping-off point was Inuvik, in Canada's Northwest Territories. It is an outpost where nature, industry, and native culture converge 200 miles above the Arctic Circle. An abandoned military base, the town now serves as a center for the Inuvialuit Eskimos, a tourist hub, and a base for oil exploration.

If one listens amid the turmoil, such sites as Inuvik on the outskirts of civilization can reveal the stifled pulse of the Earth. I could feel it here. It was wounded, out of balance, and led me to wonder what awaited us. At 3A.M., I was wide awake. The arctic night sun was like late afternoon light in Kansas. I felt disoriented.

Our room in the MacKenzie Hotel was not equipped for the heat that occasionally descends in summer. Sweating in bed, I listened to the last of the raucous bar activity on the street below. A semblance of quiet settled in and with it, through the odd, humid, arctic air, came a distant drumbeat and muffled chanting. In a region where whales are hunted with high-powered rifles from speeding motorboats, where alcoholism and child abuse are epidemic, and where strangers come to make dollars from oil exploration, I was humbled by this wild spirit sound.

I rose and stared out the window. A lone, drunken Indian was rhythmically weaving his way down the street to the drumming that came from a nearby building. There goes Native Man, I thought, shipwrecked on the shores of the modern industrial order. The drumbeat preserves a timeless wisdom, one that outlasts failed human economies and wars.

Underneath the cheap veneer of Inuvik, wisdom was alive that night. The heart sound of the drum focused my thoughts on the reasons I had journeyed so far.

An Ancient Hunger

The notion that humans can communicate directly with other animals has played upon our imaginations throughout history. "Judging by folklore and myths," writes Scott Russel Sanders, "there is a perennial human desire to converse with our neighbors in their separate dialects— to speak bear with bear, oak with oak, flint with flint—and once in a great while to leap into the universal language and hear and be heard by the creator."[1]

Even science courts the idea, but as one might expect, the scientific framework entails a laboratory environment in which forms of behavioral training become a masquerade for communication between human and animal. Real conversations do not take place in controlled settings.

What did I feel when I lent my voice or instruments to the valley coyotes? Did communication truly happen? So enthralled with their own music, the coyotes probably did not notice me much—although at times, it seemed I was able to set them singing again when they stopped. I felt an ancient hunger to join with them, to play, to be part of some forgotten animal communion I could only articulate in musical realms.

Interspecies Communication, Inc., a research group based near Seattle, believes that humans *can* communicate with other species, but only when the opportunity is pursued in the wild. Jim Nollman holds the premise that "animal languages are closer to music than to English or Chinese or Swahili." For the last two decades, IC's small band of inter-species-communicator artists has been quietly testing this premise with orcas, dolphins, and, the summer previous to this adventure, highly vocal beluga whales.

We chose Inuvik for our expedition because of its close proximity to the MacKenzie River delta. In a typical summer, more than 10,000 belugas congregate in the delta's warm, shallow waters to nurse their young. For the belugas, the delta provides a similar function to Baja's Scammon's Lagoon for grey whales, or Maui's sheltered bays for the humpbacks—all are protected marine sanctuaries. Cetaceans migrate from afar to these unique regions that are idyllic nurseries for whale mothers and their newborns. The areas are also perfect for whale watching and so are big draws for tourist dollars—a reason, in part, that some

of these areas have been protected. Tourists were not an issue in the delta. In fact, we were certainly among the first to make a pilgrimage to these remote, muddy, mosquito-ridden beaches for the simple delight of being among whales.

In our small green boat we wound our way 100 miles down the wide, sinuous delta, perpetually watching for bears or wolves on the shore. We stopped after several hours to break the monotony of the motor's drone and bask in the arctic silence for a while. Pulling the boat up on land, we immediately found grizzly tracks and fresh scat. The air smelled fresh and wild, and I breathed a joyful draught of it deep into my lungs. "Wild is the way," I said to myself. It is a mantra I repeat often in life, and moments like this keep its edge sharpened; its heft, light. Sitting in silence, we absorbed into every pore the magnificent expanse and stillness of the setting. We had arrived, and it was a many-tiered beauty.

After eating a lunch of jerky, nuts, and cheese we shoved off and soon spied a large group of sandhill cranes doing their mating dance in the tall grass. Flocks of cranes were flying overhead. Then they were all around us. We edged our way up a small channel for a closer look. Our presence startled a pair feeding along the shoreline, and a feather drifted down as they flew away. We watched it fall; Jim maneuvered the boat expertly so that I could catch it in mid-air. As we headed back out into the main channel I held the feather to the sky and gave thanks for the luck of this gift. "A good omen," Jonathan proclaimed.

After twenty hours of motoring we reached the Beaufort Sea, our meeting ground for the white beluga whales. We pitched our tents in what appeared to be an abandoned whaling camp. Nearby were modern camps where native hunters lay poised for the white whales' arrival. With guns, ammo, harpoons, and gasoline on board, their boats sat tethered to land, ready for the call from lookouts perched atop driftwood tripods that dotted the shorelines. We traveled to some of these camps in friendship, to demonstrate our instruments and to discuss our unusual mission. Responses ranged from mild fascination to cold disinterest—with most encounters leaning toward the latter.

Returning to our campsite among the ruins of this interspecies ghost town, we each felt the profound presence of a wound, the violation of an ancient pact between man and animal. There was an acute, almost palpable sense of absence. The bold arctic race that once hunted the beluga from handmade boats was long gone. In their place were modern descendents who used hollow bullets instead of harpoons, and 150-horsepower "kickers" instead of paddles. It was inevitable, I suppose, a transformation that has occurred within native peoples all over the

world when they encountered western man's technology and unspirited connection with nature.

Will Baker, a writer, photographer, and reluctant anthropologist, writes wryly of our impact on native man in his haunting book, *Backward: An Essay on Indians, Time and Photography*. "As the past recedes, vanishes, it becomes more precious. The civilized man feels a nameless nostalgia, a temptation to romanticize, eulogize, daydream, mourn; also a haunting suspicion that this barter of kitchen-ware for sacred stories involves incalculable, irredeemable loss."[2] The wild, free spirit of the small white delta whale, and the people that once hunted them and honored them as gifts, have been replaced with fear. The whales fear that man will hurt them. The men fear they will not be able to hurt the whales. We could taste it in the wind, a wind that cried for reconciliation. Yet, we carried no blame. It was just the way things were.

Becoming Myth

We listened for the beluga's playful sounds while in our tents at night and scanned the seas for them by day, but they did not come. It was alarming—this was also the story the previous year, when a similar group from IC had visited the delta. Soon we learned, via a government wildlife official, that the Eskimos thought we had come to intentionally disrupt the hunt by playing killer whale sounds into the water, thus frightening the belugas away. (The orca, or killer whale, is the beluga's natural enemy.)

Two years in a row the whales had not come. Two years in a row an IC contingent had been in the delta. The belugas had virtually disappeared from the region for the first time in memory. "How could this be," the Eskimos imagined, "unless it had something to do with the strangers with their instruments and their little green boat?" We were openly accused by some as being eco-defenders from Greenpeace. Jim Nollman describes the situation:

"From the point of view of three interspecies artists who possessed more than a passing interest in the powers of myth and symbol, this skewed relationship between musicians, Eskimos, and whales seemed at least as potent a metaphor as anything we, ourselves, could have created—even if we had succeeded in interfacing with the whales directly.

"There is more to this, another level entirely; one that skirts the edges of a cosmic mystery and belies our growing sense of humility at being handed the power to conduct an interspecies field project from

right inside the bubble of an Eskimo myth. You see, it soon became impossible for us to deny that there was, indeed, a very strong connection between the disappearance of the *beluga whales* and our own synchronized entrance upon the delta. However, our own interpretation of that connection was of a very different sort than the original accusation.

"What I mean to confess here, is that the myth about our power with the beluga whales quickly transformed into the reality of our power with the *Eskimos*. We had inadvertently climbed to the edge of an abyss which provided a unique vantage point for discovering the real terms of this three-sided relationship. We began to consider that our own full participation in the unfolding Eskimo myth might conceivably effect more positive change than our own original intent of performing an experiment in interspecies communication."[3]

The Beluga Peacemakers

While Jim and Jonathan played music on the shoreline, I walked among the ruins of the old camps. Walking is good medicine in the arctic summer, as it is a great distraction from the aggravating clouds of mosquitoes that constantly orbit about a person like electrons around an atom. As long as I continued to walk, the mosquitoes would all collect in the wind shadow of my back, and for a while I was able to forget their presence. Whenever I stopped, I very quickly remembered where I was. It took many days in the whaling camp area before that sudden memory ceased to bring a loathing that few things on Earth can bring. Humor helps. Being a vegetarian, one must always seek opportunities to get extra protein and with every meal, the mosquitoes gave of themselves freely—some were in every bite!

As I meandered through the old camps, I gathered shards and relics from my path: feathers of cranes and eagles, strips of weatherbeaten cloth from discarded blankets and tents, and beluga bones strewn about the remnants of human habitation. I treasured the bones and bright red cloth I found, but feathers are especially significant. They immediately lift my heart in the midst of destruction or sadness.

"Considered to be the 'breath of life,' the feather possesses the power and spirit of the bird of which it once was a living part," writes Gail Tuchman in *Through the Eye of the Feather*.[4] Raven, eagle, sandhill crane—gathering feathers and pondering the symbolism and life ways of the bird that dropped them helps me stay immersed in, and surrendered to, the landscape. Crane feathers, like the one I plucked from the sky a

few days before, were abundant. I recalled that in China, the crane is a symbol of longevity and above all else, unrivaled faithfulness. The large, ungainly birds were everywhere present at the far perimeters of our camp. Occasionally we could see them through our binoculars, dancing their beautiful courtship display. Longevity, faithfulness, and dance—all are qualities that would serve the belugas well. I gathered every feather I could find to use in the art forms that had begun to brew in my mind.

In one old camp, I found a grisly pit full of beluga skulls. I selected four skulls and placed each one on top of a post with a crane feather in each eye socket. The four posts, configured in a square, once supported a large rack for drying blubber. I stood still in the center, facing North, with a skull at each of the four directions. I let a halo of mosquitoes settle on me for a moment and prayed silently for healing and forgiveness in the delta. From a half-full can found on a nearby trash heap, I cast pinches of tobacco—offerings to the four winds. For the sake of ceremony, I resisted the desire to slap at the biting insects. The mosquitoes took my blood where they could, a sacrifice easily given in the Arctic.

I carried the largest and most intact skull back to camp, along with a nearly complete beluga skeleton found earlier. What a beautiful thing, a skull. Is there a more perfectly crafted capsule for the spirit and soul, a more fitting architecture of impermanence? I placed my index finger in the blow hole, and tried to imagine an infinity of whale breaths taken and held in the depths of thousands of dark blue ocean miles, then expelled into the wild marine air. What joy to possess such perfect natural affinity with our ocean planet! I ran my fingers around and around the eye sockets. Oh, to see what this being had seen, deep in a whale world we cannot know! With my fingers ringing the circular holes I longed for the ability to shapeshift myself, to have whale eyes for a whale world.

I placed the skull amongst the vertebrae and other bones I had collected. Blowing sage smoke over them, I began to consider what to create. Jim and Jonathan were asleep in their tents and the sun glowed red, low on the horizon. Everything was perfectly still—no bird calls, no waves, no human voices. Just me and the bones, feathers, and swatches of fabric I had gathered. I love this work, this art, this beginning with found elements of place, trusting the unknown and the spirits of surprise and insight. Everything disappears when one begins the art one loves. The muse bends and weaves and moves through body and soul. We become joyfully possessed as we begin to collaborate with The Mystery.

Embracing place and the spirit mystery within the found artifacts before me, I began. I hung the bones with twine from a goal post-like

frame that was once the center support of a whaler's canvas tent. Abruptly, a wind started to howl, setting the ten-foot-long, two-headed beluga into an uncanny swimming motion. Feathers sailed out from this bleached-bone sky whale—eagle, sandhill crane, owl, seagull.

"We salute you, beluga, and miss you in this place," I shouted into the wind. Cloth scraps from the old camps flew as prayer flags, flapping our message to the whales. "We love you! We are different from those who have greeted you here with bullets. We sing your life. Let's play music together. Come!" And yet, with all the hunters poised nearby, we began to wonder if we really did want them to come.

On a driftwood-strewn beach near our island campsite the next day, I made a life-sized white whale out of hundreds of pieces of driftwood. Its eyes were purple lousewort flowers. To make its big red heart, I nestled a piece of nylon from an old camp blanket within the pieces of wood. From the beluga's mouth, rising to meet the ocean, came a long spiral of feathers and small sticks.

I then built a tall tripod with several storm-beached logs carried to the island on the currents of the MacKenzie River. Atop this tower, similar to the Eskimo whale-sighting towers I could barely see in the far distance, my driftwood beluga could be viewed in proper perspective. In the balmy, late-night sun, I sat fifteen feet above the beach and photographed the only kind of whale we would see on our entire trip. This stick-and-feather whale, and the beluga-bone "Sky Whale" of the previous day would have to suffice. We would reluctantly have to content ourselves with these "sightings" in lieu of the real animals.

From the perspective of a passing seagull my creation had a life of its own and I sat above it in contemplation, the highest thing on the island.

I looked north toward the icepack barely visible in the distance, and felt preternaturally alive. Everything was perfectly still and balanced. My pilgrimage felt complete and I had the thrill of knowing that I had done something exactly right, and that in a way I had not anticipated, I had "seen" the beluga.[5]

Suddenly, I heard Jonathan's yell. I had not noticed the storm front rapidly approaching behind me, which presented a dangerous situation because the low elevation of our island camp made it prone to complete immersion during a storm. We broke camp hurriedly, and within an hour were battling wind and waves in our tiny craft as we searched for higher ground. I knew my sculpture had returned to its origins—just driftwood again, awash in the stormy sea, yet newly instilled with our message to the whales: "Endure. Be invisible to your tormentors! Hang in there until the day when you're respected as Earth partners and the

musicians you truly are; until the Eskimos find a way, other than your unceremonious killing, to preserve their native roots."

Of the many artful offerings I have left behind on endangered reaches of Earth, the Beluga Peacemaker is perhaps my favorite because its "life" was the shortest of all. Quickly absorbed by the delta's watery embrace, it illuminates the fear that consumes our species—the fear of impermanence. We need only remember what the Buddha taught, however; that impermanence is the underlying force of creativity on Earth. Everything is becoming in the ever-flowing, one, grand song of Mother Gaia. A beach became trees became driftwood became a whale sculpture became driftwood, soon to become soil and trees once more.

"Form is emptiness and emptiness is form," according to the teachings of Buddhism.[6] We are all drifting particles, inextricably connected in an ever-changing sculpture of time. Our tinkering with this cycle in a fruit-

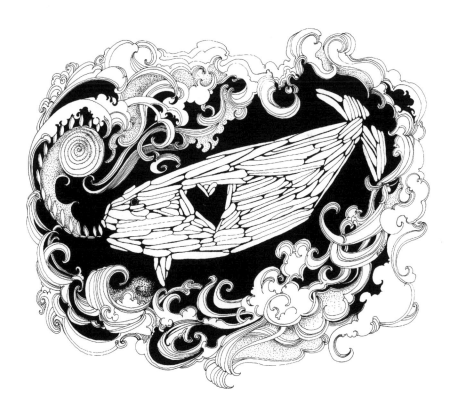

less search for permanence, our attempt to "fix" what has never been broken, continues to spawn the social and ecological crises that grip our world.

The organic works left on the delta shores were our way of affirming the sacred circle, of honoring *Change* as the Goddess energy that binds us all together as one. We felt tossed in her turbulent center by our confusion as to whether we should try to will the belugas away from the delta to safety (as the Eskimos envisioned us doing) or call them in to converse with us. Were the Eskimos right? Had we been communicating with the belugas on some kind of interspecies soul level? Was it only our egos or the superficial parts of ourselves that wanted the whales here in the flesh? To us they were the very spirit of the wild Arctic we had come so far to encounter, and we could not help but wish for them. Yet day by day, they remained elusive.

An Abundance of Animals

In *Arctic Dreams,* Barry Lopez writes about what gave the Eskimos a sense of wealth, of satisfaction—beyond a shadow of a doubt, what made them happy. In one form or another their reply was invariably "an abundance of animals."[7] My campsite whale art became a way of mourning the deep loss we felt in the absence of whales. Sometimes, we would hear their playful sounds only to realize with bitter disappointment that we had been asleep and were only dreaming. The sound of wind-lashed waves upon the shore, the thick hordes of buzzing mosquitoes, and the occasional lonely croon of a sandhill crane sang an accompaniment to our desolate outpost. How we longed for our lead player, the beluga whale!

I have since come to wonder if such tales as this are the kind of animal stories we will read about in nature magazines of the future. What a rare privilege it is today, to be among wild animals! Throughout human history we have been blessed with an animal abundance and now, as the survival of our own kind teeters at the precipice, we are quoted an increasing number of species that forever leave the planet. Ten, fifteen, twenty per hour—how many will it take before we awaken to the truth of what is happening? Does the popularity of wildlife art and nature magazines signify how rare *real* animal encounters are for most of us, even when we seek them? In their absence, we are comforted by nature films, Disney cartoons, wildlife art, glossy nature photographs, and animal knickknacks of an astounding variety. All are indicative of how accustomed we are to the absence of wild nature, and how deeply we miss it.

The Beluga Peacemakers

I treasure the animal encounter and communication stories I have collected during my time on Earth. I tell them and retell them, hoping that others will remember their own stories and seek more wild experiences while they can. Few things are as sacred as this remembering and telling about nature.

As we three sat around the campfire in full anti-mosquito regalia, the red sun would travel along the horizon for about four hours, painting us in a continual glowing warmth that is akin to twilight in our more southern latitudes. This was our favorite time of day and when we gathered around the campfire, our talk always turned to animals. For countless millennia among humans, it has always been so. This evening, each of us mourned the absence of whales.

"For one species to mourn the death of another is a new thing under the sun," said Jim, quoting Aldo Leopold.

"Old Aldo's been dead for some time," quipped Jonathan. "Nowadays we are an entire world in mourning and we're just beginning to recognize it." All three of us sat staring into the fire, shoulders hunched, feeling glum and dejected.

I tried to brighten our mood by sharing a story about music-making with frogs in Belize. "One night in a wild rain forest grotto along the Bladen River, I sat down with my flute and joined in with a chorus of dozens of frogs. Our music reverberated among the overhanging rocks and within minutes, something happened that I have never been able to explain. The sounds of the frogs 'traveled' up the interior of my flute and vibrated on my lips. It didn't matter which note I played. Perhaps we were in the exact same key, I don't know. I do know that I 'felt' their sound in my mouth. Something from them was communicated to me. A kinship, a welcoming, a frog embrace…that's how I chose to understand it. Amazed and in wonder, I left them singing their frog music to the jungle moon. I fell asleep that night as if listening to a lullaby."

I asked Jim if he had any idea what caused this phenomenon. "What you experienced," he said, "reminds me of what happens when people are singing in a choir, and the resonances set up sympathetic vibrations in the air. The music almost attains a physical heft."

"It's all about communion," declared Jonathan. "For a short time you were the guest artist in a froggy choir. Community comes naturally to animals who have zero baggage. Unlike us, they have no history, only evolution. Whether whales, coyotes, or frogs, we listen to them and watch them and covet the pristine presence they bring to each moment. We can barely fathom their raw animal simplicity, and when we experience a touch of it, it feels like paradise. Oohhhhh how we crave, sometimes, a part in their band."

"How true," I added. "It's like we keep trying to return to Eden but we cannot. It's impossible. The moment we entered, it would not be Eden anymore. Like you said Jonathan, we have too much baggage. Moments. Golden, sacred, animal moments. That's the best we can hope for, and really...it is enough. It has to be. These are the times we live in. I suppose that's why we've come all this way."

As in every night of this trip, I fell asleep listening for the song of the beluga. It was the lullaby that we all intensely longed to hear. But there was only the regular buzz of mosquitoes who wanted my blood, tap-tapping against the walls of my tent.

The Hunt

We were aware of Eskimo roots in whale hunting. At one time the hunt had been a matter of sustenance and survival. As in many aboriginal cultures worldwide, food had a greater significance than it does in our modern society. Paul Shepard writes, "Animals were seen as belonging to their own nation and to be the bearers of messages and gifts of meat from a sacred domain."[8] Animals gave their life in sacrifice to the hunter's arrow or harpoon. It was a gifting so humans could live. The whale hunt, in a sense, was a form of worship, a sacred act done in accordance with strict, time-honored tradition. Indiscriminate killing was unthinkable, and thus the whale and Eskimo co-existed in harmony.

While no one can dispute the depth of cultural longing by any native people, the modern hunt conducted with high-powered machines and automatic weapons seems a desperate and misguided attempt to preserve Eskimo tradition and community. "The Indians, for their part, both detest and desire this outcome," writes Will Baker. "They revel in machines with a fierce ardor, aware of their magical dimension in a way we seldom are. We would react similarly if a shaman demonstrated to us conclusively that he could send his soul flying far away to spy on distant happenings, or could change himself into a jaguar."[9] Again, one must try to refrain from accusation and blame. In the face of slaughter this becomes a spiritual practice of a very high order. I am reminded of the Dalai Lama who considers the Chinese soldiers, who murdered thousands of Tibetans, to be his greatest teachers.

Continuing to challenge one's ability to be compassionate, Nollman describes the hunt in his report from a previous trip. "It is a brutal bumbled massacre. The most telling point is that the hunters may actually

lose a greater percentage of wounded animals *today* than they did before the advent of firearms. This occurs mostly because the traditional harpoon always tethered an animal to the boat. Unless that line broke, the animal was secured no matter what else happened. Guns, on the other hand, offer more power, but no such security."

W.J. Hunt, a scientific observer who gathered statistics between 1972 and 1975, estimated that for every ten whales killed, four were lost.[10] It is important to note that this does not take into account the wounded whales that managed to escape.

"Hunters cannot even seek what some choose to call a 'humane' kill," Nollman continues. "Should the whale be killed outright, the body will immediately sink like a stone in the muddy, coursing waters and will almost certainly never be recovered. Instead, the modern beluga hunter relies upon a soft-pointed bullet because he shoots not to kill, but rather to wound; to impair the animal enough to get within harpoon striking distance."

Mark Fraker observed during the hunt of 1980, "In one case forty rounds were fired at a large male before it was killed. I could clearly discern twenty-seven wounds within about thirty centimeters of the eye... In another case, a hunter expended sixty rounds at a whale that he was ultimately unable to secure because he had used up all his ammunition."[11]

"The survivalist need to hunt the beluga in order to feed the aboriginal village has essentially vanished, to be replaced by the generic village supermarket selling pork chops as it does everywhere else in North America," argues Nollman.[12] The hunt is a desperate reaction against the supermarket, against modern life by a confused culture yearning for its roots. It will not redeem their cultural identity any more than painting cave walls in Europe will redeem ours. We are all lost together, all looking for a way home.

I believe whales offer us a tremendous opportunity to find this way home. Whale brains have been evolving for thirty million years longer than ours have. Like great Ocean Buddhas, they wait patiently—even while we kill them—for a time when we will greet them as kin. When that day comes, "perhaps they'll help us forgive ourselves and so find family reunion," writes Brenda Peterson in her book *Living by Water*. "After all, whales are the most great-hearted mammals on Earth."[13]

Strange Ceremony

The full weight of the beluga's absence and all the distance we had come became most difficult to bear on the eve of our departure from the

delta. We longed for completion of some sort, and decided to hold a simple ceremony at sea. I still had the rusty can of tobacco from the whalers' trash heap near our first camp. We would cruise out a few miles and offer tobacco to the four directions. And, just perhaps, if we played our music quietly and prayed...

At midnight when the sun hung just above the horizon and the wind was still, we motored a few miles toward the ice cap, further than we had yet ventured from land. Each moment was pregnant with the possibility that we might still see a beluga. Our bodies were charged and ready. How we yearned for the whales to join us! But they did not come, and after we silenced the motor, the perfect arctic stillness of the delta wrapped around us like a fog.

Yet something wasn't quite right, and as we tentatively struck up a tune with our instruments we realized what it was. There was a barely audible drone to the west and, slowly, it grew louder. A speck could be seen now and it grew larger as it headed directly toward us. Without speaking aloud, I quickly scattered tobacco to each direction and then began to play a plaintive tune on my bamboo flute, hoping to defuse the situation. Jim joined in with a slow, even beat on his clavenets. Five minutes later, we were bouncing in the chop of a powerful motorboat idling beside us, manned by three Eskimo hunters with rifles in their laps.

Nollman later wrote an account of the scene: "Two of the men seemed in their mid-50s with twisted faces the result of a lack of teeth on one side of their mouths. The third was a handsome young man whose red headband and ponytail made him look like a Samurai. The three of them looked at the three of us utterly wild-eyed. It was a look of barely controlled fury, and bespoke the interrupted bloodlust that must inevitably accompany men out to assassinate big powerful animals like whales. Here was a savage madness I'd never seen before expressed on the face of a human being."[14]

Either from fright or in an assuredness developed after being in the delta wilds for two weeks, we could think of nothing else to do but to continue playing our music softly. It was a potentially explosive situation. In a way we were trespassing, but such a notion seemed silly so far from land. Nonetheless, it was not our home and our ideas about whales were obviously not something the Eskimos were willing to consider.

"What are you doing out here?" the young man with a red headband demanded. "Don't you know you're scaring away the whales?"

"I'm just playing my flute and hoping to attract some belugas," I answered. "You don't really believe that our music will frighten them away, do you?"

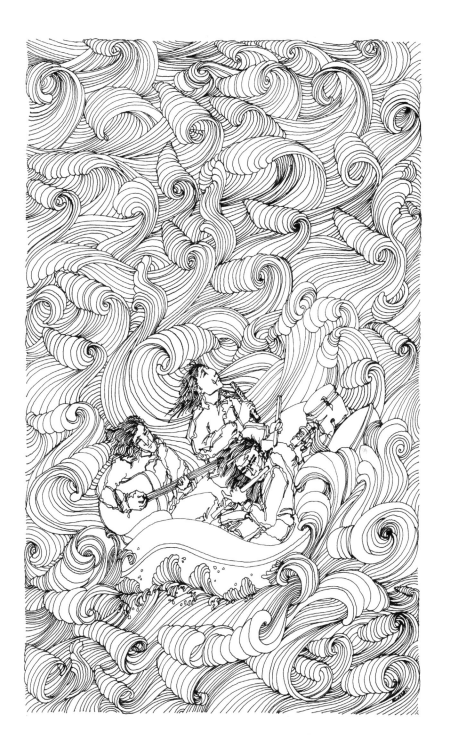

Maybe it was the way I said it (I sometimes tend toward sarcasm), for our interrogator became enraged and shrieked, "Go back to your own country!" as the helmsman gunned the boat and sped off. We were confused and shaken. This wasn't the closure we had sought from ceremony. Perhaps we missed an opportunity for some important dialogue, but we all admitted we were simply relieved to be still afloat on the freezing, wide-open sea. We motored slowly back to shore, broke camp, and began the long journey up the MacKenzie to Inuvik.

At the end of the trip, in Inuvik, we were interviewed on Arctic Radio. We asked the Eskimo hunters to consider that it might be their use of speeding boats and high-powered rifles for the previous ten years that had finally taught the beluga that it was unsafe to enter the delta. We asked for restraint and a moratorium on their killing until an accurate count of beluga populations could be ascertained. Most significantly, we questioned the natives' belief that they *own*, like so many goats, a sizeable share of the world's remaining beluga whales—thus making it necessary for us to ask their permission to be among the whales in the manner we chose. We don't know who was listening that night, but we hope to have reached at least one person, to plant a seed of questioning, of thoughtfulness.

Qaumaneq

I'll never forget how the low midnight sun slowly tracked the heavens to the north, painting the arctic landscape for hours in magic light that we south-landers only see for a half-hour at a time. Hollywood filmmakers and professional photographers prepare carefully for this time, so as not to waste a single golden moment. Eskimos call the glowing time "qaumaneq"—*shaman light*. By clock time these hours are from about 11P.M. to 3A.M. We patterned our days around them, not wanting to be asleep within such enchantment.

Playing music near the beluga sculptures we left at every camp and photographing them during this radiant time made me wonder about their power. What impact would they have upon the native people who happened to see them? Would they accentuate the myth and power the hunters had given us—that we were scaring the belugas away from the delta? Were the strange sculptures we left behind a way somehow of warning the whales, a hex of some sort? Would stories carried home by those who viewed our campsite works keep the power and spirit of our "beluga art" alive? We hoped so.

The Beluga Peacemakers

In a sense, the art we left behind *was* interspecies communication. It was not the form we intended at the outset, but as we talked on the homeward jet flying over Alaska, we decided to accept the Eskimos' notion that maybe there was a deeper reason for our journey. In a profound way, a shamanic way perhaps, we had reached out to the belugas and their modern hunters, forward-dreaming in a sense, to a time when all species could share this earth-water planet as equals. Like the tribal drumbeat that pounded through the night in Inuvik, we chose to believe that we had helped sustain something wild, something sacred.

"Attitude is everything," I thought, as I looked out the airplane window at the unbroken wilderness below. Choosing to honor our role in the protection of the whales we had not seen made much more sense than mourning their absence. Still it was unsettling, expending so much energy and going so far for an encounter that never happened. I mused upon the possibility of one day making another mythic journey to the Arctic, but the thought of it made me sigh with sadness. Perhaps Dorothy was right when, after returning from Oz, she proclaimed to her family, "If ever I go searching for my heart's desire again, I know that I don't need to go any further than my own back yard."

It's true. "There's no place like home"—and I couldn't wait to sit out in the middle of my prairie pasture and play music with the valley coyotes.

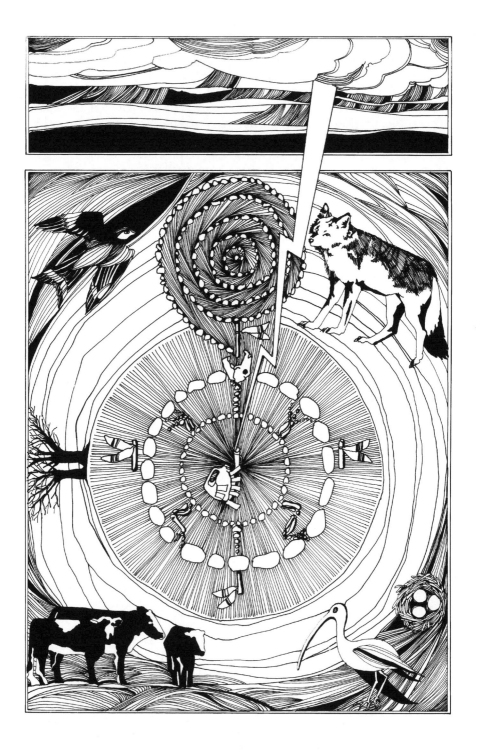

Chapter 3

The Golden Prairie

*"You can't see the moon in its early new days
but isn't it radiant, gold and round, nevertheless?"*
—from the poems of Kuan Yin

ndians watched in amazement when the white man began to plow the great prairies of America. As one story goes, a warrior sat beneath a tree observing a man with horse and plow turn over a stretch of blooming spring prairie. In the waning light when the man had finished, the warrior approached him and stopped at the edge of the new alien ground. He looked at the man standing on the freshly plowed soil and pointed down at the black earth. Before walking off he said, "Wrong side up."[1]

Industrial agriculture, 10,000 years in the making, had finally reached the prairies of North America, and the native people watched the enactment of what increasingly is seen as the worst mistake in the history of the human race. According to biologist James Lovelock, "By far the greatest damage we do to the Earth, and thus by far the greatest threat to our survival, comes from agriculture."[2] The depth and richness of our soil is a basic measure of health for the planet, and since Western civilization arrived in the Great Plains of North America, one-half of the topsoil has disappeared.

When Eve handed Adam the forbidden fruit, in essence she passed agriculture, for centuries a female art, into male hands. As Neolithic gatherers, women contributed significantly to human sustenance and when they learned the art of gardening, they provided even more. "When women invented agriculture," writes Evan Eisenberg in *The Ecology of Eden*, "they displaced men as breadwinners. The delicate balance between the sexes achieved in the course of four million years of hominid evolution was knocked off kilter. Woman's new magic was more than men could bear. There had to be a reaction."[3] And there was. The art and beauty of gardening was appropriated by man. Because men wrote the

scriptures, they portrayed Eve passing the apple to Adam—the story a simple cover-up of what truly happened.

Our ability to plow, to literally turn the earth inside out, coincided with the advent of metallurgy about 8000 years ago. This also coincided with men realizing that their sperm was the "seed" and they were able to claim power over childbirth, which was previously considered to be a magical act that only women could pull off. Now women became the mere "vessel" for the all-potent seed as men grasped the power of the seed planted for agriculture. A male god was invented, and with it came the cessation of goddess-worshipping societies. Could it be, Eisenberg wonders, that when we took up the plow and the sword we gave up worshipping the Great Mother from shame over raping her?[4]

As Vibrant as a Living Woolly Mammoth

In November 1990, over a century after Native Americans watched the first turning of the prairie in disbelief, I stumbled across deep furrows with cameras in hand. The air smelled wrong, unnatural, a fragrance of something better not known, a taboo. It was the sweet scent of soil harshly ripped open and exposed to the sky for the first time in thousands of years. I knew this prairie. I had walked it many times, watched thunderstorms unfurl above it, photographed its wildflowers, admired its coyotes, and delighted in its diversity. Now I felt violated. I felt as if something within me was being torn apart. Essentially, I was witnessing and feeling a rape.

I headed toward the rear of a giant, ripping, diesel plow, attempting to record the abrupt halt of twelve thousand years of evolution. Not since the gargantuan glacier tongues last rumbled across the land had this prairie faced such death. Only scattered remnants of the original prairie remain in the Midwest. The eighty-acre Elkins Prairie, near Lawrence, Kansas, was one of them—as primeval and vibrant as a living woolly mammoth in the midst of farmhouses, roads, and corn fields.

The monstrous tractor and sixteen-foot-wide plow began the destruction at 3A.M., so as not to alarm activists. The driver, hired by the landowner, was one of the largest men I have ever seen. He spun his rig around and chased me over the rise. I took hasty refuge in the early morning fog, cameras muddy, heart about to burst, my body cloaked in the still-living grasses.

Thirty Douglas County police had cordoned off the land to prevent environmental activists from stopping the farmer. As dawn broke, tear-

ful protesters lined the highway. One woman made her way through unseen and ran to the hill-crest to stand in the path of the approaching tractor. I'll never forget the sight of her. She stood resolute in the head-high grass, ringing a small bell as the growling machine approached—she was hoping somehow to still the madness. A policeman spotted her and rushed in to drag her away.

The only "why" available was that the owner was plowing the prairie to eliminate the need for an environmental impact statement that might jeopardize a proposed highway bypass. In other words, money. To him, Elkins Prairie was valuable only as a site for a truck stop or industrial park.

Over the years, local activists had been working steadily to gain purchase of the prairie, with the assumption that they would eventually prevail, that everyone—the county, the city of Lawrence, and the University—held this last piece of prairie as sacred, that in some way it was already protected by its rarity. Wrong. Unlike corporations or private property owners, neither individual plant species nor whole living systems such as a prairie have legal standing. (Elkins Prairie contained 130 different species of plants.)

Sacred or not, there was absolutely nothing to prevent an individual from eliminating one of the last large remnants of virgin prairie in eastern Kansas simply because he wanted to. I wrote a poem to process the insanity of the event.

As Likely That The Wind Never Blow Again

Nearly forever, the circle was perfect
and bison millions grazed your green colonies
sailing across your waving seas, between the crest
and where you ran down toward the river.
Do you remember?
Suddenly,
a wild surrender began.
You held soft witness to a great passing
and the buffalo infinity was no longer.
You'd have thought it as likely
that the wind never blow again.
Was it then you glimpsed
your death, on naked horizons
no longer balanced by those ancient shapes
against the gloaming?
Piece by piece, your web was torn

Desperate Prayers

shades of green and gold to raven
steaming sometimes,
like the wolf-ripped gut of a bison killed at dawn.
Wrong side up
your prairie nations slipped under the white man's blade.
Diesel ghoul, ever claiming, claiming, claiming...
leaving you an island, "a relict prairie" they said
alien in the land that was your own.
You'd have thought it as likely
that the wind never blow again.

The end times grew near
and you clutched the final strands as only a prairie can.
Milkweed, purple coneflower, prairie rose
big bluestem, little bluestem
treasuring the soft pad of coyote
the shadow call of red-tail
the nibble of deer people
in the waving green, true friends from the wild time.
New ones came, for you had become holy
"Sacred Ground" they said,
because you were so few, and their steps upon your back
were not unlike the ones that walked before
in the time of buffalo and grizzly.
Promises of safety...Haaaah!
If only...
Cloaked in darkness they came, the unmakers
as if blackness could hide or forgive their steel power lust.
Twelve thousand years of wild perfection
sacrificed.
No choice for a prairie island
grace—in a sea of madness.

"Strange," the prairie echoes, drifting on a breeze
while stepping across your crusted furrows.
"Strange, this dark passing,
like the white death before
I join the wild fold again, whole, on the other side."
You'd have thought it as likely
That the wind never blow again.

Hexagram 47

All hope for humankind is linked to our ability to restore Earth's ecological balance. If we are to succeed in this daunting task, we must find ways to counter the despair that enters our lives when our last virgin prairies are plowed, when our ancient forests are cut, or when our clean rivers are defiled. We must stay continually present in the face of catastrophe and avoid the seduction of denial. However we can, we must seek to avoid the "hell" defined by Derrick Jensen as "the too-late realization of interdependence."[5]

"What we face is probably the pass-fail test of maturity for all sentient species," cautions Diane Harvey. "There is what looks like a coming-of-age initiation presented to us here and now. We either will prove ourselves to be worthy of the treasure of self-awareness and the great gift of individualization and free will, or not. Either we continue as we have been, and fail to make the grade, or we will successfully emerge from our local provincial cocoon."[6]

Somehow, we must transform our anguish into personal power.

For thousands of years, the *I-Ching* has provided excellent counsel around manifesting such a strategy. "If you indulge in insecurities, you will succumb to the overwhelming urge of the times and lose yourself in losing," states the *I-Ching*.[7] It suggests that in periods of adversity our words will not influence others, nor be believed. Instead of words, one must rely upon actions. Our deeds must speak as our prayers. "Thus the truth will become evident."[8] The words of this ancient oracle spoke so strongly to those of us who sought understanding after the loss of Elkins Prairie that I suggested we create the Chinese *I-Ching* character for adversity, Hexagram 47, in a corner of the newly plowed prairie.

Trespassing on a cold and misty winter afternoon, we gathered tall bundles of big- and little-bluestem grass standing on the prairie's unplowed fringe. Quietly and with grim determination, we arranged them in the shape of the adversity hexagram upon the ripped, blackened earth. Each golden prairie stalk acknowledged the part, however small, that we all played in the ailing cultural machinery that undid the ancient web of prairie. We exerted great effort to resist the notion that "this is just how things are, and there is nothing we can really do about it." This belief would lead to a path of hopelessness, and we must continually resist its seductive power.

"Of course we may choose collective cowardice and apathy, and thus ensure the self-fulfilling prophecy of hopelessness," writes Diane Harvey. "If we won't labor to discover our spiritual identity in time, and assume

our great responsibilities as conscious and innately free beings, then no one will do it for us."[9]

Ablaze against the dark ground, and hidden from the sight of passing motorists by the gentle sweep of a hill, the Chinese figure was a celebration of our resolve to be hopeful, to be a force in Gaia's army. It was our salute to what the prairie had been—our way of honoring this tiny piece of Earth for its life and beauty.

The ceremony that followed, our witnessing and declaration of this ravaged piece of Earth as still sacred, transformed an ending into the beginning of a coalition to protect the remaining remnants of virgin prairie in eastern Kansas. It marked the birth of the Kansas Land Trust.

A Glacial Perspective

A few days after creating Hexagram 47, I trudged across the plowed prairie to sit alone with the symbol. Making my way awkwardly through the deeply plowed furrows, I noticed little wisps of still-living prairie refusing to yield their lives to a tractor. After all, they had been there for more than 10,000 years. (The discing of the field and planting of a bean crop a few weeks later would seal their fate.)

The Golden Prairie

The afternoon was lightly overcast and the sun was a hollow glow in the western sky. When I arrived at the figure, its rain-dampened grass glowed golden upon the black earth as if lit from within. I sat down in the center of the symbol and felt the full weight of what had happened here. Tears came easily while I sat in sadness as dark as the upturned soil.

Then a raven called out as it flew overhead, and suddenly my thoughts shifted. I felt the soft, moist grass beneath me and felt myself quietly transported to the prairie as it was before the last ice age eliminated it. It was alive with hundreds of plant species waving in the wind— some different, many the same that gave their lives here so recently. Buffalo, camel, and woolly mammoth all walked upon the land. It was the Golden Prairie...a vision of life in perfect balance. And then, as if watching a video on fast-forward, I saw the approaching massive glacial sheet descend upon the prairie and slowly erase it all in a colossal, white, icy death. Nothing existed but cold and whiteness, until the day the glaciers began to melt. I saw great rivers carry the water away. Then, the prairie returned. All of the plants and animals known to pre-colonial North America were present and abundant.

The vision of the Golden Prairie took root inside me and to this day helps me maintain a kind of sanity while digesting the terrible impacts of our species upon nature. Can we not compare civilization to a kind of ice age? What will appear in its wake when it recedes, which surely it must?

Taking the "glacial perspective" has not become an excuse for doing less. Rather, it has relieved a tremendous amount of environmental angst over the years and has made my own efforts to fight for the wild much more joyful and strategic. Ice ages, floods, earthquakes, civilizations—perhaps they all are the same in a sense, engineered by Mother Gaia in a mysterious way beyond our understanding. Right or wrong, when I am overcome with anger or despair about the loss or devastation I experience in nature I need only recall the Golden Prairie. Everything is impermanent, and the equanimity at the heart of life protects life. Beauty and balance will be beautiful and balanced again. Gaia knows well the practice of resurrection. I hope.

Elements of Place

For me, the need to celebrate the prairie as sacred had begun a year before, deep within the Flint Hills, one hundred miles to the south. Sitting within the prairie hexagram, I recalled the relatively vast and still-living unplowed prairies of the Flint Hills, just a few counties away.

Now more than ever, that seemed the Golden Prairie and my mind drifted back to my adventure there.

An old farmhouse burning, a turtle skeleton, and a handmade wind ornament were the elements of place I encountered one spring day in the Flint Hills of Kansas. I was scouting a site for the creation of a prairie shrine that would celebrate the native Tallgrass Prairie—my bio-region and home for the previous fifteen years. Actually, it would be more than just a shrine. It would be a shield of sorts, a declaration of sacred ground from which to rally and rail against Fort Riley's proposed acquisition of the region for tank training maneuvers.

I discovered three wind ornaments blowing on the front yard fence posts of a small house in Burdick. This town is a sleepy farm community that would be rocked by exploding shells if the military's bid for expansion were granted. I stopped to ask for directions. An old woman of the self-sufficient, Kansas-backcountry variety was bidding farewell to her son's family when I pulled up. She gave me directions and asked me if I was "one of them government people." I said "no." She said "good." Then I commented on her cut-out plastic jugs twirling in the wind. "Ya want one?" she said. "Sure," I replied and was soon headed down the road with one on the seat beside me. I thought of Tibetan prayer wheels—these could be an American version; in this case, the wind does the turning.

I quickly forgot the details of the woman's directions as I usually do after becoming engaged with an unusual personality. It was okay though— I had the map that was sent to me by the Preserve Rural America Society, a group that organizes communities against military base expansion. There were four areas selected as possible zones for government acquisition, each about 100,000 acres in size. The zone I chose to explore was the southernmost one, about fifty miles from Fort Riley. Most of it was prime Flint Hills grassland, and I was anxious to find an auspicious site for the sculpture that was beginning to take shape from the events of the day.

As I usually do when I want to find the wild spaces of a region or let art determine its own shape, I slipped into a *"wu-wei"* frame of mind. This is a Chinese term that means not doing, not forcing, just flowing—allowing ourselves to be guided by surprise and the unforeseen. Writer and naturalist Annie Dillard expresses this notion perfectly in her book *Pilgrim at Tinker Creek*. "The secret of seeing," she says, "is to sail on solar wind. Hone and spread your spirit until you yourself are a sail, whetted, translucent, broadside to the merest puff."[10]

"Broadside to the merest puff," I began turning off on progressively smaller dirt roads; roads that headed away, into the hills; signless, wireless, houseless, four-wheel drive advisable—the more rutted and rocky, the better.

It was on one of these, after fording a river, that I rounded a bend and came upon an old farmstead burning to the ground. No one was around. The fire was in its early stages and flames danced almost playfully from the upstairs windows. I debated about whether or not to rescue the beautiful, oval-glassed, ornate front door but thought it too dangerous. Instead, I photographed the scene and marveled that this one-hundred-plus-year-old house had somehow awaited my precise arrival to burn to the ground. Memories locked in wood—of children laughing, late-night lovemaking, and dinner table discussions—were set free in the smoke that wafted up through the immense cedars that shaded the grounds. The barn was burning also, and I noticed the backroad I was following wound between it and the house, up a steep hill, and out of sight. I smiled inwardly and knew, with the certainty such events claim, that I had stumbled upon the Taoist "mysterious pass," that indeed I was about to enter *sacred* terrain.

A Taste of Heaven

After watching the buildings climax in flames, I threaded my way between them, the heat blasting my old Subaru for a moment. Once up the hill, I discovered the source of the fire. As anyone who is from the prairie lands knows, "burnin' pasture" is a spring rite, and this particular prairie fire had worked its way into the domain of the abandoned farm below. I followed the track through freshly burned landscape to a rickety fence gate. I knew from past experience in the hills that this was what I was looking for. This gate would open onto a ten- or twenty-thousand-acre pasture of native Tallgrass Prairie hills, valleys, glades, creeks, and a sky that descends everywhere to your very toes. Virgin, unplowed prairie space— more rare and harder to find than a grove of giant redwoods.

In *Becoming Native to This Place,* plant ecologist Wes Jackson describes the kind of wildness I had found. "Though the prairie is fenced and is now called pasture and grass, aside from the wilderness areas of our country it is about as close to an original relationship as we will find in any human-managed system."[11] At the Land Institute near Salina, Kansas, Jackson has been leading an effort for many years to develop a plowless system of agriculture that mimics the prairie. Here, a perennial polyculture of cereal grains is being hybridized from the prairie. This exciting system of agriculture holds tremendous promise in being able to "hand the apple (albeit mostly eaten) back to Eve."

69

The patch of prairie I had found once supported vast herds of bison. Now it supported vast herds of cattle. It was private land of course, but I learned that it was owned by folks who understood the craving of one such as myself to stretch out in a land that has the taste of heaven and the feel of a century ago. And to my delight, the cows had not been turned out—yet.

I slowly motored across thirty miles of giant pasture that afternoon, much of it freshly burned and exuding the clean smell of ash. I found the skeleton of a turtle, its bleached white bones lying upon the black prairie like a beacon on a dark night. I picked it up, and headed east to a high point of land that presented a sweeping panorama of the prairie world. Here was a forever view. Sunrise, sunset, the four directions—all seemed to converge here. It was perfect for the sculpture which at that moment I knew I would call the Prairie Shield.

Refuge for the Imagination

Few Americans have heard of the Flint Hills. They are not the home of still-wild and dangerous predators nor do they contain rivers with adrenaline-pumping rapids, or vistas of mind-numbing spectacle. Devoid of hype, the land boasts no signs or indicators of its greatness. Nothing on your map will direct you here, for this land is not the widest, deepest, or longest of anything. It is the last of something, though. The Flint Hills contain the last large reserves of unplowed native Tallgrass Prairie that once covered a quarter billion acres of this continent.

The region is dotted sparsely with ranches and small towns. Here and there along the roadsides are prairie islands—patches of big bluestem, tallest of the prairie grasses, standing higher than I can reach. Fenced off as highway median and thus safe from munching cows, these lonely stands hark back to not so long ago when this was an inland sea of grass supporting one of Earth's largest concentrations of mammals. Passing these haunting remnants, I often slip into a daydream of buffalo infinity, lurking wolves, and teepees nestled in cottonwood coves. No sooner am I there than a bend in the road or a deep rut yanks me back into these troubled times and the sad realization that, in terms of land lost, the Tallgrass Prairie is quite likely the world's most damaged ecosystem.

Today, only about one percent of the original Tallgrass Prairie persists, and most of that is in the Flint Hills of eastern Kansas, a rough ellipse extending forty miles east to west at its widest and some 200 miles north to south. Protected from the sodbuster's plow by its flinty subsoil, the

Flint Hills prairie survived the onslaught of manifest destiny. This is a lost land, a refuge for the imagination where time and time again, less turns out to be more. Hill after hill, gentle sculpted curves swell and crest as far as the eye can see in shades of green or tan, painted with white windblown snow or rainbows of wildflowers, depending on the season.

The bluestem ecology of this area is without parallel. More than 300 species of birds, some 80 species of mammals, and 600 species of plants have been identified, many found nowhere else. It is one of Earth's most complex and endangered ecosystems. In addition, biologists have recently found that the grasslands have been grossly underrated as carbon sinks. In fact, they may be as effective as primary rain forests in counteracting the greenhouse effect![12]

There's something else about the prairie that I could never quite put my finger on until I found John Madsen's book, *Tall Grass Prairie*. Prairie, he says, is "as close to being a fountain of youth as anything some of us will ever know."[13] Few displays in nature can compare "to the rich, summer-long bursts of life to be found on tallgrass prairies that arise, phoenix-like and full-grown, from the ashes of their autumn burnings."[14] No wonder I was continually drawn to the Flint Hills of Kansas.

Battleground

It was here that the government proposed to "acquire" (through our tax dollars) 100,000 acres of land to blast, compact, uproot, and otherwise destroy in the name of weapons training for the M-1 Abrahms Tank and Bradley Fighting Vehicle. A look at the effectiveness of these weapons would be almost humorous if it were not for the excess and stupidity they represent. *U.S. News and World Report* portrays the M1 as rolling into battle but then running out of gas before the fight is over (one tank division needs 600,000 gallons of fuel a day, twice as much as Patton's entire Third Army used when it raced across Europe).[15] In research tests the M1 broke down for more than a half hour every fifty-eight miles, thus requiring a separate maintenance team traveling with the crew, presumably prepared to get out and make repairs during battle. As for the Bradley, it is made of aluminum, which is flammable and often explodes when hit. The world's leading experts in tactical tank warfare, the Israelis, refuse to use the Bradley because its huge size makes it an easy target. The leaders of our army wanted to loose these lemons upon the prairie.

It was not the army's sad absurdity, however, nor the plight of the many farm families that would be uprooted by the fort's expansion that attracted my attention as an environmental artist. Multitudes of angry Kansans had already rallied upon this ground in defense of their quality of life and against the waste of tax dollars. Few, however, had spoken for the prairie itself.

When this prairie adventure took place, there was no sizeable portion of native Tallgrass Prairie federally protected in this country. We had token preserves managed by the Nature Conservancy (10,000 acres in Kansas, 15,000 acres in South Dakota, and 50,000 acres in Oklahoma), but nothing of the scale that Fort Riley wanted to acquire for weapons training. The once-heated battle for a Prairie National Park had all but died in the Midwest. Its last gasp consisted of an Audubon-sponsored effort to buy, from a willing seller, the beautiful 11,000-acre Flint Hills' Z Bar Ranch and turn it into a Prairie National Monument.

Although it is a personal dream to one day take my children into a vast, pre-settlement style, mid-continental, "big open" with thousands of square miles of restored prairie, complete with bison, grizzly, and elk, the region in its current state is a kind of refuge already—one for the imagination. The Flint Hills have few people, abundant space, a fair amount of wildlife, and virtually no tourism. Naturally, I'd rather see bison on the prairie instead of cows but I'm a dreamer, and the truth of the matter is that until the world realizes that it makes more sense to eat grains and vegetables than it does beef, the landowners here will continue to graze cattle. Unlike the western Bureau of Land Management lands, this is country designed by nature to be grazed, albeit by bison, and aside from perhaps burning a bit too frequently (annual fires decrease the diversity of forbs), most of the Flint Hills ranchers do an adequate job of caretaking the prairies.

Although I'm as "anti-grazing" as the next conservationist, during the battle for a prairie park I could never quite come to terms with the virtue of removing ranchers and cattle from a big chunk of ground and replacing them with bison, elk, rangers, parking lots, interpretation centers, and hordes of gas-guzzling, wrapper-spewing, ozone-depleting tourists. I had no trouble with the elk or bison of course, but the rest of the package made me queasy. Kansas has a kind of virginity when it comes to tourists, and I couldn't help but feel a little protective of it. In a sense, these hills are sort of a "national park" already, one that preserves a special reality and kind of American wildness difficult to find these days—an endangered way of life without hype, glitter, tourist attractions, or signs pointing the way. The Flint Hills are an

uncommon and authentic place, a very long way from everywhere, protected by obscurity in the center of our nation in the state least populated by tourists (aside from North Dakota), wide open to quiet adventures and discoveries.

As others have argued, the integrity of the hills is perhaps better protected as it is, with cows (God help me) instead of bison, ranchers rather than tourists. It's a point well taken, for most Kansans would prefer to see travelers on their way to Colorado or Missouri than as tourists. It's not that they aren't friendly; they are among the most welcoming folk you will find, and they'll assure you out front that Kansas is a great place to live…but you wouldn't want to visit there.

The Prairie Shield

I can say with a fair degree of certainty that no tourist had ever shared the Elysian prairiescape in which I began to build the shield. Deep in the hills, miles from the nearest road, I gathered large white rocks and formed a circle about ten feet in diameter. I aligned the four directions with the two significant features that rose above the landscape—a pair of huge cottonwoods to the west, and a lone, monolithic hill to the north, toward Fort Riley. I marked the directions with cedar stakes tied with owl feathers. From the small, brown, shiny flint rocks lying helter skelter across the prairie, I arranged a turtle like the one whose bones I had found. From the shield's north point, the turtle head emerged open-mouthed, emitting a rock spiral that wound to the crest of the hill. Spinning on a stake at the spiral's center was the homemade prayer wheel adorned now with prayers and prairie affirmations that I had written. I applied black ash from the burned farmhouse to the direction lines and the turtle's shape, to highlight it from the native grass. And finally, I pounded a pipe, taken from the fire site, into the center of the turtle's back to function as a lightning rod.

In the course of four trips to the hills that were required to complete the shield, I experienced many facets of the prairie. One of the wildest, most enchanting sounds in nature often accompanied my work—the otherworldly, deep, whirring of a nighthawk breaking the vortex of its dive above me. One hundred feet or so from the site was a nest of curlew eggs. I often observed the parents' attempt to lead me away from the nest with their infamous broken wing routine. I made hurried descents from camp at night to escape the deadly lightning bolts, called "grave diggers" in these parts, and lay awake until the storms passed, giddily enjoying the

light and sound shows the prairie is so famous for. And then there was the disappearing coyote—the trickster. He was two hundred feet away. I turned around to grab my binoculars and when I looked back he was gone—no trees to hide behind, no gullies to descend into, solid gone. This was close to prairie primeval, and for a while, its magic was my own.

Common in Native American mythology is the notion that all life exists on the back of a giant turtle, thus they call the Earth "Turtle Island." This is wise counsel, for it depicts Earth as a living, finite being—one that must be nurtured, protected, and used wisely so its life, and our life in harmony with it, may continue. The turtle, whose death enabled me to find its skeleton upon the blackened prairie and which took life again as the centerpiece of my shield, was a tribute to this concept. There was to be a second death, however, and one can view the turtle shield's ultimate fate as a metaphor for our time.

The Final Prairie

On my final trip to complete the shield, I encountered the white man's prairie—a prairie I had nearly forgotten. So far I hadn't been bothered by cows, but when I reached the site I knew man's favorite beasts had been there. The circle of white stones had been broken—the turtle was barely recognizable. Dung was at the center, and all about me the earth was trampled. The air reeked with the acrid stench of a thousand cows.

At first I was furious. Cattle were still in the area and when a maverick bunch came to investigate, I lashed out at them with a mixed flurry of insults and stones until my arms and lungs gave out. And then I sat down and laughed. How could I have been so stupid? This was, after all, no pristine prairie—just a giant cow pasture. What did I expect? Create a piece of Earth art and if the Earth is filled with cattle...

It took an hour or so to rebuild the shield and by nightfall I was nearly finished, waiting only for the light of sunrise to again add the ash and lightning rod. When morning dawned I was surrounded by cattle—hundreds of them. I leapt up and took action. I whooped and flailed my purple windbreaker as I ran through the dewy morning grass at high speed. I had my retriever along and he quickly realized what I had in mind. It was to be a one-man-one-dog cattle stampede. Kona, whose main talent until then had been retrieving sticks and frisbees, suddenly became an expert cow-getter. With me flagging my jacket and Kona barking and biting heels, we quickly moved the stinking beasts across the draw, a good mile away from the shield.

The Golden Prairie

So began a day of fasting and the completion of the project. I photographed the site from various angles and stayed up late into the night sitting beside the circle. I sang and beat the drum a bit, but mostly I just thought. I realized that after I left, the cows would soon return and claim the shield. They would chew the feathers from the stakes, urinate on the stones, trample the ash, and knock down the prayer wheel. Nothing intentional; it would just be their cow way. All that would remain would be a lightning rod and scattered rocks. And, an idea. An idea that by enacting a notion, a prayer—by honoring the prairie as sacred ground— the universe would respond with healing power. It was an idea as old as thought itself and I hoped it was true.

To protect the shield in its finished form would have taken eternal vigilance, a ridiculous notion in that pasture. In the larger sense, however, eternal vigilance is exactly what is called for in the protection of Turtle Island's remaining wilderness and biodiversity. My frustrating encounter with one of the "killing C's" (cars, cattle, and chainsaws) is a metaphor for the task at hand for Earth Patriots now and always— define and protect sacred ground. This must be done eternally and with a high degree of vigilance, for there will always be those who want to take it down, grind it up, and turn it into something else.

The prairie flowers were in full bloom when I returned to the site a few weeks later with my wife Christine and my one-year-old daughter Sierra Sky. As we crossed the open grasslands, I explained how the Plains Indians considered the turtle to be a symbol of long life and how it was customary for new mothers to seal their baby's umbilical cord into a beaded, turtle-shaped pouch. This, they believed, would ensure the child's longevity. As we neared the hilltop, I expected to find the shield ravaged by cattle; after all, they were a part of this "art." A small part of me, though, held onto the notion that perhaps the shield had hexed the beasts—that they had left it alone. I was wrong on both counts, for what I found was beyond mere cow destruction. The iron lightning rod, the feathered stakes, and the prayer wheel were totally gone. I scoured the area, finding only a few feathers and bits of twine. The large stones had been scattered—the turtle unrecognizable, the hoop broken.

We piled the turtle stones in a circular mound adjoining the still-intact spiral. It looked good and we left feeling strong, yet bewildered about what had happened. Weeks later, the mystery ended with a letter by Jack and Nancy Methvin—the couple who leased the land and who had given me permission to do my art. Someone, it seemed, had been watching me through binoculars from a distant hill. There had been a few cattle thefts in the area and evidently the spy thought he was onto

something. When he investigated the site, he figured it to be the workings of a satanic cult. The sheriff was called and together they gathered "the evidence." The determined duo contacted Jack and Nancy, proudly presenting their findings. Despite the duo's fervor to bust a band of satanic cattle thieves, the Methvins managed to convince the disappointed prairie detectives that, alas, it was only "eco-art."

One has to laugh. But what does this story say about our species? On the stage of the final prairie, an act as old as civilization played itself out—an act done in fear of the wild, the different, the unknown—an act of separation and control. Our toxic ideologies have woven the bloody fabric of human history for thousands of years and do so more than ever today. How many have died, how much of Earth has been ravaged in the name of this or that religion, this or that ideology? We hold on to our beliefs like a drowning man his gold.

Beliefs are dangerous and indeed toxic to the degree that they separate us from the sacred web of nature. They have led us to a great forgetting—to the very edge of a fatal abyss of separation that began with the invention of agriculture so long ago. We are trapped in the dualism of thinking ourselves apart from the wondrous nurturing and sustaining being that supports us. The one grand and timely healing for all Earthlings and our sacred planet home is the remembering, finally, that we must simply love (protect, nurture, celebrate) First, The Earth! We humans have known this for ninety-nine percent of our time on Earth. It is not an ideology, it is simply good sense.

The winter after completing the Prairie Shield, I moved with my family to Washington state. Five years later, in 1994, I returned to Kansas for a visit. Elkins Prairie was unrecognizable, crawling with earthmovers and giant "cats," well on its way to being a freeway off-ramp. As for the Flint Hills, the proposed Fort Riley weapons testing range had been defeated and the base itself much reduced. The 11,000-acre Z-Bar Ranch was now owned by the Federal Government and would soon be Tallgrass Prairie National Monument.

Wanting to celebrate at least one victory, and feeling the need for the restorative powers of my favorite prairiescapes, I returned to the Prairie Shield site. I was staggered by what I found. A dozen oil wells dotted the landscape. The biggest one stood beside four storage tanks less than fifty feet from the circular mound of rocks that once had formed the shield. On the oil-blackened ground I stared in disbelief at the repulsive pumping machine, wishing I had ignored my impulse to return. I should not have been surprised. Living in a fallen culture with nearly everything

"wrong side up," the "fountain of youth" was not the prairie. Of course not. It was oil.

Feeling gut-punched and betrayed, I walked back to my idling van fully aware of my complicity in the process. I feebly tried to imagine the Golden Prairie and felt soothed somewhat by the memory, but it did not last long. I could not get the pumping oil wells out of my mind.

On my way home that night I ran out of gas on the Topeka Turnpike. Honest.

Chapter 4

A Desert Quartet

"Real stature comes from an attachment to the Unknown."
—John Hay

hroughout history, we humans have gone to the desert to probe the mysteries of life. The distance and scale, aridity and silence, beating sun, and endless sky create a powerful sensorium—perfect for ruminations about our existence. It is perfect space in which to go artfully mad for a day or two. Over the course of two winters, the desert provided me with a playful stage for several artful inquiries into human relationships with the four elements.

I. Machine

"Every heart longs to be part of something big and sacred...We will not survive if we continue to relate to each other and to our environment as parts of a machine, an image that renders people violent, addictive, and searching for more."

—Matthew Fox

I forced the steering wheel hard to the right and fastened it tightly to the floor with a bungy cord. With the accelerator set just above idle speed, I opened the door and stepped out onto the cracked and barren lakebed, leaving my machine to circle behind me. I walked eastward without looking back.

Desperate Prayers

I was in Oregon's huge Alvord Playa, the northwestern portion of the Great Basin Desert which once held an inland sea called Lake Lahontan. Judging by the tire tracks that branched in all directions, the Alvord Playa was the kind of wilderness that could briefly contain an automobile. This was important, since I had come here to acknowledge my reluctant love affair with motorized vehicles (currently in the form of a Volkswagen bus), and to examine the postmodern antagonism between the ease of movement afforded by our addiction to oil, and our sense of home.

The fossilized "bathtub rings" that lined the base of the Steens Mountains rose steeply ahead, marking the lake's fluctuating shore-lines—shorelines that teemed with mammoths, saber-tooth tigers, dire wolves, and musk oxen at the close of the last Ice Age 11,000 years ago. I tried to imagine such an ancient and beautiful time, as my van circled behind me.

When the drone of the humming engine could no longer be heard, I turned and contemplated the scene. Here on the broad playa you can literally see Earth's curvature. I marveled at this roundness and watched my green van circle in first gear, a quarter of a mile away. Since I was fifteen years old, the automobile had been such an impor-tant, freedom-bestowing, thoroughly taken-for-granted portion of my life. But at what cost? How many hours, how many miles, how many birds and rabbits crushed at high speed, how much money, how much distraction, how much ozone destroyed, how much wilderness divided and paved to make way for my car? I stared in stupid fascination at my circling rubber-tired spaceship, my wheeled slave and master. "Oil-sucking fool," I loudly confided to the desert. "You're addicted. We all are."

I cursed the fact that for most of us, the car has become essential for the simplest acts of living. And yet, what an act it would be to leave the van circling and walk away forever! To where? To a sailboat, a wilder-ness cabin in Alaska, or an organic farm off the electric grid? I begged forgiveness for my impact on this tortured, sacred Earth and walked back toward my machine. The Gregorian chants emanating from the car stereo grew louder as I approached. I noticed the imprints left by the rolling tires—four white, concentric rings in stark contrast to the gray, alkaline lakebed. I entered the center ring and lay down facing the sky, my van orbiting around me in the piercing sun, like a vulture awaiting my death.

It's a relationship most of us share, this romance with wheeled trav-el, and yet has there ever in the history of the world been a more destruc-tive relationship? Several facts stand out among the awesome tally of

cumulative damage: Automobiles are the biggest source of greenhouse gases, have killed twice as many Americans as all our wars since 1776, and result in a monthly dumping of used motor oil equivalent to the Exxon *Valdez* catastrophe. And, every year we blacktop 1.3 million *more* acres for them. The media encourages us to see AIDS as a plague, but if we looked at life from a planetary point of view, as philosopher William Irwin Thompson points out, "it would be more truthful to have all the cover articles of the magazines screaming about the plague of the automobile. The automobile is clearly more deadly to life, limb and atmosphere than the HIV virus."[1]

Ahh... the planetary view. Here on the curving lakebed, such a view was as natural as the clouds passing lazily overhead.

The Quixote Principle

As I lay on the cracked playa, I considered the facts and recalled the *Quixote Principle,* articulated by Jim Corbett. Corbett is an author and co-founder of the Sanctuary Movement, which provided badly needed refuge for Guatemalan Indians who escaped to this country in the 1980s with a price on their heads.

"To open the way," Corbett writes, "a cultural breakthrough need not involve masses of people but must be done decisively by someone."[2] For every solution, there is a courageous and decisive act performed in perfection by someone, somewhere. For the civil rights movement it was Rosa Parks refusing to go to the back of the bus. For the environmental movement it was Rachel Carson, a scientist who defied the industrial mentality of her time by writing *Silent Spring*. Our most pressing problems await such acts and people.

I was staggered by the immensity of the issue at hand, and wondered if there *was* such a decisive act. Feeling numb and despairing, I could only get up, climb back in, and turn the key. With the engine cut, I was engulfed by perfect desert stillness. It was a beautiful metaphor at least, and for the rest of the day my bus and I were still.

By dusk, in mid-January, the temperature drops to well below freezing in the Oregon high desert. I had not come here to suffer from the cold, so I started my machine and drove to the hot springs a short distance away. It was empty of people. I soaked in the cement basin, letting the mineralized waters from deep within the Earth recharge my being. The heat was barely tolerable and I pushed my limits to the edge, hoping to dislodge something—just what, I knew not. Sweating and with a

quickened heart, I poured forth confessions and promises to the starry heavens above. The sky beings seemed especially close and personal that evening. A night bird began to call somberly nearby. When I was empty of words, I walked, steaming, to my VW van.

I followed the rutted track past the springs out onto the dry playa. Setting my course toward the Pleiades now rising in the east, I opened the door of the moving vehicle and carefully climbed onto the roof rack. The idle speed on my rig was perfect for a leisurely night cruise in first gear auto-pilot across the ancient lakebed. It was a dreamlike and joyous rooftop ride with the stars thick about me like a robe. I danced, played my harmonica, smiled continuously like an idiot, and then sat in silence as my machine carried me across the black and starry realm on a strange odyssey through the night. My teeth began to chatter as the last of the hot springs' influence left my body and was absorbed by the winter darkness. I climbed down to the open window and from there, jumped to the ground. Jogging alongside for about half a mile, I acknowledged my co-dependency to my van with terse commentary—two very different specks moving across the desert in the murky illumination of the Milky Way.

"Only by knocking against the golden calf of mobility, which looms so large and shines so brightly, have I come to realize that it is hollow," ponders writer Scott Russel Sanders.[3] These words resonate with me, as I have often considered the disparity between our ancestors knowing only a watershed or two, and our flitting in and out of great numbers of these regions.

While running beside my bus, I recalled a time in Mexico's *Barranca del Cobre,* a canyon complex deeper than our own Grand Canyon. It was one of those significant moments in life when much becomes crystallized in a single event. I had pulled off the cliffside road to urinate, and while leaning against my van, looked out into the distance. I saw a large cave cut broadly into the steep white limestone of the opposite canyon wall, several hundred yards away. One side of the cave was stained black by countless millennia of cook fires. Smoke from the coals of a dwindling breakfast fire now hung lazily in the still morning air. I trained my binoculars on the cave area and recognized a family of Tarahumaras residing there. Tarahumaras are the largest indigenous group still living a traditional way in North America. A few goats were nestled in the rocks, and two children sat nearby playing. One person lay near the fire pit, another worked on a task in the shadows, and a dog stretched in the sunlight.

Barely-audible voices occasionally drifted my way—painfully familiar somehow. It was a scene that nearly broke my heart, so sharply did

it articulate my own estrangement from the Earth. In awe, with tears in my eyes, I watched from the brush, a voyeur peering into our ancient past, riveted to the glimmer of what we once had been. I longed to remember, to know what they knew, to experience the deep sense of home and continuity such rootedness creates. The amnesia that I inherited as a member of industrial society cleared a bit that day, and I felt the cellular stirrings of something wild and free pulse through my veins.

There are principles regarding the impacts of mobility that may be drawn from my experience in Mexico and others like it: *Our native logic is coupled to the breadth and dimension of a walked environment.* Our alienation from nature is in direct proportion to the speed at which we move through it. (I read somewhere that ninety-five percent of those who travel through our National Parks never venture more than a hundred yards from their vehicles.) Mobility, it seems, has become idolatry; and the sacred, increasingly in retreat from us.

I ran out in front, stopped, and stood in the path of my van, tempting fate. "Let your life be a friction against the machine," advised Henry David Thoreau in 1854.[4]

"Easy for you to say, Henry," I muttered, "you never made love in a '55 Chevy at the drive-in movies, or blasted across Kansas at eighty miles per hour on your way to the Rockies." I hopped onto the front bumper at the last moment to avoid being run over. There I would ride for a while, only to repeat the trick again and again before slipping back to jog alongside my humming machine. I was sweating and breathing hard, beginning to lag behind. "Our genetic and sensory evolution has not been able to keep pace with the evolution of the machine," notes author Jerry Mander in his profound book, *In the Absence of the Sacred.*[5]

Cut loose from all ethical guidelines, the machine has replaced the Wheel of Life as the fundamental metaphor shaping our society. "Life came to be seen as a road, to be traveled as fast as possible, never to return," suggests poet/farmer/ philosopher Wendell Berry, "or, to put it another way, the Wheel of Life became an industrial metaphor; rather than turning in place, revolving in order to dwell, it began to roll on the 'highway of progress' toward an ever-receding horizon. The idea, the responsibility, of return weakened and disappeared..."[6]

As the rantings of favorite writers rambled through my brain, I stopped and stood panting on the playa. My bus proceeded without me. "This could be it," I thought, "the decisive act." My heart thumped madly. For the longest seconds of my life, I watched my combustion

engine spaceship slowly slip into the emptiness of the night. In that brief moment, alone and untethered to civilization, I flashed on just how far man, the toolmaker, had come. In sleek craft powered by the juice of ancient jungles, we speed about the globe between climate-adjusted cocoons where we dwell and toil sealed from the realities of rain, cold, dust, and insects. Our acceleration has so thoroughly fostered the illusion that we are separate from nature that we have become blind to our impacts upon the Earth. Increasingly extraterrestrial, *we,* as filmmaker Godfrey Reggio suggests, have become the alien.[7]

As the hypnotic "putt-putt" of my rig was slowly swallowed by the desert silence I considered my choices: a) chase car, b) freeze to death. I thought of my jacket, my down sleeping bag, and the homemade chocolate-chip cookies now 100 feet away and moving. I panicked, and chased my rig. Sprinting up alongside, powered from a charge of adrenaline, I gripped the door handle and clambered in. No addict felt the rush of relief more sweetly than I did with the recovery of my machine that night. I sighed in ecstasy. For a few moments it all seemed "natural," exactly right. Sure, freezing to death and letting my machine crash in the sagebrush umpteen miles away would have been a decisive act, but only for me. I would have made my point, but who would have understood? Certainly, it was not *the* "decisive act." At the moment, I doubted whether such an act existed. The thing was just too big.

Centering Down

Exhausted, humbled, and empty, I returned to the rings made that morning by my tires and went to sleep. When I awoke there was fresh snow on the Steens. Near the terminus of the hot springs, eight Canada geese floated quietly, appearing and disappearing in the cold morning vapors. A lone coyote howled.

I started the engine and drove my van into the rings so my tires were aligned with the tracks made the previous day. I bungied the wheel, got out, and after fifteen minutes, my bus-turned-paintbrush had created another interlocking set of rings. The resulting image of the two overlapping circles (in this case quadrupled by four tires) formed at its intersection an ancient almond-shaped symbol known as the *mandorla*.

The two circles represented a dualistic viewpoint: man/woman, light/dark, Christian/Muslim, human/machine, etc. To demand the acceptance of one way of being over all others is a lose-lose situation and yet, across the planet, we are polarized in just this manner—thus endan-

gering the entire continuum of life on Earth. The almond-shaped zone, or mandorla, that the circles share is the place where a third way can emerge—the state of perfect balance between two apparently opposing forces. Thus, the mandorla is an expression of reconciliation—a sacred marriage where *right/wrong* and *either/or* is transformed to a *both/and* way of being—a place where miracles can occur.[8] In prehistoric times, this was the "magic place" of the Mother Goddess, the doorway between the worlds where new life emerged. During the Great Depression, hobos scribbled the double circle symbol on walls, bridges, and boxcars. It meant "don't give up."[9]

For an hour or so that morning, I sat in the center of my machine-drawn mandorla and pondered the meaning it held in the present moment. Facing east, I toasted the sun and drank from a bottle of water filled at the source of the hot springs the night before. With the contents that remained, I carefully cast a liquid circle around myself and sat in silence.

There may be a place for the mindful use of our vehicles in the ultimate scheme of things, but I chose not to think of that. I chose instead to consider what the Quakers call "centering down." To the rings, to the desert, and to the Earth, I vowed to vastly curtail my mobility. I would resist the modern currents which continually prod us into motion...motion which continually weakens our connections to place...motion which allows our streams to be polluted, our soils and air to be poisoned, and the native diversity of our bioregions to be diminished.

"The globalization of culture and information has led us to a way of life in which the nearby is treated with contempt," writes anthropologist Helena Norberg-Hodge.[10] Our places need us now, more than ever before. I vowed I would find mine, settle in, and defend it. I would come home.

I cannot think of an act more decisive than this one. It is an act that must be done by us all... and soon, if we are to curb our rush toward the abyss driven in part by our addiction to oil and machinery. As Terry Tempest Williams puts it, "staying home may be the most radical act we can commit."[11]

II. The Sun

"have you ever felt for anything such wild love—
do you think there is anywhere, in any language,
a word billowing enough
for the pleasure that fills you,
as the sun reaches out,
as it warms you
as you stand there,
empty-handed—"

—Mary Oliver, "The Sun"

For the next few days, I cruised Oregon's High Desert on my way to California's Mojave. I was documenting the effects of the livestock industry on public lands, and the results of a century of overgrazing were obvious just about everywhere I looked. I saw little wildlife, but hordes of cattle. I saw native bunch grass thriving on the highway side of fences, but only exotic cheat grass on the other side. I saw dry and eroded stream channels, trampled wetlands, and hillsides crisscrossed by the terracing of cattle trails. I saw thousands of miles of barbed wire fence. Some were adorned with what Terry Tempest Williams calls "Jesus Coyote, stiff on his cross, savior of our American rangelands."

"We can try and kill all that is native," she writes, "string it up by its hind legs for all to see, but spirit howls and wildness endures."[12] A stop to honor these shrines of wire and fur, so common in the overgrazed regions of the west, may reveal a coyote truth or two about equality and the great web of life. Indeed, no other animal is more systematically or aggressively persecuted throughout the west and yet, their numbers remain relatively stable. " 'We are here,' they say," writes naturalist Robert Michael Pyle, " 'we'll eat your apples, your voles, your cats, the afterbirth of your calves; we're here, we set your dogs to barking, we intend to multiply. We are here to stay.' "[13]

City of Mirrors

On my second day in the Mojave Desert I passed a small billboard advertising Luz Solar Electric Generating Systems. To the north I could see a huge network of long, silver, parallel lines and decided to investigate. I was stopped by a guard at the gate, and while we waited for clearance he told me about the vandalism of the previous night. It

seemed that the giant mirrors along the plant's edge were favorite targets for wayward locals and passing motorists. Some of them had been damaged beyond repair, and mirror shards lay everywhere in heaps along the fenceline.

Finally an engineer arrived, and agreed to take me on a brief tour. "Got your sunglasses?" he asked. I did, and soon I was smack in the middle of the collectors, maneuvering for pictures and asking questions. My guide explained the system with the enthusiasm of a man who loves his work. "The parabolic trough collectors individually track the sun using sun sensors and microprocessors. The collectors focus sunlight onto specially coated steel pipes mounted inside vacuum-insulated glass tubes. The pipes contain a heat transfer fluid which is heated to approximately 735 degrees Fahrenheit and pumped through a series of conventional heat exchangers to generate a superheated steam. The steam powers a generator to produce electricity delivered to the grid."

Inch for inch, I thought, the desert was being used much more wisely here than it was on the overgrazed public lands I had passed through. This solar facility made sense. Using our vast, sensitive, and wild desert to produce a paltry five percent of the beef consumed in this country did not make sense.

Walking among the silver mirrors, each reflecting its own bright sun, I felt the rush of something I had never encountered before in my relationship to technology—the sacred. In a somewhat distant sense, solar technology is a modern form of sun worship, something as ancient as south-facing caves, and here among this city of mirrors I walked in a kind of wonder almost akin to that reserved for desert canyons and ancient forests. Ahhh...the great Sun, the only thing that casts no shadow.

I passed a heap of broken collector shards the size of my van, and tried to imagine the sound these objects make as they are shattered. No doubt this was a factor in the vandalism alongside the chainlink fence boundary. From the roof of a building in the center of the plant, I captured the photograph I wanted. On the road fifty miles later, I realized my mistake and cursed myself. An eco-sculpture had come to mind as I passed a succession of sand dunes, but I had failed to collect the perfect material with which to make it—the oddly curved, broken shards of thick mirror glass piled up at the plant. I had violated the first rule of a "found objects artist"—collect, always collect.

Like most mobility addicts, I was strongly averse to backtracking. Fifty miles was simply out of the question. I drove on, and began to think of places where I might find similar materials. I looked for aban-

doned shacks, and after a few stops in search of broken mirrors I discovered something even better. Just outside Amboy, a town hovering on the edge of ghostdom, I found a deserted stucco house at the end of a long driveway.

I parked my car and entered the derelict building through a screen door hanging by one hinge. An old mattress lay on the floor among broken glass, old clothes, and assorted trash. A tattered and dirty bedspread lay in a lump below the bed. Graffiti covered the walls, and the desert wind blew high-pitched through the torn window screens, making the curtains and their shadows dance eerily within the old house. In a side room draped with spider webs, the empty cavity of a huge mahogany television cabinet stared blankly at the ruined scene all around. It was the "spell binder" itself, reflecting the ruin of this house. The scene was a microcosm of television's more global impact.

The TV picture tube lay in shards heaped on the floor amongst the dirt and trash. How perfect for my art—no material could better reflect the spell that so tightly holds our entranced culture in denial. Controlled by corporations, our TVs and what they broadcast are emblematic of our separation from the natural world and the danger in which that dissociation has placed us.

I gathered the mirror-like shards into a rusty, bullet-ridden bucket, then headed south to the dunes.

Solar Snake

The Algodones Dunes are the most extensive sand dunes in California—a mini-Sahara set against the Chocolate Mountains. Thirty-two thousand acres were protected by the California Desert Act in 1994. One hundred thirty thousand were left open to off-road vehicles. I passed Glamis Beach, a single-store town proclaiming to be the "sand toy capital of the world." Judging by the appearance of the machines and junk spread in every direction, I believed their claim.

As is often the case, the road through the dunes marked the dividing line between the "wilderness" and the sacrifice zone. I parked at an overlook and headed out into the newly protected region with my bucket of shards and my camera pack. It was mid-afternoon.

Barefoot, I walked through sand until out of sight from the road. Then I hunted for the right dune at which to create what was coming to mind. Insect tracks decorated the vast sea of sand here and there, the only sign of life around me.

Desperate Prayers

I spied a large black beetle, making her way up the steep side of a dune. Where was she going and what was she looking for, I wondered? I watched as she approached the nearly-vertical lip of the dune. She kept falling back and then tried again and again, always failing. Why so many errors? Why couldn't she get the message? I picked her up and set her on the other side, wondering what weird kind of balance I may have upset, what lesson perhaps she needed to learn. But then again, my offering of attention to her plight may have been a great gift. She ambled quickly down the other side on her way toward…?

Years later I read a passage by Evan Eisenberg that reminded me of my encounter with this beetle. "Nature's spendthrift inventiveness, her antic diversity—who needs 350,000 species of beetles?—give her a margin of error that human artists, engineers, and politicians can only envy. But 'margin' is the wrong word: we are talking about pages of error, reams of error, continental shelves of error. In fact, error is what makes the whole thing go. Error is not just permitted by diversity; it is what permits diversity. If the mechanism of genetic transmission had been flawless from the outset, you and I would be archaebacteria."[14] The beetle had "errored" beautifully, and I am certain that she soon found

another steep dune on which to err and err again in chaotic perfection.

I settled on a dune. My notion was to stand the curved pieces of mirror-like glass upright in a pleasing design, each reflecting the sun toward a central point. The latter notion proved to be impossible. Each time I managed to reflect a fragment to a precise point, the effect would be gone a moment later due to the constantly changing position of the sun. I experimented with camera angles and sun refractions until I found something that seemed to work—a serpentine progression at the top of a dune where one shard projected a diamond-like sunburst to the camera.

In the course of this process I was struck by the similarity of the shards with which I sought an ordered form, and the fragments of my own life—some working, some not; others lost, torn, or atrophied—driven undercover by the momentum of Western Civilization, which feeds on our daily sacrifice of the wild. The "hunting and gathering" and eventual assimilation inherent in my chosen way of art is a personal revolt against the forces that attempt to drive us further and further from nature. It is art in rebellion against what author Chellis Glendinning labels "our original trauma of domestication"—something that we all share.[15] The Solar Snake seemed a way to call home the splintered shards of my spirit and, using the ancient life-regenerating symbolism of the snake itself, it seemed also a way to shed the pain of separation and grow a renewed sense of belonging.

The mirror-shards' previous "life," as a TV tube magically bringing illusion and entertainment into the living room of its owner, was over. Cracked open, transformed, it wound its way snake-like along the top of the dune, each mirror reflecting me, the sand, and the sky. From the Buddhist perspective, death is a mirror in which the entire meaning of life is reflected.

"What is your vision for the world?" the reflection seemed to demand. "For us all to wake up," I decided to reply, "to look around and *truly see* where we are and then to act on behalf of the planet that supports us." The transformed picture tube of broken mirrors echoed my prayer across the dune. Nothing I have read states the issue of our time more succinctly than the words of Diane Harvey: "Since the same struggle between the forces of darkness and the forces of light most likely goes on everywhere in the physical universe, of what value is a species so feeble and ignorant it won't even stand up for itself on its own planet?"[16] This is the harsh question we must face as we wake up to take our place in the new millennium.

After making a few photographs, I sat near the head of the Snake and ate an orange. Facing south, I could see a sand buggy, just a speck in the distance, moving soundlessly down the face of a dune like the beetle I

had encountered earlier—both, like myself, like all life, powered by energy converted from the sun. The temperature was dropping, and I angled myself on the dune's west slope to soak up the waning afternoon rays. I drifted for a while, the vibrant orange light of the sun godlike on my closed eyelids—the Snake and I in simple celebration of wholeness and the star that sustains us all.

"I shall be cured at the sight of her. Let her open my eyes," prayed an Egyptian poet. "The sun's light is a better medicine than all of the medicines."[17]

When the light began to fade, I gathered up the shards and with palms folded together, bowed toward the sun. I placed a section of orange at the spot where I had knelt with my camera—an offering to the dune spirits, a treasure perhaps for a fortunate beetle.

III. Wind

"The ecological golden rule:
Each generation should meets its needs without jeopardizing the
prospects for future generations to meet their own needs."
—Allen D. Danner and Mary E. Gomes

A week after making the Solar Snake, I was at the Tehachapi Wind Farm in southern California. Leaving my van hidden in a wash across the main highway, I dashed from juniper to juniper with my rusty bucket of glass shards in hand. I intended to create a tribute to the wind.

My first experience with wind harnessed by man was while playing around a stock tank on the South Dakota farm we rented while my father was working toward his master's degree. I was ten, and would often climb halfway up the old windmill for a view of the prairie or to show off to my fourth-grade girlfriend. The happy creaks and clanks of the blades and gears were delightful—the resulting water in the tank a marvel to my spirit.

Some of my early professional photographs, while working for the state magazine in Kansas, were of windmills and sunsets. Continually I am drawn to them—an attraction that once cost me a good deal of money when I fell prey to a company with a unique windpump design that never found a market.

Years ago, halfway across the world during a stormy afternoon in Maui, I explored my first windfarm. High on a ridge, I walked between

rows of giant turbines that vanished every few minutes into thick, swirling clouds—the heavy *whhopp-whhopp-whhoop* of their blades the only clue to their existence. The deep, encircling sound was captivating and produced a giddy, charged-up feeling that tapped something in my spirit. At Tehachapi with my bucket of shards, the feeling returned. Yet in retrospect, this charge is diminished with my new awareness of a huge problem that plagues windfarms. The blades are killing birds.

The challenge of wind power is that birds and turbines are in competition for the same resource. In places like Altamont Pass in California, the number of raptor kills has been alarming. In the Columbia Gorge where I now live, the famous Chinook winds attract windsurfers from around the world; and now, wind power companies have arrived. They are laying the groundwork for mega-wind farms—some in areas with high raptor activity. While studies are underway to develop techno-fixes, the problem remains an issue of critical importance.

Back in Tehachapi I was still unaware of the avian issue, something that underscores arch environmentalist David Brower's wise words: "Assume all technology guilty until proven innocent."[18] Looking back, I question the "sacred feeling" that crept over me in the windfarms and at Luz. Perhaps it was an abundance of negative ions or a kind of techno-shamanic sound that came from everywhere at once. Maybe I had just fallen prey to their flash. Whatever the case, both solar and wind energy production are far more benign than dams and nuclear power plants.

The Windstar

Protected from view by a rough crescent of cholla cactus and in an area unlikely to receive more than packrats and rattlesnakes as visitors, I began to spread the shards into a sunburst design. Some newly found pieces made the sun: its center, an old silver hubcap rescued from the highway near Amboy; its corona, a faded red "aerobie" flying ring found in the surf near the decommissioned San Onofre nuclear plant. The mirror shards worked beautifully as the rays of the sunburst. There was nothing "natural" about this piece, and yet when it was finished it seemed to possess a kind of galactic, organic quality.

We're all the stuff of stars, they say—ancient atoms, swirled and steeped in an infinity of time. And so it must be, also, for the detritus of Western Civilization—shards of plastic, steel, and glass; gathered bits of ancient energy altered for a time by human ingenuity. Sub-atomic particles all, with lively electrons spinning in their orbits, the same stuff as

feathers or bone, rock or living flesh. What holds them together for a time is the place of their dancing—a prairie mandala, a shoreline circle, a desert wind-farm star—and perhaps, a story or photograph.

As I placed each fragment upon the ground, I gave thanks. I thanked wind for the way it weaves the world together, its thread of breezes and storms invisibly embracing the web of life. I thanked wind for the way it lifts hawks and vultures in the sky, for the way it fills my sail as I cross the lake windsurfing, for the churning thunderheads that blow across the prairie on summer afternoons, and for each breath by each being ever inter-changing. For ten thousand ways of the wind I could not name, I gave thanks.

I imagine the Windstar is still there among the cholla and the turbines, buried a bit by shifting sands—reflecting the celestial round, the occasional stare of a coyote, and my thankfulness.

IV. Earth

"If the lad or lass is among us who knows where the secret heart of the Growth-Monster is hidden, let them please tell us where to shoot the arrow that will slow it down. And if the secret heart stays secret and our work is made no easier, I for one will keep working for wildness day by day."
—Gary Snyder

Two winters after making the Windstar, I drove along the edge of the Great Salt Lake. My destination was Kennecott's Bingham Canyon, the world's largest open-pit mine. I had seen pictures of this gigantic "inverted mountain" and I knew it was one of Utah's greatest tourist attractions. No picture, however, could have prepared me for the sight that greeted me when I first peered into the immense circular abyss. A leaden feeling gripped my stomach. It seemed nearly impossible that humans could have created such a deep and gaping hole in Earth—but there it was before me, in all its awful grandeur.

The next day while tourists posed for pictures near the visitor center viewpoint, I planned my descent to the pit's western brink. After a tour of the enormous complex the previous day, I felt compelled to do something. I decided to spend the night in my van on the mountaintop high above, then hike into the mine early in the morning.

95

Desperate Prayers

Before night fell, I scanned the area for interesting materials that might determine the shape of my action. Among the shotgun shells, styrofoam, and beer cans typical of such places, I picked up a disposable plastic spoon. What better an emblem for us moderns, the world-champion "takers," than the ubiquitous plastic spoon? I stashed it in my day-pack while readying gear for the coming adventure.

As the first stars appeared in the east, I walked to the edge of the mountain and stared down into the dark, gaping cavity. This is where the spoon has taken us, I thought. A crude version of this implement was one of the first tools of our species. This early tool moved in magnification before me, as a multitude of mammoth diggers filling the electric super trucks that moved steadily in and out of the mine like giant, glowing monsters in a relentless effort to fulfill our desires.

In 1863, the first hand shovels began to dig what has become a monument to conspicuous consumption in Utah's Oquirrh Mountains. Today, giant electric shovels work nonstop, 365 days a year, digging wider and deeper for copper, gold, and silver. Two and a half miles wide and a half-mile deep, Bingham Canyon mine, the richest on Earth, took its place beside the Great Wall of China as one of two human creations visible to the first astronauts.

"The American way of life is not up for negotiation," retorted President George Bush in 1992 at the Global Environmental Summit in Rio de Janeiro when asked by representatives of developing nations to consider reducing our consumption habits.[19] Paul Wachtel in his book *The Poverty of Affluence* explains just why this is so, and why this philosophy is being echoed by President George W. Bush in 2001. "Having more and newer things each year has become not just something we want but something we need. The idea of more, of ever increasing wealth, has become the center of our identity and our security ..."[20] Our malls have become our cathedrals—"to have is to be," our credo. Consumption, in essence, has become our religion.

In *Becoming Native to This Place,* Wes Jackson puts a wise spin on the problem: "In Genesis, the primal sin involves disobedience, an exercise of free will. In our modern non-Paradise version, 'original sin' is our *unwitting acceptance* of material things of the world,"[21] what Lewis Mumford calls "the magnificent bribe"—proffered so that we might ignore what we lose in the bargain. I had never been anywhere before that so clearly articulated what we do indeed lose in the bargain: quite literally, Earth.

Numerous governmental decisions, now antiquated and culturally ingrained, have nudged our "unwitting acceptance" into an ever-expand-

ing abyss of consumerism. The mining law of 1872 is a perfect example—
a veritable "Rip Van Winkle" of government giveaways, chides my editor-
friend Will Nixon. "In 1872," eco-journalist Jay Letto notes, "Ulysses S.
Grant was President, Charles Darwin continued work on his evolution
theory and George Pullman introduced the 'sleeper car.' One hundred
and twenty-one years later, while we've had twenty-four new presidents,
evolution has become a science, and the sleeper car lost out to air travel,
the Mining Law—which regulated hardrock mining such as gold, silver,
lead, copper, uranium and zinc—remains intact."[22]

Bingham Canyon was once public land. However, the 1872 mining law
allowed purchase of mineralized land for less than five dollars per acre
and thus, through a chain of sold and resold claims, Kennecott took over
Bingham Canyon and similar operations elsewhere in the west. The U.S.
government collects no rent from mining claims, nor royalties on the min-
erals extracted. There are no requirements for environmental protection.
The net result in the case of Kennecott's Bingham Canyon operation is
one of the largest plumes of contaminated water (between fifty and sev-
enty square miles) in the country, now beginning to impact Salt Lake
City's drinking water supply. The entire Kennecott property is an EPA-
proposed Superfund site. Obsolete as it is, the mining law of 1872 is a law
cherished by industry, and they will spare no expense to keep it in place.

Entering the War Zone

I awoke before dawn, and after a quick bowl of granola, began the
steep 1500-foot descent to the edge of the mine. Pausing to gaze out
over Salt Lake City, I noticed the lights twinkling, and the first red sun-
lit streaks appearing over the Wasatch Range. To the south, I could see
formations known as the "Yosemite dumps." These thousand-foot-tall
man-made mesas of waste rock, visible from Salt Lake City, are grow-
ing shrines to the awesome power of consumer demand. The eerie roar-
ings and scratchings of the lighted trucks and shovels dominated the
day's beginnings.

I questioned my intent. What am I doing here? Why I am I doing this?
"It needs to be done," I said under my breath. "It just needs to be done."
I remembered a phrase gleaned from somewhere that I had long ago pen-
ciled on the barnwood wall of my Kansas ranch—*the "real world" must
be challenged with one of our own making.*

Moving swiftly down the precipitous slope, I startled small herds of
mule deer and they bounded away. And suddenly, while maneuvering

across a steep, damp streambed, my handhold crumbled. Two tire-size boulders crashed down from above and fell under my quickly arched body suspended bridge-like across the narrow chasm. I collected myself, took a few deep breaths, and gazed out across the expanse. "This is crazy," I thought. I was accustomed to such thoughts in situations like this one, and so I continued on and soon reached the flats at the edge of "the hole." No one was in sight.

The barren flats were interspersed with piles of grey, rocky earth the size of houses. I wondered if they were toxic. It felt like a war zone. *It was a war zone.* Two elk darted into the woods north of me. Strange refuge. Nearing the rim, a coyote looked my way and froze before dropping into the abyss. A few yards from his point of departure, a peninsula formed the outer, most precipitous lip of the mine. Here I decided to build a medicine mound with the plastic spoon as a centerpiece.

It's my sense that in order to regain the balance with nature that our species has so arrogantly discarded, new myths and symbolism must be conjured to inspire and initiate the grand changes necessary to guide us homeward. Thousands of people across the planet are engaged with such art, story, ceremony, and activism. They are antibodies to the expanding malignancy. A new mythology is steadily building with the power to lead us beyond the inevitable collapse toward a resacralized relationship of sacred communion with Earth. Every day there are opportunities to break trail on this path, and I relished the unique one before me now.

Rust in Peace

Soon I discovered the rusted, half-buried ruins of an old engine lying several yards from my chosen spot. I was flooded with the kind of joy savored by dinosaur hunters at the moment of a lucky find. As in the cover image from an old Earth First! calendar, two large gears had long since become one, joined by rust. I pried the fused object from the earth, and positioned it a few feet away from the edge of the immense pit. On top I placed the flywheel, once the engine's heaviest moving part. "May they rust in peace," I laughed to myself. Hunting among the rock piles I found an area of softer dirt, damp from a recent rain. I filled the stuff sack I had in my pack and dumped the contents over the gears, sorting out the bigger rocks in the process. As if on cue, a small band of coyotes began wailing behind me. I couldn't see them in the glaring sunlight, but they were close, just beyond the ridge of tailings at my back.

I feel good in the presence of coyotes. They are survivors, *par excellance*. When I first visited the farm in Kansas that I would name Sleeping Beauty Ranch, it was two coyotes that led me on my first walk. I trusted them as an omen of great good luck. Robert Pyle reminds us in *Wintergreen: Rambles in a Ravaged Land*, of the saying: "When the last man takes to his grave, there will be a coyote on hand to lift his leg over the marker. The image should be struck on a new coin," he writes, "with Charles Darwin on the other side: not negotiable, but a good-luck coin to remind us of change and evolution, and of creatures that will be happy to adapt if we ourselves cannot."[23]

I laughed, energized by coyote music. After a half-dozen dirt bag shuttles, I began to pat the circular, flat-topped mound into completion. I left the flywheel's hub exposed at the summit and placed white rocks in a circle around the mound. With a loose thread from my shirt, I attached a tiny gull feather to the spoon and placed it in the center of the hub. While the feather waved in the breeze, I gathered a handful of the black, sun-baked deer pellets sprinkled about the area and set them around the protruding hub. Finally, I positioned feathers at the mound's cardinal points.

Hearing a machine close by, I ducked out of sight beside the engine shards and the old mining machine it had run. While wondering if I had been spotted by the trucks moving below, I noticed the push rods, scattered like pick-up sticks and crusted with rust. The image of a tipi rushed to mind, and quickly I made one beside me. Perfect! When the truck had moved on, I gathered the twelve rods and set the tipi above the spoon, enclosing it within. I stepped back and howled with delight. "Restoration! Resurrection! Transformation! Repeal the mining law of 1872!"

Restoration! Resurrection! Transformation!

The spoon rising from the buried flywheel, covered by a tipi: I struggled with my understanding of the combustion engine for the metaphor. The flywheel converts and smooths the opposing motion of the pistons, transferring the momentum to the drive train, thus allowing the car to move (the feller buncher to cut, the shovel to dig)—in essence, for progress to *pro-gress*. One could argue that the flywheel was a bad idea, and yet there is a ray of hope within the "runaway system" it symbolizes. "In systemic terms," notes Laura Sewall, "a runaway system is far from equilibrium and so has the greatest potential for either breakdown or breakthrough, and the outcome is unpredictable."[24]

Blazing pathways of non-consumption is the front-line work of the con-servation revolution, and legions of courageous people have come forward to lead the exodus from the all-consuming passion that is draining the life from this planet. "Green, which used to mean *Go*, is now the signal to *Stop*," writes Vicki Robin, co-author of *Your Money or Your Life*.[25]

John Updike once described the spell of America as "a vast conspiracy to make you happy." It is a conspiracy because it harbors no truth. We must stop shopping to fill our time, to maintain our relationships, and to fulfill our needs for admiration, affection, and esteem. There is no need to blame ourselves. It isn't an easy thing to avoid succumbing to the persua-sion of the worldwide advertising industry, which spends $450 billion annually to cleverly convince us to buy the products of the "new, modern, and cool" way of life. The ability to find satisfaction and meaning in a materially humble life is a benchmark of ecological sanity that has been choked off by the toxic messages of corporate advertising.

It is a form of toxicity when an organism gets wrong information. This is how herbicides work. Herbicides kill by supplying hormones that signal the target plants to grow faster than their ability to absorb nutrients allows. The chemicals literally force plants to grow themselves to death. Recognize the eerie similarity? Our daily doses of toxicity are the adver-tisements from the marketplace.

The power of the global marketplace rests on our lack of awareness regarding the system of which we are a part. "At a structural level," writes anthropologist Helena Norberg-Hodge, "the fundamental problem is scale. The ever-expanding scope and scale of the global economy obscures the consequences of our actions: In effect, our arms have been so lengthened that we no longer see what our hands are doing. Our situation thus exac-erbates and furthers our ignorance, preventing us from acting out of com-passion and wisdom."[26]

My mound was simply a cairn on the path of expanded awareness. It is the path of progress redefined—a homeward path where our primary task is restoration and restraint, the teaching of wisdom over cleverness, and of an Earth people intertwined with an Earth community.

Whether it's coiling up old fences that defile the landscape, planting trees, repairing a streambed, or filling giant holes in the earth—clearly, restoration is the artform of the new millennium. I firmly believe that if it can be imagined…it can come to be. We can accept responsibility for restor-ing the land. We can choose to heal one piece at a time, little by little.

I scooped up two handfuls of dirt and threw them over the edge of the pit beside the mound I had made—which suddenly struck me as being the exact inverse of the giant hole before me. It was a rather pathetic gesture

I suppose, in beginning to fill this monstrosity. It was symbolic, though, of the task that lay before us.

I imagined prehistoric times, when the first spoon-like implement was chipped, carved, or found—the better to scoop out the brains of a buffalo or the marrow from the femur of a deer. I felt a strange link with that early ancestor. In a sense, I was in collaboration with him or her, as well as with all the inventors of the engine, the birds that supplied the feathers, the deer who made the pellets, and the geologic forces that formed the earth and rocks—even the alchemy of elements being changed into iron and plastic.

Desperate Prayers

Understandings from the Earth are born strange and beautiful like life itself. They are sacred things—at times, the very stuff of myth. I felt a power in this and knew that if those early tool makers were to stand beside me now, they would grasp my intent and approve. I could almost feel a collective slap on the back and grunts released in blessing.

As often happens when creating healing art from found materials in the midst of destruction, the experience of receiving a deep flow of energy and information occurred within me. My body became filled with a kind of circular synergy. It was an experience of grace, grace born in the linking of myself with my ancient ancestors and with Gaia. I experienced a remembering and a power beyond my own capacity as a separate entity. It was simply the experience of deep contact with my ecological self, the essence of my wholeness.

"Everything wants to be round," claimed Black Elk. Whenever I complete a found-materials mandala upon the body of Gaia, I feel this within my entire being. It is a sense of completion, rightness... a homecoming, almost as if all the shards themselves are able to celebrate wholeness, a wholeness greater than the sum of its parts. The more we find ways to contact the roundness of our ecological selves—our union with Gaia—the more empowered and grace-fully we can live on this planet.

A yellow-shafted flicker emerged from the abyss and perched for a few moments on a nearby bush. The bird eyed me suspiciously and moments later, a magpie appeared to watch more closely from the opposite direction. All the while, the robotic trucks slowly spiraled—full and empty, full and empty, along the cut and blasted benches of the upside-down mountain. I chanted, and awaited the sun which had disappeared behind a front of passing clouds. I called forth my vision of the Golden Prairie and knew this time of devouring the Earth would pass, and that one day something uniquely wild and strange would exist here—a lake, an eerie forest sanctuary, a navel-like place of pilgrimage perhaps. Something of the sort would exist here, possibly because we learned to use the implements of destruction—electric shovels, bulldozers, and the like—as tools of restoration. Gaia knows well the practice of resurrection, and as an integral part of her, we do as well. We must only listen and remember.

Suddenly, the cloud front moved by and the scene brightened before me. I collected a few photographs and before leaving, prostrated myself in front of the mound, placing both hands firmly on its cool, moist, hand-patted dirt. "I love you, Earth body. Deliver us from consumption. Guide us in restoration. Help us to remember. Please."

Chapter 5

The Solace of Ancients

"You are the world and the world is on fire."
—J. Krishnamurti

here are very few areas on Earth that have escaped the heavy hand of Western man. Fewer still lack any human history whatsoever. In the dense forests of southern Chile there may be such regions, and within an ancient grove of alerce trees, I felt instinctively that I had found a place that held no memory of my species. I trod upon the moss-covered earth with reverence, each footfall a sacred act as if *homo sapiens* had been given another chance and the future hung in the balance of my stride.

Primal. Ancient. Virgin. Wild. Timeless. Favorite words, to be sure, but mere words failed to describe what I felt here. It may have been the diamond-shaped, geomantic arrangement of the giant trees that held me spellbound, or the way the yellow and white flowered glade opened just so, upon them. I dropped my pack and stood in silence before the mossy behemoths in what seemed the abode of time itself, homeland of the original mystery. Breathless and in awe, I felt the spark of recognition that in rare moments connects one to the source. Here was Eden. Here was "home" in a sense I had only imagined.

What was this curious sense of longing and belonging? It may have been nostalgia in the true sense of the word, not the cheapened version triggered by classic fashions, cars, and movies. Nostalgia. The word's two Greek roots translate, literally, as "return pain" and the craving I felt was indeed painful. Why this was so, I am not sure. Certainly I was angry at the mistakes of my kind and yearned for another chance, a ticket back 10,000 years to the fork in the trail, to a *tabula rasa* before we messed

things up with the invention of agriculture and the spurning of all that is female. This exquisite sadness that may suddenly seize one during perfect moments of wildness may be a memory seated deeply in our being of a revered home left countless generations ago. Or perhaps it is something entirely different. It may be what naturalist Kathleen Dean Moore calls "a landscape on an intellectual plane, a Platonic realm of ideas where perfect truth and perfect beauty become one glorious idea that can't be distinguished from love."[1] Whatever it is, this feeling often descends upon me in wild places when the light is "just so," and I am quiet inside.

As I stood transfixed in the forest glade, however, I realized that *wilderness is not home,* something I could never before bring myself to concede. As I made that confession, a sense of relief passed over me. Later, coming upon these words by Evan Eisenberg, I better understood what I had felt: "As soon as man becomes man, he must leave the place where he was born—namely wilderness. But the expulsion takes a subtle form. For he leaves wilderness by entering wilderness. Each place he enters ceases to be itself, and so he is expelled from its true self: he is left with the husk of a place. The only way to avoid expulsion is not to enter at all."[2]

If we do enter, it must be briefly, treading softly, with breath held, in awe. For my kind, wilderness can never truly be home; for the hard truth is, when we return to Eden, we inevitably destroy Eden. Still, I longed for the fundamental animal belongingness I felt in that grove. I had dreamt of it and sensed it all my life without really knowing what it was, until it washed over me as I stood ankle-deep in the luxurious moss. I felt as though tiny rootlets had begun to sprout from my extremities and that soon I would be anchored in place, one with the Tree of Life. Yet I am human, not tree—and too soon had to return to my modern home. It was the winter of 1991, and my family and the forest wars of my continent awaited. A part of me though, perhaps the best part, still resides in that grove and sometimes I am able to dream back the vestige of a wild and innocent belongingness held by my ancestors so long ago.

Redwood Summer, 1990

Why am I so drawn to the trees? Perhaps it is because I was conceived among the redwoods. My dad worked as a backcountry ranger in Sequoia National Park and my mother joined him there after they married. Talk of children began in the realm of giant trees—"ambassadors from another time," Steinbeck called them. In the iron-hinged cedar photo album my mother keeps, there is a picture of me in my crib, sequoias beyond, with

our black and tan collie Tuffy standing guard. When I hear stories of those days, I have a sense of feeling protected by the trees. Now I realized it was my turn to protect them.

From as far away as my Kansas farm, I felt acutely the pain of the trees' increasing demise. Magazine stories and letters from friends who witnessed the cutting of unprotected redwoods angered me deeply, and were in part the inspiration for selling Sleeping Beauty Ranch and moving west. In the summer of 1990, we began our move to the Columbia Gorge in Washington state. My wife Christine, my two-year-old daughter Sierra, and I headed southwest first to participate in Redwood Summer, a season of massive protest against the destruction of California's last stands of unprotected redwoods.

When we arrived at the activist base camp in our VW camper, it was a jumble of tents and cars, mud and dogs, men, women, kids, long hair and short, with a big cooking area in the center. A large plywood sign displayed neatly tacked posters noting the rules of the camp and various Redwood Summer events. Bearing bodily witness to forest destruction was the work at hand, and non-violent civil disobedience training sessions were a daily event. The vision was to inspire public sympathy across the country, to push Congress toward protecting redwood groves still vulnerable to the saw. The mood of the camp swung widely and included quiet desperation, rage, humor, and humility. Quickly we found ourselves helping to plan an action.

In the middle of the night, I left camp with twenty-five others to occupy a ten-acre redwood grove in an area called Navaro. It was about to be logged—illegally, we thought. In the predawn light we discussed strategy and awaited the loggers' arrival. Seven people, unknown to one another until then, nestled inside the hollow burnt cavern of a redwood giant that was a sapling when Jesus Christ was born. We vowed to stay until cutting in the grove ceased. Along with a man named Jake, I would film the event; the rest of the group would stay behind to form a second wave of action (if people in the first wave were arrested). Soon the workers arrived and, after shouting insults, went to get the police. While awaiting the authorities, the seven inside the tree chanted:

> *The Earth is our Mother*
> *We must take care of her,*
> *Hey yanna, Ho yanna, Hey yan, yan*
> *Hey yanna, Ho yanna, Hey yan, yan*
> *Her sacred ground we walk upon*
> *with every step we take...*

In the mid-afternoon of a very hot day, fifteen deputies in freshly starched uniforms entered the grove, and the chanting was renewed in earnest. I left the hollow tree to film the event, as each of my new friends was arrested and brutally dragged through the forest to a paddy wagon. One of the officers saw me with the camera and I ran away, not wanting my tape to be confiscated. I hid in the bushes, and somehow had the presence of mind to remove the tape (which contained additional Redwood Summer footage), hide it within the tangled roots of a fallen maple tree, and keep running. I made it to my car and drove away before the officer was able to catch up. I later retrieved the tape, and some of the footage was eventually used in a documentary.[3]

Twelve vehicles, twenty-two policemen, and a goodly sum of public money intervened to enable tree cutting to continue. The next day, loggers met fifteen more activists taking a stand in Osprey Grove, named that morning for its osprey nests. This time the enraged loggers greeted the activists with a barrage of rocks. A young man named Terry suffered head injuries before some loggers stopped the violence and left to call the police. Once more officers came, en masse, to haul away the forest saviors. Almost ritualistically, like a macabre dance at the edge of Armageddon, the scene was repeated again the following morning. The number of arrests now stood at forty-two. Logging the grove had been effectively slowed and tomorrow was Saturday, July 21, the day one of the largest gatherings of forest defenders in history would rally and march for the redwoods in Ft. Bragg.

Off With Its Head

That night my family and I camped in a massive clearcut in the hills above the logging town. It was an eerie place as all clearcuts are, but the ravaged, deathly pall of this one was magnified by the size of its massive, fire-blackened stumps. I felt an enormous emptiness. *This was recently a 2,000-year-old climax forest.* As I examined the thousands of blackened stumps before me, the old prayer echoed in my skull—"Mother Earth, forgive us, for we know not what we do."

We camped on a level spot bulldozed out of the mountainside to serve as a landing for the transfer of logs. Dominating the foreground was an immense stump, ten feet tall and nearly thirty feet around. Nailed upon it was a large paper "bull's eye." Shells of various caliber were scattered about, and the stump was riddled with bullet holes and lead sunk deeply into the wood. I ripped off the target and sat down, feeling the presence

of an evil so acute I could hardly breathe. I was chilled by its depth, and the disregard for life. I felt little hope for a species that could so thoroughly denigrate one of the Earth's true elders.

I thought of the corporations liquidating "their" (as if such beings can really be owned) last stands of redwood trees to pay off junk bonds. I thought of how environmentalists are blamed for the loss of logging jobs when the true causes are automation, overseas shipping, overcutting, and the processing of logs in Mexican mills for $1.50 an hour.

"We need everything that is out there," said Harry Merlo, CEO for Louisiana-Pacific. "We don't log to a ten-inch top or an eight-inch top or a six-inch top. We log to infinity. Because we need it all. It's ours. It's out there, and we need it all. Now."[4]

"Why, why, why?" I wondered. Why couldn't local loggers realize that they were being sold out and that soon, when the forest was gone, there would be no jobs for them? One would think such comments by Merlo so outrageous that even the most strident logger could see behind them. But they cannot, and there is a good reason. It is an echo of what many consider to be the oldest story in history, the story of Gilgamesh and the felling of the Cedar Forest—"the Land of the Living."

Gilgamesh is the archetype of many heroes in Western literature, so we are wise to understand this tale. Ancient scribes recorded the story roughly 5,000 years ago, and it is the account (basically a logging adventure) that characterizes man's seemingly inherent need to dominate nature.

It goes like this. King Gilgamesh conquers the wild man Enkidu, who knows the way to the remote Cedar Forest guarded by a fearsome monster named Huwawa. The conquering of the wild Enkidu symbolizes the king mastering the wild nature in himself. He is now intoxicated. He wants more. He wants to conquer wild nature in a bigger way, and thus Enkidu (now his servant) leads him to the faraway mountain realm of the Cedar Forest.

Why turn against nature, one may wonder? "Knowing that it is our fate to die—and, what is worse, that it is our fate to know that we die— makes us furious at nature," writes Evan Eisenberg. "So we attack nature—partly in hopes of loosening its death grip on us, partly out of envy and spite."[5] Gilgamesh storms the mountain and enlists the help of the Sun god, who sends eight mighty winds to bound and blind the monster. Subdued, Huwawa tries to strike a deal with the king. He offers to supply a sustained yield of timber if the hero will just spare his life. But the Mesopotamians who record this tale wanted all the wood in the forest and like Harry Merlo, they wanted it "now." Gilgamesh answers the offer by cutting off Huwawa's head.

"This is a turning point for the western mind," explains Eisenberg. "Nature offers its services: flood control, pest control, climate control, gene banking, resources renewing themselves without end. Of all these boons there is no better symbol or dispenser than the forest. In brief: energy, information, and the two combined in ten thousand kinds of work done for us absolutely free of charge—'on the house' we might say..."[6]

What an offer! And yet how do we respond...and continue responding, up to the present moment? *Off with its head!*

The Medicine Stump

I originally heard the myth of Gilgamesh from my father, who taught one of the first environmental studies classes in California. We lived only a mile from the San Bernardino mountains, but often we couldn't see them because the smog was so thick. I remember playing catch with my brother on the front lawn when I was eight years old. A helicopter flew overhead, proclaiming by megaphone that there was a smog alert and we should go indoors. I remember being taught to "duck and cover" in school, and watching images of atomic explosions on television. I remember the first big word I learned how to spell: "apocalypse." It was a strange and beautiful word, I thought, and it made my mother cringe and my dad smile eerily.

My first memory of this word returned as I stood in the clearcut, gazing upon the blackened stump of an ancient being. "The path into the light seems dark," the Tao advises. Could anything be any darker than this sight before me?

While the fog bank floating below the mountainside received the setting sun, I crisscrossed the stump with yellow and green ribbon. As those who live in timber country know, loggers fly yellow ribbons from their car antennae to symbolize solidarity with the wood products industry. During Redwood Summer, activists flew green *and* yellow ribbon from their cars in an effort to demonstrate their solidarity with the loggers. The activists tried to show that they were indeed concerned about the long-term effects on loggers' livelihoods. I had just enough ribbon in my pocket to properly honor our giant camp-side stump.

From a discarded Coors beer can, I cut three shiny strips of metal and attached them in a sunburst pattern at the point where the yellow and green ribbon intersected. I picked up some discarded plastic oil containers, and from them cut two yellow and two white arrows. These I placed at the

four directions, all pointing in toward the sunburst. Darkness had arrived by the time I finished the artful offering. I stepped back and paused for a moment, then began explaining to Christine what it signified.

"It's the Medicine Stump," I declared as I entered the van and sat down for dinner. "First of all, it's an apology to this hillside for mankind's ignorance and greed, which is at the root of such massive forest destruction. An apology and a thankfulness for the beauty it held for thousands of years. Second, it is a prayer for the healing of ravaged forests like this everywhere. And third, it's an appeal for the unification of the yellow and green camps...the loggers and conservationists."

I gestured emphatically at the tree stumps and could feel my voice rise in volume as I continued. "Sustainable forestry, which includes ancient forest protection, is the only way any semblance of a logging lifestyle can be preserved in the Pacific Northwest. Timber workers have got to realize this. If we could just join forces we could force the corporations to end their liquidation-style logging! Divided as we are now, the corporate powers will continue to have their way not only with the redwoods, but with all forests until little is left. United, we can beat them."

Christine looked out the van window at the transformed stump. She was, of course, familiar with my work and was generally supportive—and always tactful. She paused thoughtfully and offered me more spaghetti. "It's interesting, what you've done, but do you really think something like this can make any difference?"

"Who knows?" I sighed. "I know doing nothing won't do the trick. If one cares deeply, one must try everything—work the edges, explore forgotten angles. One must create and tell stories. The universe operates in strange and mysterious ways. Who knows the secret combination, or the whereabouts of the key that will open the doorway leading to a reciprocal, sacred relationship between Earth and human?"

Christine wistfully gazed again out the window at the devastation that engulfed our little van. "You're right, I guess. One must look everywhere. Even in clearcuts."

I got up early the next morning and walked out into a light fog. I placed an owl feather on top of the stump at each cardinal direction. "When you see an owl feather," said an old Huichol teacher in Mexico, "pick it up and dedicate it immediately to the light—to seeing through the dark times, flying with grace and ease through unclarity, to positive ends of whatever kind are important to you—dedicate it and then *that will be its teaching.*"[7]

I gathered nearby flowers of thistle, mint, and yarrow and carried them into the burnt heart of the old one. I sat inside for a short time, praying for our last remaining wild forests.

When I exited the center of the dead one, I witnessed an unusual optical phenomenon in the eastern sky. In all my life I had never seen a fog rainbow! The sun pierced the thinning mists and silhouetted a Douglas fir high upon a ridge as if it were God's original *Tree of Life*. The effect was startling and beautiful. A full-spectrum sunburst emanated from the tree, almost too astonishing to believe. After a minute or two, the fog thickened and the phenomenon disappeared. I knelt in awe beside the stump, dumbfounded by the celestial magic I had witnessed—and its synchronicity. I remembered the "Golden Prairie" and came to believe that our great redwood forests will surely stand again one day in a more perfect world. I could almost visualize it. I gave thanks for the "peek behind the veils" that synchronicity has come to symbolize for me.

"According to Taoist, Buddhist and Confucian thought," writes Carolyn North in her little handbook *Synchronicity*, "the whole cosmos is perpetually in motion, every particle shifting in relation to every other particle, everything synchronized in time and space...To the ancient Chinese, it was simply a fact that correspondences existed between our individual lives and the grand sweep of the universe at any given moment in time."[8]

Was the timing of the fog rainbow somehow a response from the Great Mystery to the offerings I had made that morning? Certain Chinese thinkers would have easily endorsed this notion. I suppose I could too. Life is a mystery to be enjoyed, not figured out. It is much more interesting when we allow ourselves the grace of connection in the deepest and most magical ways. The important thing is to never, ever take for granted the revealed beauty Gaia sends our way. If as much as possible we can practice life in a state of gratitude, such moments will continue to be revealed to us.

The Death Mask

After Redwood Summer, I became the lead photographer for the *Clearcut* Project funded by The Foundation for Deep Ecology. The magnificent coffee table book that resulted was a massive, full-color documentation of a ravaged forest landscape from California to Maine, Alabama to Alaska, and Canada. In the winter of 1993, I went to Washington, DC, with 100 other activists from across the country. We walked the cold marble aisles of Capitol Hill and presented to each member of Congress a copy of *Clearcut: The Tragedy of Industrial Forestry*. We had hoped the book would be a wake-up call of grand proportions—

but it soon became obvious, after witnessing numerous reactions by Senators and Representatives of the "my, what a beautiful book" sort, that they just didn't get it.

At first I silently cursed them. *How, for the love of God, could they not get it?* Ninety-five percent of our original forests are gone! Only five percent remain! Deforestation has been the handmaiden to the collapse of almost every civilization before ours. *Wake up, damn it!* Soon I realized that they were simply manifesting the systemic sickness of our time, a disconnection from our earthly roots. How could I condemn them?

"To dwell on the absurdity of a culture that congratulates itself on its 'progress' while carrying out geocide is to risk hearing your mind go *spronning* while spending the rest of your days gnawing bark off trees," writes philosopher Brian Swimme. "To avoid this fate, I have had to make some fundamental adjustments toward my society, and toward my profession, science. The perspective I've settled on is this: the patriarchal mind-set of our culture is very similar to a frontal lobotomy. I think it is important that this be understood once and for all, for otherwise one is condemned to eternal soul-rotting fury. We need to remember the basic helplessness associated with individuals who have had significant portions of their brains removed."[9]

When I first read Brian's perspective, I felt a great weight lift from my shoulders. "Yes, no wonder!" I exclaimed to myself. We can only expect so much from such people, and all the moral indignation we can muster will get us nowhere, fast. We cannot reach them in a head-on manner.

I also realized a problem inherent in the imagery I flaunted. All of us have been heavily nurtured on images of every sort, from beautiful nature to photographs of war, in advertising, magazines, books, and on TV. Beautiful or ugly, imagery no longer moves people as it once did. Over-imaged and glossied-out, our emotions largely neutralized, we have lost the ability to respond in meaningful ways to overwhelming evidence (whether in imagery or scientific report) of the destruction of our life-sustaining ecosystems.

In the midst of printing an exhibit of the book's clearcut photographs that would travel the country, I came down with the flu. One night, my high fever was accompanied by nausea. Between bouts of vomiting, an endless scroll of hellish, black, and ravaged clearcuts played and replayed through my mind. If only, I imagined, such painful images could cause people to really *feel* the pain of Earth! What a difference it would make! But alas, they were just pictures, and I was only dreaming.

The picture on the book's cover, however, seemed more than just a photograph I had taken. When I first saw the way it had been cropped

and formatted by the graphic designer, I could hardly believe what I was seeing. Formed by the contours and shadows of the barren, ravaged hillsides of a giant clearcut not far from my new home in Washington was an anguished face. It stared upward like a specter from the holocaust. It was the face of deforestation, the tortured face of Mother Earth upon all the devastated landscapes I had witnessed as I flew above cutover lands from Alaska to Chile. Held in the gaze of this death mask, a gaze recognizable on faces of refugees and other victims of senseless violence, was the destruction of countless life forms and habitats.

The *Clearcut* face became a kind of talisman for my anger. When I first saw it in print, it occurred to me again that Earth may collaborate with us if we are open to the possibility. This was a lucky shot produced more "through" me than "by" me. Clearly, the Earth had something it wanted to say. If it could verbalize, I imagine the words would be akin to what author Scott Russel Sanders wrote in his book *Staying Put*.

"The machines work around the clock. Their noise wakes me at midnight, at three in the morning, at dawn. The roaring abrades my dreams. The sound is a reminder that we are living in the midst of a holocaust. I do not use the word lightly. The earth is being pillaged, and every one of us, willing or grudgingly, is taking part. We ask how sensible, educated, supposedly moral people could have tolerated slavery or the slaughter of Jews. Similar questions will be asked about us by our descendants, to whom we bequeath an impoverished planet. They will demand to know how we could have been party to such waste and ruin. They will have good reason to curse our memory."[10]

Redwoods of the Andes

With the completion of my photography for the *Clearcut* Project, I was invited to join an Ancient Forest International expedition to southern Chile to document alerce trees. I was hoping that these remote, ancient forests would heal my spirit after recent experiences of battling to save trees, and time spent viewing cutover land. "Whether we know it or not, we need to renew ourselves in territories that are fresh and wild," suggests cultural ecologist and Buddhist teacher Joan Halifax. "We need to come home through the body of alien lands."[11]

Cradled above deep Andean fjords, largely unseen and nearly untouched, there is a relict rain forest that harbors Earth's oldest giant trees. (Only the much smaller, gnarled bristlecone pine of California lives longer.) It is a mist-shrouded realm, protected by

obscurity in broken archipelagos often unnamed and unexplored. In these isolated southern fragments of Chile's once extensive temperate rain forest, called the *Bosque Valdiviano,* is the ancient and magnificent *alerce* (ah-LAIR-say).

Charles Darwin first called attention to these trees. Their scientific name, *Fitzroya cupressoides,* honors Robert FitzRoy, captain of the *Beagle.* Still somewhat of an enigma to taxonomists, the alerce most closely resembles the giant redwoods and cedars of the Pacific Northwest, and like them, it is a conifer—among the most primitive of life forms. It has been nicknamed "the redwood of the Andes," and understandably so. In 1988 Antonio Lara, a Chilean botanist, counted 3,600 rings on an alerce stump half the diameter of many living alerce trees. This was ten more rings than found on the oldest *known* sequoia, thus establishing the alerce as the oldest giant tree.[12]

Six to over twelve feet in diameter, the dominant alerces range from 1,500 to probably over 4,000 years of age. California's desert-dwelling bristlecone pine is known to have reached an age of 4,900 years, making it the oldest known living thing. (The tree was cut down to determine this!) However, one may extrapolate from the recorded ring counts and size of alerce stumps, and conclude that there is a chance that an alerce may exist which is, in fact, older than the desert ancient. It is doubtful we will ever know for sure because after a few thousand years, most alerces develop heart rot, which confounds ring-counting efforts. Whether or not an alerce may in fact be the world's oldest tree is a mystery that will likely never be solved.

Far from the limelight of South America's tropical rain forests, southern Chile's enchanting wild and ancient groves are the focus of a growing crusade to protect this last large piece of Earth's temperate rain forest. At the center of this effort has been a grassroots conservation group called Ancient Forest International. Based in California redwood country, AFI has a heartfelt mission to protect an original forest that mirrors its own, once-extensive redwood forest. In a compelling example of parallel evolution, Chile's temperate rain forest can perhaps best be understood as a sister biome to the forests of the Pacific Northwest. AFI's strategy is to alert the world conservation community and raise money for the creation of international native forest sanctuaries in the 7.6 million hectares of native forests remaining in Chile.[13]

In the 1970s, AFI founder Rick Klein became intrigued by rumors of redwoods in Chile. On Klein's initial forays he discovered only giant stumps along the coast where, two centuries before the first California redwood was axed, the Spanish began cutting alerce to repair their

galleons after the long Atlantic passage. Pioneers continued cutting lumber and shingles from the rot-resistant, easily worked alerce. That their homes still stand testifies to the virtues of this tree. Nearly extinct in the lowlands, the alerce is limited to isolated patches along steep Andean ridges and in remote hanging valleys along the southern coast.

This lost forest in the southern hemisphere beckoned to me. That in the 1990s a rain forest nurturing some of Earth's oldest life forms could be largely unknown seemed a wild fantasy. I felt called to play a part in the protection of something possessing a wild quality nearly extinguished in the twentieth century. As conservationists have often found, "what is not known cannot be saved." With this in mind, I joined Klein and a team of scientists to gather photographs and information that we hoped would inspire the protection of this land.

The Spell of Ancients

From a glacial lake one day's walk above the tiny frontier outpost of Hornopiren, a dozen of us followed a meandering and barely recognizable woodcutter's path until it disappeared into tangles of roots, bamboo, and giant ferns three times our height. Rick did his best to remember the way as we stumbled in the cold, light rain with our heavy packs. Thinking us crazy, half of our group turned back, retracing the way to base camp via the trees we had flagged to mark our route. The rest of us continued until dusk, encountering our first grove of alerces like the ruins of some lost and ancient city. Disoriented, exhausted, and cold, we made camp as best we could on a ridge choked by immense ferns, rotting logs, and vines. We were blessed, however, with a tiny stream. Rarely had water tasted so sweet and pure.

After considerable effort, I managed to pitch my tent on a splintered slab of a fallen hulk some 200 years into its deliquescence. I positioned myself upon a luxurious cushion of moss. In essence, an ancient giant reposing on the forest floor is more alive than a standing one, so densely is it packed with life. Sitting in this ten-thousand-year-old temple, I sipped my tea and watched the Southern Cross wheel upward between ghostly white columns of alerce. Too exhausted for deep abstractions about time, I sleepily succumbed to the ancient beings I had come so far to embrace.

Old-growth alerce forests contain the densest concentration of life on Earth, comparable only to the most superlative redwood groves, and they store at least twice as much carbon as tropical rain forests. Less than

one-twelfth the size of Earth's tropical forests, the world's shrinking temperate rain forests are in dire need of attention.

Though not decimated to the extent of forests in the Pacific Northwest, Chile's last virgin forests are, nonetheless, under siege. The 500-year history of alerce exploitation should have come to a definitive end in 1976. It was then that Chile took an unprecedented step, outlawing the cutting of its two rarest and most endangered trees—the *araucaria* and the alerce. By this single action, Chile established a bold model in forest conservation, something the U.S. (in the case of its original old-growth ancients) and other countries would do well to quickly follow. Unfortunately, funding for the enforcement of this courageous legislation has been minimal, making it difficult to prevent poaching and burning. Monetary constraints notwithstanding, a significant flaw in the plan is that it does not protect the forest as a whole system. The *coigue* (coy-way), a long-lived hardwood tree that often grows alongside the alerce in a symbiotic relationship, is open game. Multinational timber companies are targeting the region as a potential feeding ground for their voracious appetite in wood fiber. They are funneling millions of dollars into logging what biologists consider to be the world's largest remaining temperate forest.

We awoke to a forest painted with rising mist and god beams[14] slanting through the tall trees. Soon, we were able to orient ourselves to what previously had been obscured by clouds—the slumbering volcano, Hornopiren. After drying our equipment in the welcome sunlight, we began to thread our way to a place called Valle Hermosa, where Rick had camped the year before.

We were always on the lookout for *pudu*, the world's tiniest deer (only thirty centimeters tall). We saw occasional signs of puma, the other notable mammal in this forest remarkably devoid of animal life. The recent ice ages—plus the isolation of southern Chile by a desert to the north, high Andes to the east, and Pacific Ocean to the south and west—have cut off entire orders of plant and animal relationships. The result is an almost benign wilderness, curiously free of mosquitoes, poisonous snakes, and food-stealing rodents.

I say *almost* benign, for what this forest lacks in animal life it counters with a profuse and verdant botanical density unsurpassed on the planet. Devoid of any large animal trails, the forest floor may be three or four layers deep. One can walk upon decaying logs, balanced on top of older logs, without touching solid ground for hundreds of feet. Strewn boulders and fallen alerces in various states of repose hide moss-covered traps that can instantly "swallow" even the wariest hiker, elbow-deep, until a companion comes to the rescue. But it is the dreaded *quila* that

truly frustrates one's mental and physical capacity. The few who have entered these forests invariably return with tales of being humiliated by a dreadful botanical *quila* hell. This weblike variety of bamboo weaves and links itself into fierce, thick tangles virtually impossible to penetrate. The *chukao*, Chile's water ouzel, is at home here and will chirp and happily flit among the green bars of your cage. The bird mocks your every grunt and curse as, exhausted, you resort to a pathetic crawl while dragging your muddy backpack behind.

The prolific *quila* has served to guard the secrets of the last high alerce forests by limiting their access from below. The tangled vegetation is impassable to all but the most inspired adventurers. Combined with the 160 to 270 inches of annual rainfall and the surprising lack of game, the *quila* discouraged land use by coastal-dwelling native populations.

Our small group slogged its way up the valley through a shallow swamp, looking for a suitable camp. Eventually, an enchanting meadow opened before us. It was rimmed by alerces and coigues stunted and twisted into bizarre, poetic shapes as if configured by some ageless, Japanese master gardener. The bonsai then gave way to a grove of giant alerces under whose canopies we settled. We had made it to Valle Hermosa, and it was heavenly. Each of us settled into a private reverie, making little forays around the grove and meadow, writing in journals, taking pictures, and simply basking in such rare and verdant wildness.

Solace Grove

After a few days of photography, study, and reverie, Rick, his daughter Sera, and I decided to further explore the valley. We gathered our gear and, each of us picking our way, followed a small creek that wound gradually upward from one cathedral grove to another. After a mile or so, the creek gave way to a small meadow full of wildflowers. Visible beyond this delicate glade was a marvelous group of titans somehow different from the others we had encountered. Stepping from the deep shade, I entered the sun-drenched meadow. I gazed across waist-high grass and flowers upon the grove which opened, diamond-like, before me. Stopping abruptly, I felt a transcendent wave of familiarity emanate from this strange gathering of trees.

"The forests were the first temples of divinity, and humans took from the forest their first ideas of architecture."[15] So wrote François-Rene de Chateaubriand (1768–1848) to describe gothic churches with their secret passages, vaulted columns, dark sanctuaries, and cool, refreshing interiors carved with foliage.

Desperate Prayers

Had anyone yet beheld this sight? Perhaps a passing shingle cutter looking for fallen alerces—but almost certainly no one else. In the presence of these gnarled, moss-covered beings draped with ferns and red flowering fuchsia, I was struck with the feeling of witnessing original Earth, distinct from the feeling of walking in more famous forests whose giants have been embraced by the eyes of so many. There is a memory contained within places and trees. They store and record their encounters with humanity, and when such experiences are absent, one can sense an infinite wildness.

In such sacred moments, one has the rare opportunity to be an emissary for our species, to greet with respect and joy a life and place wild in the purest sense. The self-conscious feeling at first of being an intruder and wanting to apologize for my presence gave way to an acceptance and honoring of a truly great gift. In such moments, a bonding occurs and a trust is born. One returns an agent for the place and for all things still wild and free.

Sera named this gathering of trees, as humans seem inclined to do. She called it Solace Grove. In the emerald light, we stood in the center of this enchanting grove and extended ourselves in a reverent manner befitting a greeting between species. Naked, with arms uplifted, we gave thanks for the honor of a privilege we had never known. For two days we basked in the dharma and delight of these strange and beautiful elders. We had crossed a gateway it seemed, and now, our pilgrimage ended, knew we would never again see Earth in quite the same manner.

While no healing art felt necessary here, we were well aware of the grove's vulnerability. Massive clearcuts were only a two-day walk from this spot. As a prayerful method to consolidate our hopes for the safety and protection of this place, we gathered red and yellow flowers from the glade and formed a simple circle upon the luxuriant moss in the midst of the grove. In true wilderness I create nothing that will last beyond a short time, being mindful that in such places one should leave as little trace of one's visit as possible.

"God is a circle whose center is everywhere and its circumference is nowhere," said Rick, quoting Greek philosopher Empedocles, who lived over 2,000 years ago. "Yes, but I wonder if the Creator has favorite places? If so, I bet this is one of them," I added, smiling. "Untampered, pure, virginal places like this one, where the heartbeat of perfect wildness is strong. May such places always exist."

"Yes, may such places always exist," echoed Sera with tears in her eyes.

We turned from the grove and began our descent down the steep forest canyon. As I walked along, I couldn't help but despair over how many

glorious places have been destroyed in the ages of man. I asked silently, in the deepest way I was able, that Solace Grove not join the list. I dreamt forward to a time when such forests will reclaim some of their former ranges, a time when the circumference of the circle we left in the grove will be immeasurable, its center everywhere.

Off Limits?

After a very long and tedious trek through forest, swamp, and quila, we returned to our lakeside base camp at the foot of Hornopiren volcano. Inside the ruins of an old stone hut, we huddled around a fire and discussed the magical and wild emerald wilderness from which we had emerged.

"We can call such places sacred, but that is meaningless to corporations who see only money in the forest," I began. "Sacred places fall daily in the name of progress."

"We can probably achieve protection for Solace Grove," said Rick as he prodded the fire. "But I wonder, is simple protection enough for such a wild and magnificent place? Perhaps some places should be consecrated by our complete absence so they can evolve with zero impact by humankind. Shouldn't there be eco-centric wildlands where evolution and nature can reign free from man's interference?"

"Yeah right, Dad," pitched Sera sarcastically as she kicked a log into the center of the fire, sending a shower of sparks skyward. "How are you going to make that happen? How are you going to keep people out?"

"Such places would draw people like magnets," I added, "just *because* they had that kind of protection. There would always be those who would sneak in to Eden, for that's what it would be. Unless there was some impenetrable fence around it."

"Or...unless, unless..." posed Rick, "people didn't know the places existed. There are such places like that here in the deep south of Chile that have never felt a human foot upon them, so difficult and torturous they are to get to."

"You're right," I said, moving back from the fire's heat. "I've seen them from the air, but they're too small to be truly significant. Still, it is something that such places exist at all with over six billion people on the planet. Perhaps the next time around, when Mother Gaia has balanced our numbers, such a thing might be possible."

"And these little places can be the model for that time," said Sera triumphantly.

"And a prayer," I added, "a prayer that one day we will have the wisdom and generosity of spirit to grant nature large corners of Earth, true sanctuaries that can exist unmolested by any human interference whatsoever. Places where wild Earth can dream into itself and be whatever it wants to be."

If Evan Eisenberg had been with us he no doubt would have shared his eloquent perspective of "sevenths": "If the Sabbath is a wilderness in time, then wilderness is a Sabbath in space," he writes. "If we can set aside a seventh of our time for holiness—that is, for purposes higher than human aggrandizement—why not a seventh of our space?"[16]

Wilderness is the heart and soul of the world, and I would propose that one-seventh of Eisenberg's seventh be the sacred domain of only gods and animals.

Partly inspired by AFI's efforts and the photos of our trip, Esprit clothing magnate Doug Tompkins purchased, in 1995, 800,000 acres of temperate rain forest now protected as Parque Nacional Pumalin—the world's largest private forest park. Modest trails and facilities exist on its edges. The rest is protected by *quila*, cliffs, and obscurity.[17]

Chapter 6

The River Hoop

"Like a prayer wheel, I spin in the winds of time; in the downbeat of the mother, in the dark heart of prayer, I soak in the mystery. And I do this for you and me and everybody we know and those we don't know. It's my offering."

—Gabrielle Roth

Part One

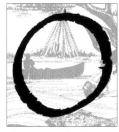

ccasionally life signals us so directly and with such synchronicity that our attention is pulled across the boundaries that often separate us from Earth. We are invited, it seems, to step outside what Mircea Eliade calls "the terror of history"—challenged to part the veils and gaze upon the magi. If only for a brief moment, these enchanting encounters are offerings to weave into the web of stories that contain the myth of our lives.

One day along the great river of the Pacific Northwest, which Indians call Chiawana and whites call the Columbia, a mysterious scrap of paper entered my life. Burned around its edges, a handwritten letter fragment randomly spared from flame, the paper held five words stacked vertically:

> spare
> breaking
> will
> good
> bad

Desperate Prayers

I plucked the message from a wind-beaten sagebush, then dropped, exhausted, upon the dunes of Squally Point. It was late summer and I had been windsurfing, struggling upwind in the Columbia River Gorge to reach a favorite spot. I had finally reached my destination, the rocky point sheltering a tiny bay, surrounded by sand dunes and framed by steep, orange and yellow lichen-tinted walls of basalt. Few know this place. It is far from the famous sites downriver visited by "boardheads" from around the world who come to surf the giant swells pushed against the river's current by strong, regular Chinook winds. It is not a wild place, but has the illusion of being such—the kind of spot treasured by all who struggle to hold a course with nature in the ever-expanding urban settings in which we dwell. These are private places to reflect and imagine, to pretend for a while that all is well in the world.

As I lay on my back catching my breath, I searched for personal significance in the words. They felt meaningful, but a message eluded me. I tossed the scrap back to the wind and fell into a short sleep. When I awoke, I walked out to the broken-down Indian fishing scaffold at the end of the point. The wind was raging, and continuous streams of sand blew ankle-high above the dunes, the soft, high-pitched sound of the blowing grains soothing, sensuous, and ancient. When I grew weary of the howling winds, I retreated to the lee side of the bay, which was protected by the dunes and the point's rocky outcrop. There I found, half-buried in sand, a discarded salmon hoop net, rotten, torn, and filled with debris.

All summer I had been collecting odd pieces of flotsam and jetsam along the Columbia, preparing to build an "eco-shrine" to honor the great river, now endangered in so many ways. As with other shrines and mandalas built and left on troubled ground, I was searching for shards, natural and human-made, that could be rendered into sacred art. Until this find, the river had not yielded anything dynamic enough to serve as a basis for a sculpture. The rusty iron hoop that held the net in place was teardrop shaped, about four feet in diameter. It was just the kind of object I sought—a modern version of a prehistoric fishing tool essential to the river people who have lived here for thousands of years. Hoop nets are still in use along the river at scaffold sites that are passed down among family members. Checking with a friend who lived across the river from Squally Point, I learned that this scaffold site had been abandoned for several years. The platform lay half-fallen into the river, ready to wash away in the next high flow.

I returned the next day by car to photograph the site, search the area further, and consider how I would get the hoop up to the highway at a later date. As I approached the dunes, I found the source of the mysterious

paper scrap. Within a broken circle of rocks, sandy remnants of a partially burned pile of letters were strewn about like shattered bone. I bent down for a closer look. My body went limp, as a ghost-like presence seemed to descend around me. Written boldly, in the same fine hand that penned the fragment I had found the previous day, was my name. I picked up piece after piece, and at the beginning of a note or on the front of an envelope was written Dan, or sometimes Daniel. After careful analysis, I concluded that the pyre was made by a jilted lover—Daniel, a young Native American. With this discovery, the compelling koan posed by the scrap I had found the previous day gained new import. I knew the hoop would become the centerpiece for my project.

I considered the letter fragment I had found, and the personal fit validated by the scraps of love letters. My own relationship was very stressed, and a breakup felt inevitable. The whole experience seemed a metaphor for the style of art that had taken root in my life: create wholeness from pieces, make circles from shards. A remarkable synchronicity was at play, and I wondered what would blossom from it.

Physicist David Bohm, writing about superconductivity, helps us to peek behind the veil into how synchronicities might appear in our lives. "...electrons cooled to a very low temperature," he writes, "act more like a coherent whole than separate parts. They flow around obstacles without colliding with one another, creating no resistance and very high energy. At higher temperatures, however, they begin to act like separate parts, scattering into a random movement and losing momentum."[1] In other words, when we are "cool" and "in the flow," signs, omens, and synchronicities are more likely to appear than when we are "overheated," rushed, or stressed out. On pilgrimages or special quests in the wild, our intentions are likely cooler and more flowing than during our everyday lives. Our sense of time slows, taking on a sacred quality. During such experiences, new doors may open. Committing to "just being" on the river, inviting the *wu-wei* mind wherever and whenever we are called to go deeply in nature, and to go slow once we are there...all invite the presence of invisible hands to guide us.

Deep in Ghosts

Pockets of old-growth Douglas fir and Ponderosa pine survive among the broken cliffs that surrounded my Washington home above the Columbia. I shared this space with them from spring 1990 to spring 1999. They were giant trees already 200 years old when Lewis and Clark passed

through in 1805, a little older when the last condor that inhabited the Gorge was shot by a settler. In the company of these venerable giants, the past has a palpable presence. Ghosts are everywhere. And no wonder—the mid-Columbia region (where I still live, although now on the Oregon side) once supported the largest concentration of Native Americans in North America. Not a day goes by that I don't feel them.

We are alive at a time when the full truth and magnitude of what we have done is clear. Just enough wild remains for us to fully comprehend the perfection and wonder that once was present on Earth—the beauty of humans and nature co-existing in a dance that honored the sacred balance. Our grandchildren, surrounded by fewer living reminders, perhaps will not feel such deep pain. They may not know the heartbreaking agony that pierces one with the recognition of living in such a profound absence…an absence punctuated with scraps of the venerable wild so close by. In this sense (and this alone, considering the kind of world they are likely to inherit), it may be better for them. Yet, I would not trade away this bittersweet kinship to a beauty so ancient and wild.

Aside from a few prominent cliffside trees, Lewis and Clark would scarcely recognize the modern Columbia River. Its 1,200-mile course from the Canadian Rockies to the Pacific Ocean is a pale shadow of its former grandeur. The river and its tributaries are like a sleeping giant shackled under slackwater pools, backed up behind millions of tons of concrete in dam after dam. Conquered by the Army Corps of Engineers, the river's flow is now controlled by technicians sitting at computers inside office walls. Only one fifty-mile stretch of the river's original bed survives—protected, ironically, by its course through the Hanford Nuclear Reservation. Here, along a bar in the Hanford Reach, is the largest remaining run of wild salmon in the entire Columbia Basin. The wild fall Chinook salmon spawn near the point where researchers suspect that underground radioactive plumes may one day enter the river.

Pilgrimage to "The Reach"

The big fall Chinooks were running when I decided to make a pilgrimage to the Hanford Reach. My first glimpse of the river was under starlight when—after driving many miles of rutted, rocky road—I stopped on the bluffs that overlook the grand, omega-shaped river bend that gives The Reach its name. The river stretched out before me. Beside it in the distance, Hanford's five abandoned nuclear reactors were softly lit, just barely visible.

The River Hoop

The sun had not yet risen and the eastern sky glowed warmly as I hiked along the bluffs in a howling October wind. I could see the large white forms of six trumpeter swans along a sandbar directly below me. Mt. Adams and Mt. Rainier rose up in snowy splendor on the western horizon, lit with pink alpenglow. As I neared the river I was startled by an unexpected sound—the sound of moving water, something you rarely hear on the Columbia (which acts more like a big lake than a moving river). But indeed, here the river was still alive! I could see the fast-moving current, and my ears joyously took in the gurgling sound it made as it moved across the rocks. I stooped beside the little rapid and dipped my hand into clear water. A bald eagle glided across the river a few hundred yards away and landed in the dawn sunlight on the bar across from me.

I stood and marvelled for many minutes. The river was bright blue—the most brilliant blue I had ever seen in an American river. The water wound around the white cliffs that descended abruptly to a reflection of sky. I had only a few hours to spend here, as I was on my way to points north—but the place felt magical, and I promised myself a return visit by canoe the following spring.

The Reach is both a museum of environmental destruction and ecological beauty...a place where time has turned back on itself. For fifty years, the area around Hanford has been off limits to the public, and like several other Department of Energy restricted sites across the country, such limitations have left native habitats more intact than in many of our National Parks.

One evening months later, canoeing down the Reach, I decided to camp on an island created by a thin channel that cut a strip of land off from the main flow of the river. Paddling down the channel, I scouted the island for a campsite. Suddenly, a big buck leaped from the island into the water ahead and began making his way across the channel toward the mainland. The world seemed to stop as the apex of our committed paths converged, two species of the same world, made of the same breath and molecules, alive together on the river aglow in the last rays of the setting sun. What message did we carry for one another? The stag passed before the bow of my canoe so closely that I saw the bright red orb of the descending sun reflect in his magnificent wild eye. He showed not an ounce of fear. I backpaddled the canoe to hold my position in the slight current, watching as he emerged from the water and stood, dripping, in the luminous warmth of the sun's final beams. We stared at one another across (what is for me) the heart-wrenching gulf that separates human from deer. Did his deer mind and soul feel anything of the sort? I doubted it. And yet, just before he turned to pass into

the brush, I felt the separation between us dissolve in a perfect moment of communion.

"Thank you," I said, "for your trust and your beautiful animal way."

I paddled in bliss to the island shore and looked for a campsite. The evening was calm. I found a small, sandy shelf behind a giant log that must have drifted into place when the river had been extremely high. It was a spot that afforded a 360-degree view of my surroundings, all five of the abandoned reactors, the river flashing blue-gray in the steely gloaming, the white cliffs downriver that I had first seen reflect the blue sky upon the water. I thought of my camp the previous night amongst shell middens of the Indians that had once inhabited the area. A broken mortar and other remnants of their stone tools were scattered about, and now this evening across the river, silhouetted against the southwestern sky, were the derelict reactors built during the Manhattan Project that supplied plutonium for the bombs that were dropped on Hiroshima and Nagasaki. What bizarre temporal intrigue! Thinking of the amazing juxtaposition of two very different cultures separated by a mere two hundred years kept me awake late into the night. There was a kind of grace here I had never before experienced, and I played a few sleepy bars of "Amazing Grace" on my harmonica before I let the wonders of the day slip away.

After packing the next morning I decided to walk to the island's western end to photograph the reactor directly across the river. There were scores of old iron fenceposts that ran helter-skelter across the western portion of the island. When I canoed down the channel the evening before, I noticed how these posts totally marred the stark beauty of the scene. I now spent several hours pulling up posts from the rocky ground. The loose, rocky soil yielded them easily, and each time I collected ten or twelve posts, I created a tipi. When I finished, six tipis stood upon the barren land. I decorated them with feathers, sticks, and cloth strips ripped from an old hunting vest found nearby. The little "village" felt so appropriate to the setting, and was such an improvement over what was there before, that I began to laugh.

"What a metaphor," I thought, as I sat down in their midst directly facing the desolate gray reactor across the river. Turning the hodgepodge of posts into a symbol for community was the antithesis of what the reactor represented. Community meant life, continuity, commitment, and cooperation. The old abandoned nuke across from me stood simply for an abuse of power—death and destruction beyond compare. My hope was that other river runners would sense this dichotomy and be moved to stop and enliven the "tipi village" with an occasional offer-

ing or prayer. Perhaps just passing by would bring a smile and ignite something beneficial within their hearts.

"When community appears, spirit descends," writes Louise Callen.[2] I broadcast my prayers softly to the sky, land, and river before I left. "May communities committed to living in concert with nature spread around the world. May the production of nuclear weapons come to a peaceful conclusion throughout the world. May we be shown a way to safely contain their deadly poison."

After a series of "accidental" releases in the 1950s, the Columbia was dubbed the most radioactive river in the world. The radiation from these discharges has since settled into sediments or washed to sea. While an underground plume from buried nuclear waste continues to migrate toward the river, extensive cleanup efforts are underway that will—hopefully—halt this threat. Today the river is most immediately threatened by clearcutting, pesticide runoff, overgrazing, dry land irrigation, and dioxin pollution from pulp mills. And, of course, the salmon-killing dams. Symbolic of the river's crisis is the growing panic at the salmon-counting windows deep below Bonneville Dam. Every year, it seems, fewer native salmon are coming home.

Gathering the Hoop

It was the plight of the salmon and the human-spawned war zone they face in their river migrations that fostered my deep need to create healing art for the Columbia. Along the shoreline near my home, I had collected rusty fence wire as well as yellow, red, white, and black rope from net rigs and boat moorings, nylon survey flags, pieces of cloth, and feathers. All were washed in a crazy baptism by the same water that massages the ancient petroglyphs and fishing falls now buried by the monstrous dams—the same water that passes by the Hanford Nuclear Reservation, that carries pesticide runoff, silt from clearcuts, and the effluent from pulp mills and aluminum factories; the same water churned by barges carrying logs and wood chips for export to Japan; the water shredded by windsurfers riding massive, windblown waves.

Sitting on the rocky bluff in front of my home, I could watch herons glide down to their rookery on Wells Island, the long-ago bottom land of the old river. Protected from development by the Columbia Gorge National Scenic Area Act, it is a wild and overgrown place, uninviting to humans. Sometimes I sail there and wander through the thorny forest

thicket, profuse with tracks and feathers. It's a small piece of wild between freeways and railroads, in the midst of the dammed, windblown river crowded with sailors. Yet on the island, there is stillness and quiet. The past feels close by. Within the willow, cottonwood, and locust forest, I gathered the feathers of owl, heron, vulture, and flicker for the shrine I would soon construct.

In September 1994, just before I found the hoop, the home of Cascade Klickitat Chief Johnny Jackson burned to the ground—by arsonists, he claimed. His place was located at the Native American "in lieu" fishing site at the mouth of the White Salmon River just below my cliff-edge home. His site was one of five thus far "given" to the Indians, "in lieu" of their many fishing sites sacrificed to the dam's drowning waters. On the banks of the river named for an extinct run of coho salmon that yearly turned the river white in their abundance, Chief Jackson's camp was a colorful collage of shacks, nets, docks, and old boats. I helped him quickly reconstruct his dwelling. From his junk pile of burnt refuse I rescued some fire-scarred feathers—remnants from his headdress—a few shiny conches, and half-burnt fragments of ceremonial cloth. With these ceremonial shards, the timing seemed right to gather the hoop.

It is good, I think, to steer our way in life when we can by natural happenstance and synchronicity: by celestial events, dreams, storms, and the sighting of animals, rather than arbitrary dates or holidays. I set in motion the act of gathering the hoop and beginning to build my shrine upon the first sighting of a bald eagle. The eagles who winter nearby were due anytime, but this one came unexpectedly in a dream. Riding a stormy night sky, it was larger than life and luminous as it passed over my seemingly roofless bedroom. I left the next afternoon in a driving rain for Squally Point, where the discarded hoop lay half covered with sand.

I pulled my truck off the freeway and walked the quarter mile to the site. Significant finds like the hoop require offerings. In our culture we are so good at taking, so forgetful of the gift of life on Earth, that we seldom pause to give thanks for the first flowers of spring, the meal before us, or the land that gives us a home. Daily, we have countless opportunities to offer thanks, and as we begin to do so, we reaffirm our fit in nature's pattern. Every culture has its method for showing gratitude and there is, of course, room for invention. Native Americans offer tobacco, cornmeal, or simple prayers to the four directions. I did something similar and gratefully placed feathers at the four directions and in the center of the hoop before excavating it from the sand.

Before leaving the beach, I paused to bury young Daniel's partially burned love letters which still lay half buried in the rocks and sand at the

lee of the bay. I covered the spot with a small pyramid of rocks. In the gloaming light I maneuvered my awkward load through the brush back to the truck, and again pondered the windblown scrap found months before:

>spare
>breaking
>will
>good
>bad

May You Always Return

Adjacent to my Washington home, on a cliff above the confluence of the White Salmon and Columbia Rivers, a narrow peninsula protrudes to a knife-like point where one can see twenty miles up and down the Columbia. It is a spectacular and sacred spot where generations before me surely stood in awe as they surveyed the river. The condors that once frequented the Gorge probably perched here with bellies full of salmon scavenged from the sand bars below. I would place the River Hoop at the tip of this point. It would be different from other shrines and mandalas left behind in other degraded regions to the vagaries of the elements and unknown visitors. This site would be cared for. It would be a place to celebrate the seasonal changes, to gather and drum with friends, to tie on a feather to mark the sunrise on my daughter's birthday, or the return of the winter eagles— something like the stone circle around the old white oak back on my Kansas farm. "We are bound to the Earth by a web of stories," writes author Scott Russel Sanders.[3] The River Hoop would help in their telling.

I shaped a large salmon out of thick, rusty wire and "floated" it at the hoop's center, supported by twirled wire extending outward in each direction. I wove colored rope along these directional wires, red for south, black for west, white for north, and yellow for east. On the morning of the winter solstice, I tied feathers and colored strips of cloth at each direction and fastened one of Chief Johnny's silver conches at the salmon's eye. At noon, carefully balancing my creation, I carried it to its position on the point and lit some sage to sanctify the hoop and its contents in their new guise. The dip net, a Stone Age invention, was now the River Hoop, my affirmation for the river's revival. My shrine on the point was a metaphor for the task before our generation. Bring the pieces together into wholeness. Reconstruct the broken fragments of our lives and our relationship to the Earth. Reweave the shards into circles, stronger than before.

I chanted, "May you always return, wild salmon, like the sun each morning. May humanity soon regain its balance with all life. May the great

changing come soon." I built a fire near the hoop and burned the old net and leftover fragments I had collected that summer. The sun came out momentarily, while brief gusts of wind played with the smoke, twirling it through the hoop, sky-bound.

The River Hoop faces east, upriver, in the tradition of the Indian bands who lived and fished here for thousands of years. Each season's first salmon was treated as if it were a high-ranking chief making a visit. Its body would be sprinkled with eagle down or red ochre. Formal speeches of welcome would be made and songs sung in celebration—all gifts appealing to the salmon people to continue their journey up *Chiawana*. Just as Christians believe that Christ, an immortal, came to Earth to be sacrificed for the benefit of humankind, so the River Indians believe that the salmon spirits ascend the river each year to offer their bodies for the sustenance of the tribes and then return the following year, on and on through the generations. After the ceremony celebrating the first salmon, everyone present received a piece of the fish to eat. Finally, the intact skeleton of the salmon was returned to the river where it was thought to revive, return home, and revert to human form.

In Lewis Hyde's marvelous book, *The Gift,* he describes the first salmon ceremony as "a gift relationship with nature, a formal give-and-take that acknowledges our participation in, and dependence upon, natural increase. And where we have established such a relationship we tend to respond to nature as a part of ourselves, not as a stranger or alien available for exploitation."[4] With the arrival of Europeans, greed replaced religious veneration, commercialization replaced gifting, and the salmon's decline began. As I write, the radio newscaster portends another species of salmon as endangered.

Dream Back Celilo

Wise ones could see it coming with the death of Celilo Falls, thirty miles upriver from the island. Radiocarbon dating indicates that Indians have occupied this site since 11,000 B.C.E., possibly making Celilo the oldest continuously occupied place in the world. "The village lay in the prosperous area of the jumping salmon where life was good and where the red men had time to contemplate on Life and God," states Captain Clark in his October 24, 1805, diary entry at Celilo Falls.[5] The forlorn fishing village that remains is a sad relic of what was once a "Jerusalem" of North America, where tribes came from great distances to trade, gamble, and celebrate. The salmon were so abundant, they sometimes turned over

small boats. Today of course, Celilo Falls is underwater—one of the world's spectacular lost places.

Craig Lesley, in his book *Winterkill,* describes the day in March 1957, when the Dalles Dam inundated Celilo Falls:

> ...some of the people refused to believe it could destroy the falls. The river seemed so powerful, and the falls had been there longer than anyone knew. Finally, the lake reached the base of the first falls, so the engineers in their hardhats and ties, and the politicians, lined up for pictures—the last pictures of the falls. Then I heard a high wail. It was even louder than the roar of the falls. All the Celilos had turned their backs to the rising water and were lined up facing the canyon wall. Their arms were crossed and they were chanting the Falls' death chant.[6]

Today, windsurfers and boaters ply the waters that flow above Celilo's eerie tomb. A simple marker notes the location of "old Celilo" at the beach park beside the freeway. It seemed a sacrilege to sail here, so I never have. The lost site fascinates me though, as it does most people. Pictures of Celilo Falls are almost cliché in the Gorge—on the walls of banks, hotels, cafes, even restrooms. It is as if the falls still exist, such an icon has their image become to this region.

One day I took my daughter Sierra, who was four, on a tour of the Dalles Dam—the dam that claimed the life of Celilo. She'd been asking about " 'lectricity." The little tourist train left every half hour and took us into the belly of the beast. We saw the fish ladders and the twenty-six monstrous General Electric generators which, our tour guide explained, "create enough electricity to power four cities the size of Portland." For several minutes, we watched for salmon on the fish-counting video screens, but we saw only shad. And then, before leading us back to the train, our guide showed us the petroglyphs. I was stunned. I had seen their likeness on T-shirts, jewelry, and in old photographs but had assumed they were underwater. There were about twenty of them on various-sized blocks of black basalt, blasted from the walls of the now-submerged Petroglyph Canyon—one of the largest concentrations of rock art in the world. Each was singularly elegant, large, and beautiful. A heart-shaped owl, an elaborate sunburst, a leaping salmon—all deeply and carefully incised. Obviously, the work crews had taken the best. Set upon cobblestone, they were protected by an ornate, waist-high, iron fence, and were framed like tombstones against the enormous white concrete of the dam that rose behind them. It was a scene that belonged, somehow, in the Holocaust Museum or, perhaps, a Museum of

Environmental Destruction. Few encounters in my life have been as sadly poignant.

On the fall equinox, 1996, I borrowed a kayak paddle and guided my windsurfing board into the middle of the perfectly still river to pay my respects to "The Falls." The late afternoon sun turned the paddle's ripples to gold as I moved slowly across the water. I had been present a month earlier when Chief Jackson stepped outside the Celilo Pow Wow longhouse and pointed out the exact location of the falls—a place he knew as a child. I stopped paddling when I arrived directly above the spot and sat quietly on my board in contemplation. The Indian name for Celilo was *Wyam,* a name taken from the sound made by the constant, pounding waters. I strained my ears to somehow hear at least an echo of the thundering falls that had roared for more than 10,000 years.

In my mind's eye, I pictured the Indians leaning from their precarious scaffolds, working their nets in a practiced motion honed by millennia of experience. I imagined the continuous leaping of salmon. I had brought an offering for this lost, sacred place. So, I let it drop. It was an ancient stone pestle found while planting a cedar in my yard. I had wrapped it with feathers, beads, sage, and a fragment from the letter pyre. The water was clear and for a second or two, I watched it disappear into the shadowy depths. "Forgive us, Mother Earth, for we know not what we do." I took some consolation in knowing that dams are only temporary impediments, and lay back upon my board. As the sinking sun lit the river red, I dreamed for a while of Celilo. It is a dream that won't go away.

Part Two
"Stay calm...be brave...wait for signs"
—Dead Dog Cafe Comedy Hour

Chief Johnny Jackson is an eloquent champion for the river he calls, with deep affection and reverence, "The Caretaker." Greenpeace and other groups pay his way to various environmental conferences where he shares pictures of the tainted, ulcerous salmon he has netted in the Columbia—victims, he claims, of chemical pollution. "The salmon will disappear if you don't respect The Caretaker," he states. He has been saying it for years. It's a tired story that haunts civilization.

Salmon preceded man on Earth. We know that *Salmo* (Latin for *the leaper*) was already a distinct genus when advanced anthropoid apes in Africa were slowly evolving into humans. Not far from where I live are

fossils of ten-foot-long ancestral salmon that ran North American rivers five million years ago. They have been around a long time. They're survivors. But can they endure the biological gauntlet they face today?

The dams take the biggest toll on salmon smolt heading downriver to the ocean, killing as many as ninety percent, say biologists. Each spring, fingerlings destined for the ocean are ground up in the turbines or are stunned when flushed through the bypass systems, thus becoming easy prey for squawfish. When these young salmon enter the still water behind dams, they become disoriented and weakened—another easy catch for predators. This problem has been "corrected" by the Army Corps of Engineers, which has made a mockery of one of life's most beautiful mysteries. They suck the young fish into tanks and barge or truck them downstream around the dams, dumping them back into the Columbia battered, traumatized, and often sick. A large percentage perish before they reach the ocean. For the "lucky" adults who survive mile upon mile of nets and the many natural hazards at sea, the pilgrimage back up the Columbia to their home stream is even more daunting. Dam after dam, more fishing nets and lures, chemical pollution, and finally—a habitat made increasingly bleak, silted, and barren by more than a century of rapacious logging, grazing, mining, and irrigation practices. "If you want to protect your rivers, first protect your mountains," cautioned the Chinese poet Chuang Tzu. If he were alive today, Chuang Tzu might add "and don't mess with the flow."

"The Northwest is, quite simply, anywhere a salmon can get to," wrote Timothy Egan in *The Good Rain*.[7] If only it were still so. Today, a more fitting description might be "anywhere you can buy salmon 'art'." Shops and galleries are teeming with artsy fish to embellish every nook and cranny of your house, office, and self. Salmon earrings, bolo ties, and belt buckles for the fashionable. Salmon pot holders and trivets for the home chef. Salmon swimming across shower curtains and T-shirts, decorating tote bags, coffee mugs, notecards, and calendars. We surround ourselves with salmon and are comforted by the renewal they symbolize.

Imagine if owning salmon art were contingent upon the collector taking some personal action to help wild salmon runs recover...say, writing to a representative or to the Bonneville Power Administration demanding that they screen their salmon-killing turbines *now* (something they were supposed to have done by 1989), helping to restore a degraded stream, or contributing to environmental groups who are trying to change the destructive forest practices that are silting our

salmon runs. For every ceramic or wood carved salmon, another action. The same for wildlife art of all kinds, and the aboriginal rock art so in vogue these days. Many indigenous tribes followed a code of this sort. It helped maintain vital links to the natural life-support systems that sustained them. Lacking such reciprocal connection, much of the art we display today dishonors the natural world we claim to love. Without this connection we may as well be adorning our homes and bodies with the imagery of pulp mills, clearcuts, dams, and factories—for surely this is what we revere through our complacency.

Hope Like a Coho

Wild salmon are the perfect totem for the Northwest and perhaps our culture as a whole. Despite everything we've done to betray them, wild salmon—though diminished in number—continue against all odds and return to their home rivers. Their hope is an insane hope, an unquestioning hope. There lies its power. To restore a forest, a river, or a prairie, to recover our earthly connections and make our way home, we must cling fast to the salmon's same insane and unquestioning hopefulness. As Northwest author David James Duncan puts it, "We must learn to hope like a Coho."[8]

Or like a River Indian. The old ways of the River People hang on in the scattered bands of Indians who practice their Seven Drum Washat religion and dip-net their salmon from cliffside platforms protruding here and there all along the Columbia and its tributaries. In the Treaty of 1855, the tribes reserved "the right to fish in all the usual and accustomed places," yet with each passing year it seems that fewer and fewer of the people fish. As salmon runs dwindle, these proud peoples must reach to greater and greater depths to resist the sucking homgenization of white culture. The stubborn and strong persist with a pride and conviction comparable to their beleaguered salmon.

It's something beyond hope that empowers the few who struggle to keep the old ways alive. "Hope," in the way we commonly use the word, is problematic, a bit of a sacred cow I think, and can work against us sometimes. It's a word we cherish and love to banter about yet when we really take a hard look at it we catch a glimpse of what a handmaiden it is in the perpetuation of the myth of progress that drives the industrial assault on the world. Derrick Jensen is a relentless warrior about the need for us to understand the problems associated with hoping. "The more I understand hope" writes Jensen, "the more I realize that it serves

the needs of those in power as surely as belief in a distant heaven; that hope is really nothing more than a secular way of keeping us in line. Hope is in fact a curse, a bane." [9]

Harsh words indeed! Ponder for a moment however, how hope keeps us corralled in a system of thought and organization which is undoing the Earth, how this word is essentially a longing for a future condition over which we have no control, leaving us in essence . . . powerless. Like most of us I would imagine, I have a hard time letting go of the word and use Jensen's view and others as a caution and a challenge to hope more like a Coho "hopes" . . . to simply trust in the Great Unknown. And then I let action follow on the heels of this trust. I think this kind of trusting in action is what gives power to the Indians that cherish the ways of old . . . and it can empower us as well!

I'm afraid it's all a semantics problem. Like "love," we have only one word for hope when in fact there should be many. Is it any wonder? English is the language of conquerors. When ever I feel the word rise up into thought or begin to exit my mouth, I have learned to pause and ask myself simply, "is it true that I really don't have control over this situation?" If I am sitting in an airplane and suddenly there is a lot of turbulence I might very well let the sentence form, "Gee, I hope this plane doesn't fall apart and crash." On the other hand, while considering the drought in my area recently and the lack of water for wildlife on the land I own, instead of saying, "I hope the animals will find water somehow" I said, "I'm going to install that wildlife watering station in the meadow that I have been putting off for so long." Examining how we use the word is an excellent way to see how we give away power unnecessarily. The system feeds on this.

We Didn't Come From Nowhere

"We didn't come from nowhere," explains Chief Jackson to a crowd at a local environmental fundraising event. "We've always been here, since time immemorial." It's true. Unlike most Indian nations that have been herded around and reorganized by war, pestilence and government intervention, the River Indians remain pretty much where they have always been . . . near the Columbia River. Chief Jackson's hair is braided in the old style, with two braids coming together as one, hanging upon his chest like a pendant. For the River People and for all Indians, their struggle is a struggle against forgetting. It can be won only by continuing to practice the old ways—the ceremonies, the feasts, the honoring of the salmon. Often disrespected as Natives are elsewhere, the River People are

plagued by alcoholism, poverty, and unemployment while children sit for hours in front of televisions made possible by forcing the great river into hydroelectric slavery. In the face of ubiquitous white culture, it takes uncommon courage to sustain their struggle. And always, they must witness the continual destruction and dishonoring of the natural world around them.

At Lyle Point, a basalt outcrop that juts out into the Columbia a few miles across the river from where I found the hoop, a small band of River Indians staged an illegal encampment for nearly a year in protest of the multimillion-dollar subdivision slated to be built there. Next to a few tipis and a sweat lodge, a sacred fire burned continuously. It was their line drawn in the sand from which they said they would never retreat. For several years lawyers battled the case in court as the Indians continued to fish from their scaffolds and hold ceremonies amidst lot signs and newly paved roads. With talk of the land once being an ancient burial ground (whether it was true could never be determined), a kind of hex seemed to descend on the place and no one seemed very interested in buying. Eventually the developers tired of the fight and sold the property at a loss to the Trust For Public Land who is now working in partnership with the Yakama Nation and the US Forest Service in the creation of a park.

Early in the occupation of Lyle Point, I donated my tipi to the group, pitching it near the sacred fire. One evening it was lit brightly by a lantern inside and I photographed it as a full moon rose slowly alongside, upriver. The scene was a potent image of renewal and faith that this site might one day be a place where something like Celilo could live on. As I watched the moon rise, I considered the paper scrap. I sensed a meaning beginning to emerge.

Points of View

On the windiest days, swells pile up nicely below the point where the River Hoop stands—a function of the underwater bar that extends from the mouth of the White Salmon River. Occasionally, while windsurfing off the crest of a wave, I have shared my leap with a salmon in the midst of its epic journey homeward. What ecstasy and honor to share a moment's joy with such a being! In the height of the summer steelhead run in 1997, I was hoping for such a moment. While windsurfing one afternoon, I glanced up at the cliffs and suddenly noticed with alarm that the Hoop was gone! I rushed home, and Christine related her unusual encounter. She had been reading by the window when an Indian man stumbled by, coming from the point. No one had ever approached the

The River Hoop

house from this direction, as the cliffs are treacherous and thick with poison oak. She went outside to confront him and saw that he was drunk. He began to rant incoherently about "that thing on the point." She tried to explain about "honoring the river and the salmon" but he would have no part of it. "This is our land and it doesn't belong there," he said, before disappearing into the woods. It was the summer solstice—light turning to dark.

The man was Pete Jackson, Chief Jackson's son. I soon learned that Pete had beaten up his father, then headed for the cliffs after a fisherman had called the police. Shouting obscenities atop the point, he heaved the hoop into space. Amazingly, the high winds and alcohol didn't take him with it. After hearing my wife's story, I walked out to the point. "Legally" this land was ours, but in his own way, Pete was right. We didn't *own* the land and the Hoop *did not* belong there.

I retrieved my sculpture a little bent, minus a few feathers, but still intact, and carried it to the highway below. I found Chief Jackson who was unhurt, and we loaded it into his pickup. As he drove me home, he mentioned that Pete had been "seein' things in the river." He was gentle and didn't seem too upset by what had happened. In the past, others had mentioned that Pete was a kind of visionary gone mad with alcohol. For Pete, drunk and belligerent, throwing the hoop off the cliff was an act of power, a way of righting the wrongs done to his people by mine. In a word, justice. I applauded his act, while condemning the violence toward his father. The tribal police soon found Pete and took him to jail in Yakima.

Reinstalling the River Hoop after it had been heaved into oblivion by a Native American led to serious reflection about my intentions with such art. What did the Hoop stand for? Healing power for the River and Salmon? A commitment to fight clearcutting in my watershed? For removing the antiquated Condit Dam on the White Salmon River, which blocks forty miles of wild salmon run? For a personal place to empower myself and my family? Were these valid reasons to place it there? Surely Pete had no understanding of my intent, and yet his symbolic act had likely gained him a kind of power and elemental satisfaction. Sensitive issues. Strange ceremony.

As the sun slipped behind the mountains, I attached new feathers to the Hoop, straightened the salmon, and set the structure back into place. The River Hoop symbolized my responsibility to fight for the health of my bioregion. It was a way to honor the sacred web of forest, river, sun, and fish, a way to dream back the salmon, the heart and soul of the Columbia River. I wrote in my journal that night, "No matter how much I despair over the pattern of stolen lands and genocide perpetuated by

141

my white forebears, this is where I am now. No amount of grieving can take us back for another try." To begin to set things right, there first must be a culture-wide shift of awareness. The River Hoop was my way to help chart this course. Perhaps heaving it off the cliff was Pete's way. I honored his act and the truth of it for him.

The necessity for change on a grand scale must somehow be made obvious to all, from Washington power-brokers to Wal-Mart shoppers...everyone. Is this possible? According to physicist Max Planc probably not. He wrote that "a new worldview does not triumph by convincing its opponents...but rather because its opponents eventually die, and a new generation grows up that is familiar with it."[10] However, massive life-threatening events that *demand* change could possibly do the trick as well, and engender an earthly respect long overdue.

One very windy day the following summer, I found myself considering this need for great change from a quite remarkable vantage point. While windsurfing alone on a five-mile downwind run that would end at Squally Point, I rested in the center of the river. The tugboat Dauby had just passed by, pushing a giant barge loaded with wood chips toward Portland. Each week or so the Dauby moves a piece of the forest away, sometimes as chips, sometimes as logs bound for Japan. Knowing about the unsustainable rates at which our forests are being logged always makes me sad and angry as I witness this loss going down the river. What makes it even worse is the immense, round, yellow and black happy-face painted on each side of the barge. Could anything be more symbolic of American oblivion to the impacts of our way of life on the environment and the world? From Walmart bags to barges, this ubiquitous "have a nice day" symbol is the perverted talisman of a self-satisfied culture asleep under the spell of corporate propaganda trading its connection to nature and community for stuff and distraction–the more and cheaper, the better–all else be damned.

Ahhhh, but what exhilaration to sail just past the Dauby's stern and try to negotiate the crazy, swirling chaos of waves, current, wind, and noise spawned by such an immensity barreling against the forty-knot wind-driven waves. This time it was too much for me and I crashed into the river, laughing. I surfaced among a scattering of chips churning in the gray-green water, the air redolent of freshly-cut wood and diesel as I watched the Dauby plow its way down the Gorge. I was exhausted and decided to rest.

Once the boat-generated chaos subsided, I floated at ease upon the waves, cradled peacefully between sail and board, buoyed by my wetsuit. On my back, mesmerized and relaxed, I gazed into the incoming waves. The red and mocha-colored Dauby disappeared in the trough of

each wave and appeared again at the crests, a bit further away each time. My mind drifted as a oneness with the river settled upon me. As the scent of diesel and chips dissipated, I began to think of the "great change" needed today, and the spectacular natural event that had carved the Columbia River Gorge.

During the final throes of the Ice Age, a little over 12,000 years ago, the Columbia took form with the catastrophic collapse of an enormous ice dam. The dam held back the waters of a vast inland sea known as Lake Missoula and when it burst, waters exploded forth at a rate ten times the combined flow of all the rivers in the world! Over 2,000 feet high at its source, this towering mass of ice and water charged toward the Pacific at nearly sixty-five miles per hour, scouring everything in its path into a maze of canyons and "coulees" visible from space. The event also created Dry Falls, the largest waterfall Earth has ever known. Recent studies of flood-deposited sediments suggest that the great flood occurred dozens of times, perhaps every fifty years or so until the climate stabilized. Geologists calculate that the approaching wall of water could be heard a good thirty minutes before it struck.[10]

Great change indeed! I had imagined this event many times standing on the cliffs near the River Hoop, but never while in the middle of the river. Surely hundreds of native people had witnessed the flood and died, but I wonder how many escaped to high ground and lived to tell the tale? I tried to picture a thundering wave, hundreds of feet tall approaching me from behind. What a great death to try to ride it! I could see the dunes near Squally Point and thought about the koan I had found there. Spare breaking. No way could such an event be spared! And the ice-dam broke again and again, creating the spectacular beauty that surrounded me…"every fifty years." Was I living in the midst of a different kind of breaking? The Ice Age is a helpful metaphor for attempting to come to terms with the impact of our own "human flood." I thought of the Golden Prairie and realized again nature's cyclic patterns of creation and destruction that come in such astounding forms and how they play, one upon the other, with divine chance and natural eloquence. Always beautiful. Always impermanent.

Thirty minutes later, I stood upon Squally's blowing dunes, with millions of hurling sand particles stinging my ankles. I realized that it is this very impermanence of form—be it sand dune, art, river, or relationship—that makes it so beautiful and so eternal.

I climbed up to the edge of the rocky cliffs that jut out into the Columbia. Multi-colored glass shards lay everywhere among the rocks, sand, and small, clinging plants, testimony to the site's appeal for occa-

sional wild trysts and river gazing. How long, I wondered, does it take for a piece of glass to return to its origin as particles of sand? Shards, dunes, bodies, forests...all of us are together on a shape-shifting journey through the universe. How we diminish our lives by measuring them in minutes, hours, days, and years!

A long tangle of heavy-gauge wire was attached to the rock with an immense iron eye-bolt. Now rusted and bent, the wire had supported the scaffolding where Indians once fished with the hoop. There was no trace of the wooden platform which had been torn from its mooring during the high spring flows a few seasons before. Serving the same end, however, was a long arc of white floats extending out from the point that supported a gill net which catches salmon in much greater numbers.

I stood at the prow of the cliff and leaned my full weight into the wind, which was howling and whistling through the wire. I stretched my arms out like wings and inclined my body far out, so that if the wind suddenly stopped I would have fallen into the river. This is a wonderful and thrilling exercise where the wind is strong and trustworthy...a kind of "wind-yoga" where one can use the pressure of the fast rushing air to play off as one would a floor or a wall. The balance and great trust required for this windy embrace can be deeply invigorating and healing, and is something sure to keep one grinning like a Cheshire cat the whole time!

After a few minutes, the tension and suspense of defying gravity over such a precipice became too difficult to sustain. I leaned back to a vertical position, broke down my rig, and carried it across the tracks and over the hill to the highway, where I hitched a ride back to my van.

The Koan Answered

Two years had passed since the Hoop was tossed off the cliff when, early one evening, I watched a brilliant rainbow appear off the point. It was perhaps the most vivid one I had ever seen. I photographed it through the middle of the Hoop, and when the colors finally faded and rain fell, I felt something well up inside me. I knew I was ready to decipher the enigma that had been riddling me for so long.

"Spare... breaking... will... good... bad." It seemed natural to form a sentence by adding words, so I did. "To spare breaking, by willing good, is bad." The koan became a Confucian-style admonition. As the prophecies from wisdom traditions around the world tell us, a major break is required for the continued life of our species. Scientists tell us this, as

well. Earth must act to relieve the stress caused by an organism that has overstepped its bounds. No doubt, the break will be painful. No doubt, our population will be drastically reduced. The balance must be restored. This *breaking* cannot be *spared*. And yet, what are the personal consequences of acknowledging this? How can we support this break and still find meaning and faith in our lives and for our children? Is *"willing good"* a form of denial that harms the deepest part of our selves?

Certainly on the surface it is easier to *"will good,"* to exist in denial, rather than to confront our despair for Earth and our future. *Willing good* is perhaps rhetoric instead of action, positive thinking (often denial in disguise), attacking the symptoms rather than the cause, t-shirt activism, the progress myth, short-term thinking, and "technology will save us" kind of notions. *Willing good* is a presidential Forest Plan, which only gives salmon runs a sixty percent chance of recovery. *Willing good* is akin to hope. *Willing good* is wearing salmon art but taking no action toward their recovery. Most of the time it is simply an avoidance mechanism, what we do when it's too expensive, painful, impractical, time-consuming, or politically unwise to do the *truly right* thing. In how many levels of our lives is this dynamic present?

Our First Nation Peoples say that we have entered a period prophesied by their teachings. It goes by many names—the Great Awakening, the Great Purification, Earth Changes, the End of History. It is a time to welcome, they say, for during this time we will have the chance to recover the sacred balance. Surely, as we gaze upon the degradation of Earth's ecosystems, upon the suffering of her creatures and people, we can see that great change is not only necessary, but our salvation. We have tremendous difficulty, however, in sustaining our gaze long enough to inspire real change—thus, we continue to perpetuate our own demise. Buddhist scholar and deep ecologist Joanna Macy puts it well. "As a society we are caught between a sense of impending apocalypse and an inability to acknowledge it."[11] The certainty that our species will have a future has been lost. This loss, felt at some level by nearly everyone on the planet, is perhaps the bedrock psychological reality of our time.

Suppression of our natural response to actual or impending disaster is a disease that seems to afflict civilization. It has crippled empires before us, and it may well claim ours. Although the Columbia River salmon runs are collapsing, the Bonneville Power Administration balks at the mandated screening of its dam turbines. A tiny fraction of our country's old-growth forests remain, yet the timber industry calls those who want to protect the rest "extremists." Our life-support systems across the planet are stressed and breaking, yet the overheated engine of

progress keeps on, those at the wheel delirious with power. In the meantime, most of humanity is oblivious, or simply content to watch the scenery as it grows bleaker and bleaker.

For me, the message deciphered from the paper scrap was a warning not to lose my resolve, to keep fighting, to resist the sometimes alluring opiate of complacency. We must welcome, even encourage the break. *"Bring it on!"* should be our cry. We can ease the transformation not by *"willing good,"* but by *doing* it, by *being bold and acting boldly*—surfing "the flood," so to speak. It is the kind of action that bubbles forth when we own our despair for the world and ready ourselves to act from within the heart of all we feel.

There was another message held in the koan that, try as I might, I could not deny. The words spoke clearly to my crumbling marriage. I could not "will it good" for much longer. A break was inevitable and seemed right for both of us.

Waiting for the Change

Novelist Lois Gould writes, "The purpose of life is to leave one's mark upon the cave. The *meaning* of life is revealed at the point where all our marks converge."[12] The River Hoop, the deciphered scrap of paper, my activism, and my marriage were all "marks on my cave" and their convergence was very real.

In her masterful work, *Dialogues with Scientists and Sages,* philosopher Renee Weber writes of her encounter with physicist David Bohm and his startling proposal that meaning itself is a form of being. She writes, "We are creating the universe. Through our meanings we change nature's being. Man's meaning-making capacity turns him into nature's partner, a participant in shaping her evolution. The word does not merely reflect the world, it also creates the world...what the cosmos is doing as we dialogue is to change its idea of itself. Our doubts and questions, our small truths and large ones are all forms of its drive toward clarity and truth. Through us, the universe questions itself and tries out various answers on itself in an effort—parallel to our own—to decipher its own being."[13]

Indeed. Four years had passed since I found the half-burnt scrap of paper hanging on the bush. For four years, it had floated in my mind before the universe helped me be ready to decipher it.

Journal Entry, 1998

Yesterday, another summer solstice came and went. To the River Hoop I added two raven feathers, found while taking a break from wind-surfing on Wells Island. Other offerings to the Hoop from celestial events and special days were ragged or missing from the relentless beating of wind, rain, and sun. I nestled in the rocks to drum and await the rising moon. As the last rays of sun cast *Chiawana* a cobalt blue, a bald eagle appeared in my line of sight, directly through the Hoop. It was flying downriver, just a few feet above the water. A wave of warmth flooded my body as I followed its flight out of sight. Never before had I seen a bald eagle here in summer. It seemed a good omen.

Five years have passed since my last River Hoop journal entry, and there is some good news to report. After many years of effort by environmental and recreation groups, state and federal agencies, and Indian tribes, a dam removal agreement has been signed with PacifiCorp—the owner of Condit Dam on the White Salmon River. The dam is set to be removed in the year 2008. Hanford Reach was set aside by President Clinton as a National Monument. And finally, coho salmon numbers are higher in 2001 than they have been in twenty years—due primarily, according to some reports, to new restrictions in coastal netting practices and the diminishment of the El Niño cycle. And yet, on the other hand, King Salmon which spawn on the Hanford Reach are at their lowest numbers in history.

Christine and I divorced peacefully and sold our house at the confluence of the two great rivers. The new owners had read a version of this story and said they would take care of the River Hoop for as long as they owned the house. (I was very glad about that.) On moving day, I took my two children out to The Point one last time. Having grown up next to this cliff, they showed no fear as we sat on the ledge that dropped abruptly into space. The River Hoop rose before us. I set down an old teapot full of feathers. "Each feather we sail through the Hoop will be a prayer or a 'thank you,' okay?" I suggested. They agreed excitedly, as I sailed the first turkey feather through the salmon shape. "This one is thanks for the blessing of being able to live in such a wild and wonderful spot," I exclaimed. It was Sierra's turn. "This one is for the salmon," she said, "may they always find their way home." "This one is for the Columbia," said Nick, as I lifted him up so he could toss a hawk feather through.

We had fifty feathers or so, and after releasing the first few something

truly wondrous began to happen. Once we sailed them through the Hoop, certain feathers began to spin upward on the breeze as if by magic. It was an absolutely beautiful sight to see. Certain kinds of hawk feathers seemed to have this "helicopter" capacity, and when we selected one of these, we said an extra-special prayer. Two red-tailed hawks flew in from the east and floated above us for a while, high overhead. Utterly enchanted by it all, we watched as many feathers climbed to the sky, floating and twirling slowly toward the hawks on an updraft. We stared until they disappeared from view.

"How high will they go, Daddy?" asked Nick. I shook my head, smiling. In awe, Sierra proclaimed, "God's gonna answer those prayers, that's for sure."

Chapter 7

Indecent Exposure and the Search for Picture Perfect

"Kodachrome,
give us your nice bright colors
give us your greens of summers
makes you think all the world's a sunny day
Oh yeah..."

—Paul Simon

uring the time I began to create healing art in endangered landscapes, I started thinking about the impacts of all the beautiful nature imagery constantly before us in our society. As a photographer, I was producing some of this imagery myself—and I began to ask some big questions. What were the true impacts of all this imagery? Might there be a relationship between the ever-expanding deluge of beautiful nature depictions and the environmental complacency of the Western world? I began to wonder if perhaps it was time to put my camera away, and I wrote an essay on this topic that was published in the quarterly journal *Wild Earth*. I include the essay here (slightly updated), because it asks the question that inspires this book: How do we declare sacred ground in our lives?

Sometime in the past, we could be educated and stimulated to protect nature by viewing its magnificent imagery. This was true for me, growing up under the tutelage of my father. The wonder of nature in the photographs I viewed was balanced by my dad informing me about what was

happening to the natural world. These were the days of Ansel Adams activism and Sierra Club exhibit format books. Since then, the production and consumption of nature imagery has become big business, and as depictions multiply in print and film, in our homes, and even on our bodies, real nature is disappearing...fast.

It is a curious aspect of humanity that we love to display what we have conquered, or are conquering. Images of wild nature and indigenous art have become the *motif de rigueur* in American decor. Native artifacts and imagery adorn lavish lodges, built on grounds once held sacred by peoples now shoved aside by industrial society. Earth-wrecking corporations like General Electric, DuPont, Weyerhaeuser, Standard Oil, and scores of others trim themselves with romantic, picture-postcard imagery. Such corporate "greenwashing" is designed to promote blind acceptance of their products by a public connected more to glossy, electronic, and knickknack representations of nature than to the real thing. Day by day, it seems, we grow more content with fakery.

From a narrow perspective, photography is easily justified. It provides a means to document events, record one's family history, study nature, enjoy fine art, gain a sense of the hunt, etc. We all agree that the camera is a wonderful thing. The point of this essay is to consider the cost of this wonder, and to examine the impacts of photography from the larger perspective. The ideas brought forth here will not be popular. Nonetheless, as all technological tools need to be carefully scrutinized, so must the camera.

Eye Candy

Eighteen years ago, social critic Susan Sontag took photography to task in her germinal book *On Photography*. In it she suggested that a society becomes "modern" when images are themselves coveted substitutes for firsthand experience.[1] And now, we *post*-moderns may be so well equipped with fine photographs of our environment—a duplicate and more accessible world of images, enduring and always beautiful—that acting to preserve our natural world has shrunk in importance. It is time to ask just what the massive proliferation of imagery has done to our consciousness.

The psychologist and writer James Hillman has said that our ability to experience the beautiful is what separates us from animals. And yet, have mass quantities of exquisite nature imagery ("eye candy," as pho-

tographer Jim Balog labels it) tainted our ability protect the natural world which sustains us?

I believe that indigenous peoples' suspicion of the camera may, in fact, be justified, for photography does indeed steal an essence from life. We have crossed an image threshold. We are now so inundated by depictions of the intimacies and majesties of nature that our ability to appreciate its everyday facets, the very facets that sustain us, has been severely damaged. Under an assault of imagery that has turned nature into commodity, entertainment, and advertising ploy, our capacity to enjoy truly ordinary yet miraculous realities atrophies daily. The over-imagery of nature has been instrumental in turning the environment into something out there—*the* environment, rather than *our* environment.

Of course, I'm speaking in generalities. Many of us have been stimulated through photography to seek the joy and beauty of "backyard nature" and to revel in the wonders of local valleys, streams, and plains. I am one who has, and sometimes making a wondrous image *seems* like the deepest expression of my love for Earth. Unfortunately, however, the number who have been stimulated by photography to delight in commonplace wildlands is small. Most, I believe, are caught in a deluge of imagery that has deepened the complacency and denial already ingrained in our society by fostering an attitude of "if-it-looks-that-beautiful-then-everything-must-be-ok-out-there."

Certainly there are exceptions. Early photographs of wild America played a key role in stimulating Congress to establish our first National Parks, and some imagery might still play a similar role. Shows like *Flipper* and *Free Willie* have helped lead to "dolphin-safe" tuna and an appreciation of whales. In larger terms, however, such appeals have failed. On the jacket notes of *Clearcut: The Tragedy of Industrial Forestry,* arch-environmentalist David Brower admits that whatever love of nature the many Sierra Club books stimulated, it was not enough. "The beauty and prose and images may have been too tranquilizing," he writes. " 'Look how much there is! Surely it is inexhaustible.' " In *The Age of Missing Information,* Bill McKibben notes that, "while virtually everyone in the industrialized world has a television and has presumably, if only by accident, seen many hours of gorgeous nature films...we're still not willing to do anything very drastic to save that world."[2] Essentially we visit nature as tourists, and while we don't damage the land as a mining or timber corporation would, we still do pretty much what they do—we value the land for one of its extractable qualities: beauty.

Picture Perfect

The notion that we gain an understanding of nature by viewing imagery of it is an illusion. What we really acquire, asserts Susan Sontag, is "an acquisitive relation to the world that nourishes aesthetic awareness and promotes emotional detachment."[3] Indeed. For most Westerners it seems that nature has become a place to visit—a park, a zoo, a CD-ROM, a video—or an image to view on the wall or a glossy page.

"Most of today's nature photography is a form of benign neglect," asserts environmental videographer and biologist Sam LaBudde.[4] LaBudde's shocking images of dolphin slaughter by the tuna industry so evoked our love for these mammals that we can now purchase "dolphin-free" tuna at Safeway. "Every species on this planet has been photographed to death," he adds, "while species extinction continues unabated." He goes on to argue pointedly, in a 1996 North American Nature Photography Association newsletter, that "nature photographers are doing a disservice to wildlife by photographing everything so picture-perfect."[5]

Over-exposure to imagery of "picture-perfect" nature has made something wonderfully precious too familiar; and we know, as the old saw goes, what familiarity breeds—if not outright contempt, then passivity and boredom. While surveys show a clear majority of the populace in favor of strong environmental regulations and safeguards, such sentiment fails miserably when it comes time to vote. Over-imagery may contribute heavily to this distressing situation. "Seeing" the bears, the forests, the salmon on TV or the printed page may somehow circumvent the need to act on their behalf. Herein, I believe, is a big reason why the environmental movement fails to achieve a critical mass. "What's to worry? The forests are fine. I know, I 'saw' them last night on Channel 4." For too many, "viewing" is believing. For too many, virtual reality is just too real.

Are we being weaned from nature, step by step? Have we become "image junkies," addicted to speed-viewing a world so shaped by moving pictures that when we do experience a forest, a desert, or an ocean, we are often disappointed? Seemingly, we expect nature to perform for us as it does on TV and on pages of fabulous Kodachrome. In reality however, most of the time it simply moves "too slowly" and thus, for most of society the sofa has replaced the vantage points of forest trail, mountaintop, and meadow. When we go outdoors we often mediate our experience by collecting images of it, becoming tourists when we could blend into a more intimate wildness. "I feel it whenever I stop at a scenic overlook, and I see it in other watchers," observes environmental writer John Daniels in an *Audubon* magazine article.[6] "I rarely *see* enthusiasm or even animation,

but mostly bored children and impassive parents showing the scenery to their cameras and video recorders."

Shaped By Spectacle

Photographs quickly set our modern standards for beauty, and thereby, for what should be cherished and protected. Perhaps our National Parks would harbor more biological richness and less "rocks and ice" if our notions of what is beautiful had not been so shaped by the photographer's love of spectacle. While the "intimate landscapes" characterized by Elliot Porter and a few others are a refreshing departure from the spectacular, mostly we have been taught to crave the grandiose, the uniquely lit, the exceptional.

"When do I see again the spectacular?" chides deep ecologist Arne Naess. "In the long run such a person mostly will develop an urge and need for the spectacular and a decrease of sensitivity."[7] A continual flow of picture books and calendars of spectacular places may help us to appreciate the beauty of Alaska, Utah, Yosemite, or other places, but they may diminish our ability to cherish (and thereby protect) the less majestic, but no less important, splendor of our local ecosystems.

Photography may be the Western world's "sacred cow." We prize it because it offers a distraction and refuge from what we fear the most—our impermanence. Surrounded by "frozen-in-time" imagery, we sink into a cult of delusion, sustaining the pretense that by grasping onto things, by collecting and consuming images, by purchasing whatever is new, we can somehow refuse death. Ironically, by leading us away from real nature, the camera may be helping to hasten—on a grand scale—the death we try so desperately to deny. Indeed, the camera is likely a handmaiden in the industrial rush toward the abyss.

Like many powerful technologies, photography is a double-edged sword, a sword honed razor sharp by the corporate technocracy that daily wields its industrial worldview through the media and in advertising— homogenizing cultural uniqueness, leveling biodiversity, and severing our natural connections to Earth. Sontag's explanation of how photography serves industrial society is even truer (now that the craft has been wedded to the computer) than when she wrote it eighteen years ago. She states:

A capitalist society requires a culture based on images. It needs to furnish vast amounts of entertainment in order to stimulate buying and anesthetize the injuries of class, race and sex. And it needs to gather unlimited amounts of information, the better to exploit natural

resources, increase productivity, keep order, make war, give jobs to bureaucrats. The camera's twin capacities, to subjectivize reality and to objectify it, ideally serve these needs and strengthen them. Cameras define reality in the two ways essential to the workings of an advanced industrial society: as a spectacle (for masses) and as an object of surveillance (for rulers). The production of images also furnishes a ruling ideology. Social change is replaced by change in images. The freedom to consume a plurality of images and goods is equated with freedom itself. The narrowing of free political choice to free economic consumption requires the unlimited production and consumption of images.[8]

When photography began to interface with the computer, all the rules about making photographs flew out the window. Adobe Photoshop software (and the like) erased the line that separated painting from photography, and forever suspended photography's unique and ironclad claim to art as document. Our trust in a simple photograph as an objective measure of truth is now gone. Sadly, however, our history of viewing photographs as representations of truth is so pervasive that it will be many, many years before this reality catches up with society as a whole. "The camera does not lie" is a premise we now know to be false, but it is so ingrained that we choose to half-believe it anyway. That is why books like *Migrations* by popular nature photographer Art Wolfe are so dangerous to our thinking about the state of the natural world. In many of the book's images, the wildlife has been digitally cloned and multiplied. Nowhere in the book did Wolfe mention that he added animals not present when he clicked his shutter. *Migrations* is merely the tip of the iceberg in a media-created version of nature, which unfortunately is what the general public has come to accept as "truth."

Shock Tactics

Countering this trend and in the tradition of war photographers, a league of cameramen and women began to document industrial society's impact upon nature in an effort to awaken a deluded and over-imaged society. So disturbing and powerful were their images of savage clearcuts, belching smokestacks, and pathetic trapped animals that such "shock tactics" became the favored weapon and fundraising tool of nearly every environmental group.

For a while, such imagery seemed to work. Sam LaBudde's images of dolphin carnage, for example, were effective. On the other hand, hun-

dreds of clearcut photographs—including a widely distributed one of mine depicting the border between cut and uncut forest—have led to relatively little change in forest policy. While Big Timber is certainly stronger than Big Tuna (and dolphins have a "warm and fuzzy" appeal), nonetheless, the neutralizing tendency of over-imagery continually disarms our visual cannons.

Many of us remember the images that may have helped to end the Vietnam War: the young, terrified, naked girl running from the bombed village, and the gun-to-head Viet Cong execution. We remember them because they were the first of their kind to be splashed across world media. But despite strong initial effects, the pictures wear thin after repeated viewings. It is as though they become less and less real. Whether war footage or clearcut forests, the wretched becomes ordinary, inescapable, "just photographs."

Via the camera, we recognize everything but rarely *see* anything. To a public over-glossied and imaged-out, a public that has seen it all over and over again, our counterfeit familiarity with a planet everywhere in danger has made us jaded and less able to respond in meaningful ways. We would be wise to reexamine the relationship between our cameras and nature while there is still a natural world to photograph.

A *Deep Photography* Ethic

I believe it is time for nature photographers and filmmakers—whether professional, amateur, or casual—to embrace a new and deeper relationship between the camera and the natural world. The ethics of nature photography (among the minority of photographers who even consider such ethics) have traditionally centered on issues relating to the "sporting" aspects of documenting the wild. Certainly, baiting coyotes with dog food, spray painting pet ferrets to make them look like their endangered cousins, portraying captive animals as wild, and getting too close to bears or mountain goats are all unethical and need to be condemned as such. But the profession's ethics need to advance beyond consideration of these obvious sins.

The Nature Photographers' Code of Practices, a British publication, lists one strict rule that must at all times be observed by the nature photographer: "The welfare of the subject is more important than the photograph."[9] While this is an apt credo that would prohibit digital manipulation as in *Migrations* and the abuses listed above, it fails to address the deeper impact of the images we make—the impact on soci-

ety and our relationship to nature as a *whole*. If over-imaging the world furthers our separation from nature, then something is inherently wrong in our covenant with the camera.

Hunting for images with our cameras can be viewed as a modern equivalent of primitive hunters stalking their food. When indigenous peoples killed their prey, they honored the animal as a gift. They prayed, gave thanks, or left offerings, believing that if they did not, future animal "gifts" might be withdrawn by the creator. The pictures from the wild that we take home—our "camera-kill," so to speak—are gifts as well; we compromise nature when we fail to honor the source of our images. Casual, disconnected picture-*taking* from the natural world is a form of consumption that helps neither ourselves nor nature. On the other hand, when we develop a frame of reference greater than the borders of our viewfinder, our relationship to nature is enlarged. A true communion with the wild can happen when we discover ways to give thanks for the gifts we have been given through our camera lens.

There are many ways to show our gratitude for the imagery that has been gifted to us. We can write a letter to the District Ranger expressing our alarm about the clearcutting or overgrazing we witnessed in a sensitive watershed, or to our congressional representatives in support of proposed wilderness legislation that would benefit the region we photograph. We can donate money and/or time to a grassroots environmental group. We can give a slide show about the problems of the region and encourage others to help. At the very least, we can pick up trash from the land we photograph. By reciprocating in such a manner, we properly honor our prey, the beautiful image. Our hunt will have been successful in the fullest sense, for both our spirit and nature's will have been fed.

Simply put, a deep photography ethic entails a reciprocal relationship where *the subject one photographs is honored by some manner of advocacy on its behalf*—our taking can be balanced by our giving. We can extend this ethic to the photographs and wildlife art we purchase for display. If it's nature and we watch it, hang it, wear it, or put it on a shelf, *let us in some way act* on behalf of the subject! My heart fairly bursts as I ponder the impact of a good portion of society adopting this ethic! It's not so far-fetched. After all, it approximates the perspective of native people's holistic relationship between art and nature. One did not casually display a bear on his shield or a buffalo on her tipi without first, and many times after, paying tribute to that being. To do otherwise, to treat nature as simply ornament or entertainment, was unthinkable.

Honor the Original

Years ago, a favorite Tallgrass Prairie shot of mine showed up in an advertisement for a farm chemical corporation. I was mortified to see the image of a place I dearly loved being used by the agribusiness mindset that had helped destroy it. Quickly, I withdrew all my images from the stock agency that had them.[10] I could not stomach the thought of an image I had captured of the wild being paired with any product that would help hasten its own demise. In a moment, I learned the importance of honoring the *original*. It was then that I decided to become strictly an environmental photographer.

To professional photographers, the original slide is sacred. If we capture a really unique and special moment on film, we make numerous duplicates, store the original electronically, lock it in a safe in a temperature- and humidity-controlled room, and never, ever loan it if we can avoid doing so (and if we must part with it temporarily, oh, the forms we make the borrower sign!). The original slide is very valuable, but—what about the true original?

We can honor the original by refusing to make our images available to corporations wishing to "greenwash" their environmental impacts, and by not allowing them to be used in advertisements that promote products destructive to the biosphere. Nor should we make them available to "image merchants" who pimp our photographs to whomever comes knocking. Rather, we can find agencies that allow one to apply a screen in determining where and to whom our images are sold.

We practice the *deep photography ethic* by telling the whole story. Shooting a few images of the clearcut beside the forest, the cows across the road from the elk, or the air pollution in Yosemite, and sharing the entire truth with our viewers, will go a long way toward suppressing the "everything-must-be-ok-because-it-looks-so-beautiful" illusion portrayed by the cropped and digitalized views of nature so prevalent today. Professionals must press editors to quit displaying nature out of context, because stock agencies, photo magazines, and television networks are all—sometimes unwittingly, sometimes intentionally—engendering a great distortion by selectively controlling the imagery in their hands. Some photographers have told the whole story well: Gary Braasch with ancient forests of the Pacific Northwest, Galen Rowell with Tibet, Robert Glenn Ketchum with the Tongass National Forest in Alaska, Peter Beard with African elephants, and Godfrey Reggio with Western civilization itself. These creative professionals helped to galvanize deep thinking and activism by balancing the beauty with the "beast."

Desperate Prayers

The camera-toting readers of nature and photography magazines represent a large number of badly needed advocates for the diminishing natural world—as do all occasional sofa-bound souls who love *Nature, Nova,* and *National Geographic* specials. I'd guess that includes most of us.

An Ecology of Images

While photography does help win occasional environmental battles and will continue to be an important component in the activist's tool chest—like computers, fax machines, and other industrial means of communication we use to spread our message—the inherent cost of our unwitting acceptance of these technologies is staggering. In her essay "A Thousand Words," Alice Walker declares that "human beings are already cameras, and that adding a second camera to the process of seeing (and remembering) shallows, rather than deepens, vision. When the TV commercial declares Kodak 'the nation's storyteller,' I shudder, because I realize our personal culture is about to become as streamlined as our public."[11]

At this point, the best we can do is to mitigate photography's harmful aspects by using the camera strategically. Effective purists are rare, and I am certainly not one of them. Yet, we must constantly battle to draw the line in our own lives. With regard to photography, we can begin by pausing before we grab our camera, asking ourselves questions that can easily be extended to the depictions of nature we view and buy:

1) Considering the effort and resources required to make this image, do I really *need* it or am I just collecting another pretty place (family moment, etc.)?
2) Will this image help somehow to protect this place, this species, my/our connection to nature?
3) What opportunity is present for my gifting back to nature? Will I follow through and do it?
4) Can I tell the whole story here, and if so, will I share it with others?
5) Can I photograph without impacting the health of this place or species?

When we cannot answer "yes" to these questions, we might choose to leave our cameras behind. I have discovered great joy and freedom after making the decision to leave my camera at home, as though a burden were released. And because most often I go without a camera, when I do bring it along the images I make and the process of making them become

160

more powerful and significant. I am only a part-time professional photographer however, and I realize that it might be difficult for one to make one's living while fully engaging the ethic discussed here. In this respect, the business of photography, like the business of living, necessitates individual decisions about balance, ethics, and ecological impact.

We are not likely to have much success with these issues unless we can take a deep photography ethic into the mainstream. Sontag signaled the need for such an ethic at the end of her book: "If there can be a better way for the real world to include the one of images, it will require an ecology not only of real things but of images as well."[12] Who will lead us to a place in this balanced ecosystem of imagery? Professional photographers are the obvious choice, but are likely to resist because these issues strike deep in the pocketbook. We each can begin, however, by looking deeply at our relationship with the camera and the imagery we consume.

This is challenging. And yet it seems to be—in the words of Castaneda's Don Juan—"the path with a heart," for almost certainly the other path is inclined toward the abyss. To walk firmly on this path will mean answering the question that everywhere plagues our society: How do we connect the impacts of individuals (in this case, the impacts of image viewing and making) to the health of the whole, and in turn, to the health of each of us and our children? Wendell Berry offers the best advice I have found: "The only real, practical, hope-giving way to remedy the fragmentation that is the disease of the modern spirit is a small and humble way: one must begin in one's own life the private solutions that can only in turn become public solutions."[13]

Art in a Dangerous Time

Throughout human history, the arts have traditionally been a means to envision our future. Today, unfortunately, the most alluring visions we encounter in the course of daily life are often the advertising messages promoting a consumer culture. Each day, adept and talented artisans employed by the corporate world manipulate highly technical tools to stimulate our senses. Even as we teeter on the brink of various ecological, financial, and sociological disasters, the sophisticated aesthetic of commercial art continues to promote an unsustainable way of life. This ethical lapse is so entrenched that it spills over into the artistic preferences of our society as a whole: art that affirms the status quo and is a safe investment. As is the case with photography, there has never been a more vital time to examine the role of art in our society than right now.

According to art critic and writer John Lane, we have reached an "artistic crisis" and need to attempt a new art. Lane writes, "The five-hundred-year-old Humanistic tradition of art for the elite, art cut off from society, from nature and the sacred cannot serve the needs of our future society."[14]

In the last 500 years, connoisseurship has traditionally determined the value or worth of an artwork. The identification of artist, date, medium, style, and provenance—all factors which lie "outside" the actual work—determine the work's value. In other words, the label is the important thing; the label, and the notion that all measure of "worth" is defined by dollar value.

Art that is incapable of being collected, like the work of ecological artists now blossoming throughout the world, has virtually no value in a capitalist economy. "There is something in the concept of anonymous creation without expectation of profit that seems to cause reactions which border between anger and fear," writes Virginia MacDonnell in her essay, *The Natural Value of Art*. "How do we assess the 'value' of an artwork which consists of flower petals, meticulously arranged on a leaf, and then set afloat on a pond's gentle surface? How can we assess the merits of a structure made of branches and vines or that's been carved in ice, and left anonymously in a field or park?"[15] The whole realm of ecological art cannot even be discussed in the vocabulary of the mainstream art world.

"There is no great art that is not spiritual—at least in its effect, if not its intent," writes John Perreault in *Design Spirit*. "Everything else is merchandise. The purpose of art is spiritual and is, in a word, revelation."[16] Unlike most cultures throughout the ages, we are generally uncomfortable assigning to art the role of medicine, magic, or myth. Instead we turn to doctors for health and healing; plastic surgeons, inventors, and entertainers for magic; and we leave myth-making to Hollywood and Madison Avenue.

The predicament of art today—and certainly it is a predicament if it is essentially furthering an unsustainable future—directly parallels the prevailing cultural attitude toward the natural world. Humankind has long disregarded the value of nature and the economic services it provides for free. What is the value of clean water, pure air to breathe, wildness? We cannot measure them until they are gone, in which case they become priceless. Generally, unless we can process and profit from it, we give such things no real value. So it is with ecological art. Despite our cultural bias toward museum and gallery-based art, forms of art that reach back to a time when art was a part of everyday life—when everyone was an artist—will continue to thrive. Why? Because such work speaks to the

core of who we are as authentic human beings, unplugged from the corporate juggernaut, connected to nature, truly alive. No wonder such art is often treated with "anger and fear," as MacDonnell writes; it calls us out of our comfortable denial.

It is a sad fact that the need for art today is satisfied primarily through consumerism, that market forces so often dominate our creativity. We must always remember that being an artist is much more about simply creating than it is about being able to sell artwork that we produce. We each have an instinctual need to create, and create we must. It is a big part of the homeward path toward the full expression of our ecological selves.

Purge the Excess

As a photographer and an artist, I have struggled with the dissonance raised by these issues. There was a time when I dreamed of "the" image that would somehow cure our industrial disease. Haah, my naivete! Such a remedy would certainly fail, for it would be only a photograph.

Even the uniquely precious satellite image of our "Blue Planet" did not reverse our destructive behaviors. While initially this startling photograph generated a wave of planetary love and Earth Day hoopla, its essence has been neutralized in over-imagery and now may serve more to distance us from Earth than to deepen our connection. Wolfgang Sachs comments on the ambiguity of this image in *The Ecologist:* "In our position as observed, we are humbled; in our position as observers, we exalt ourselves."[17] Photography has created "the planet as object," and the exaltation of this view has ushered in a new age of technocratic ecology in which humanity's leading role is that of observer, planner, and manager (i.e., consumer) of Planet Earth.

As Virginia MacDonnell points out, it would have been impossible for Leonardo da Vinci or Picasso to imagine that their roughest scribbles would have more monetary value than just about any work by an artist today, post-modern or ecological. In the same vein, it would have been impossible for Louis Daguerre, in 1838, to anticipate how photographic images would one day consume nature. In an advertisement soliciting investors he wrote of his daguerreotype that "it gives her [nature] the power to reproduce herself." He was right beyond his wildest dreams, but he could have little imagined the degree of jeopardy in which The Original was thereby placed.

No, photography cannot save nature. Nor can it save us from ourselves; more likely a story, a revolution, or a meteor. While image prolif-

eration and art disconnected from nature will surely continue, we can look deeply at what these media truly serve and begin to resist their allure. Doing so will strengthen our sacred bond to Earth, and for those of us who photograph, will help us use our cameras more strategically and begin to develop an "ecology of imagery."

We can defend ourselves against the effects of over-imagery and consumer-oriented art by finding ways to purge the excess. Purchase fewer magazines and picture books. Don't buy art unless it is connected in a deep way to some manner of positive social change or protection for the natural world. Eliminate television. Look again at the depictions of nature hanging on your walls. Are you an advocate for that place, that animal, those trees? Use your camera sparingly. Go outdoors as much as possible. Get to know your hillsides, valleys, forests, rivers, and back yard. Resist the imaged wild. Find the exotic in the commonplace. Accept no substitute for nature! Create!

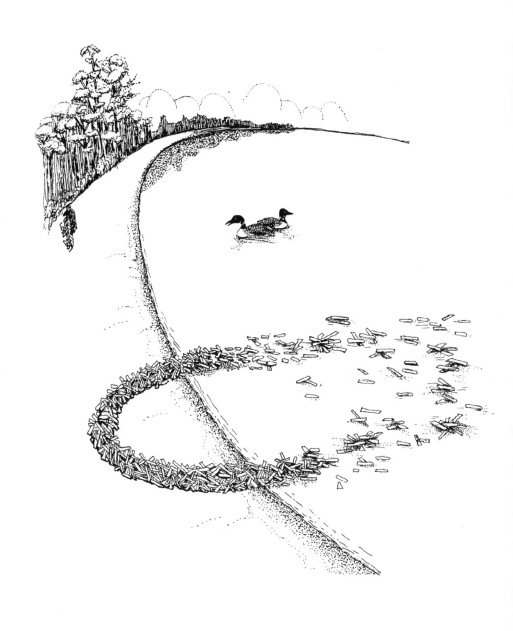

Chapter 8

The Spiritual Geography of Zero

"To be whole. To be complete. Wildness reminds us what it means to be human, what we are connected to rather than what we are separate from."
—Edward O. Wilson

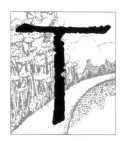

Throughout history, art has nudged society in one direction or another, sometimes functioning as a catalyst for change, other times merely supporting the status quo. Its capacity to catalyze radical shifts in society is extremely relevant today. We stand at the dawn of a new millennium, aboard a culture whose notion of progress is dependent upon gobbling up the Earth. While scientific and economic arguments for nature preservation are powerful and convincing, alone they are not enough to shift our course.

This thinking is central to my art of found materials. One spring morning as I threw pebbles into a large pool in a stream near Mt. Hood, I hit upon an idea that would take this art form into a collective, national dimension. As I watched circles ripple outward from the impact point where stones had entered the water, I was thinking about the Zero-Cut campaign to end commercial logging in our national forests.[1] The circles that spread from each pebble grew bigger and bigger as they traveled across the water, until the whole pool was agitated. I suddenly realized that zeros and circles are the same. An idea hatched, a way to call attention to the crisis in our forests. I would create *ZeroCircles* in national forests across the country, using found materials. The idea would catch on, and soon, many people would be making ZeroCircles and the needed change would occur.

167

ZeroCircles

I wrote a grant proposal and six months later, in the fall of 1998, received modest funding to begin the ZeroCircles Project. I initiated the circle art with my daughter Sierra and my brother Tom in an old-growth grove in Gifford Pinchot National Forest. This felt appropriate, as the land is named after the founder of our national forest system, Gifford Pinchot, who originated the "multiple use" concept which has been so subverted by the timber industry. Only 150 years after settlers moved here, we need guidebooks in order to find ancient forests.

The three of us made a large hoop from cedar and willow branches, tying and wrapping it with yellow and blue timber survey ribbon found nearby. Sierra gathered moss to disguise the tape, and we braced the circle between an ancient fir and young maple about ten feet above the ground. We sat down together on a forest floor of dry moss, tiny mushrooms, and maple leaves to ponder our creation. The forest was still, and completely silent. As often happens when one stands back to examine a piece of art to see if it "works," we simply stared in silence, checking to see if it made sense, if it felt right. It did. Smiling widely, we sighed and lay back upon the ground staring up at the mighty trunk that reached to the sky from the hoop near its base. All felt balanced and perfect in that moment, even though we knew well enough that this little area was surrounded by severely cut-over forest.

The joyful, flute-like call of a hermit thrush penetrated the quiet. Following this song, the silence was even more acute. Of all the bird calls, is the thrush not the most hopeful, ending in such a quickly rising crescendo? Its music added credence to my belief that somehow, in some way, this first ZeroCircle would make a difference.

This first circle was still there, covered with moss, when I visited the spot in late October 2000. It symbolizes the beginning of an artful effort to educate people, and to stimulate efforts to protect what belongs to all of us. Born from frustration with activist methods so often lacking an overt spiritual connection to the places we are trying to save, ZeroCircles offers a new way to participate in the protection of our environment.

New angles are certainly needed. A study called *Index of Environmental Trends*, published in 1995 by the National Center for Economic and Security Alternatives in Washington, DC, is discouraging. In the study, the authors measured trends in a wide range of serious environmental problems facing industrial societies. The study relied on the best available data, most of it gathered and maintained by national governments. Twenty-one indicators of environmental quality were examined, and the data summa-

rized into a single numerical "environmental index." The index shows that, despite twenty years of substantial effort, each of the nine countries measured has failed to reverse the trends of environmental destruction. (The U.S. finished seventh, just behind Japan.)[2]

In light of such information, it is time to evaluate what has worked in the past and what has not worked. It is time to explore new strategies that aim at deeper, more fundamental change.

A New Story

Veteran wilderness writer and activist George Wuerthner spoke to this in "The Myths We Live By" published in the quarterly magazine *Wild Earth:* "It is the vision and the way it is interpreted—not the science—that will capture people's hearts, and ultimately their minds...It is the storytellers who ultimately may change the Western parable, and thus, our relationship to the land and nature."[3]

After several years of the work described in the previous chapters, I gathered photographic images of beauty, destruction, and art and created an educational exhibit entitled *Sacred Ground—Sacred Sky: An Eco-Experience.* The display toured for six years through Exhibits USA and became one of their most requested exhibits. This gave me hope that perhaps I had struck a buried chord. It seemed clear that many people were ready for a new story and were looking for a way to begin to "re-mythologize" our way out of our environmental crises. Perhaps it was as Barry Lopez's crow said to weasel: "Sometimes people need a story more than food to survive."[4]

Perhaps this was why my exhibit had been so successful in reaching out to people, while my experience on Capitol Hill with the *Clearcut* book seemed otherwise. *Clearcut* was so big, bleak, and sad. Perhaps it was just *too much* for people to take in. Maybe my impression comes from trying to get an acknowledgment, a sign of recognition...*something*, from politicians. I know that forest activists have found the book to be a very useful tool, yet I also know that people respond best when they are offered a way to process the pain that comes from viewing pictures of destruction, and the realization of what we have done to Earth. They need a story path, a way to translate feeling into action—or the impact and potential for action may be lost.

Having worked for many years as an environmental photographer documenting nature's beauty and destruction, I had come to sense that something was lacking in our effort to inspire people to protect our last

ancient forests. Eight months after our massive effort to distribute *Clearcut* to President Clinton, Vice President Gore, and each member of Congress in 1995, America was presented with the "Salvage Rider," arguably the most anti-environmental legislation in history. It suspended all environmental laws in our forests for one year and resulted in thousands of acres of old growth falling to the chainsaw.

We have thousands and thousands of ugly pictures of clearcuts. We have the scientific and the economic arguments "down pat" and we tell this story well. But sadly, numerical and visual facts aren't enough in a society whose concept of the world comes primarily from television—a society whose principal storytellers have become Sony, Time-Warner, General Electric, Rupert Murdoch, and Disney. To change the future, we must change our stories. Through years of sharing my own environmental art as well as the earth art of others such as Stan Herd, Tibetan monks, and ancient indigenous cultures, I have found that people readily respond to positive, creative forms of activism. Such artful ways of framing an issue can change the "perceptive location" of those who absorb the information, a point which is often critical in garnering their attention and future support. ZeroCircles is such a way. It is a new way of telling the story, a story our tattered forests are begging for.

What is That Story?

Part of that story is that only four percent of our nation's annual timber supply comes from national forests,[5] and such logging is conducted at a loss to American taxpayers of over $300 million every year, not counting the very significant value of the lost trees to clean air and water, to wildlife, and to recreation. Iowa Representative Jim Leach (Republican) testified that "the U.S. government is the only property owner that I know of that pays private parties to deplete its own resources."[6]

More of the story: In 1990, *National Geographic* published an article that presented what should be alarming news to the American public. Less than five percent of our nation's original forests remain and they are almost entirely on public lands. One has to wonder how we let the situation get so grim. In a sense, we've been hoodwinked. Cartographers shade our national forests green, which has lent them the illusion of protection. The word "national" as in "National Park" conveys protection. And the forest service and timber corporations have been careful to line the highways that pass through our national forests with "beauty strips," borders of trees obscuring what has happened to our forest beyond.

The Zero-Cut solution, endorsed by hundreds of conservation groups, seeks to protect what is left and begin healing the rest, by ending all commercial logging on public lands. Our country supports this effort. Many polls have shown that seventy percent of Americans favor an end to logging in our national forests. A bipartisan bill introduced in Congress in 1998 and still in motion in 2001 is called The National Forest Protection and Restoration Act. It would: 1) protect our national forests and other federal (public) lands by ending the ecologically destructive timber sales program; 2) redirect timber subsidies into worker retraining and ecological restoration; and 3) save taxpayers at least $300 million annually.[7]

The Oldest Symbol

The ZeroCircles Project is an effort to call attention to the need for this legislation. It is a blend of art, spirit, and environmental politics designed to encourage the creation and documentation of zeros in all of our national forests. The zero, also a circle, is humanity's oldest symbol of wholeness and healing. It is an archetype present within us all.

"An archetype is a constellation of qualities, a pattern of patterns," writes Laura Sewall.[8] In essence, archetypes are the ultimate metaphors, or as psychologist James Hillman describes, "the roots of the soul governing the perspectives we have of our selves and the world."[9]

Is there a symbol more deeply embedded within my human nature than a simple circle? I crave an authentic wholeness that often feels lost and left behind. Pieces of the circle seem missing and yet I *feel* the archetype and can see where the missing pieces fit in. It is just a matter of finding these pieces. Jungian psychologist Robert Johnson notes that "when we encounter the images of the archetypes we always feel *the power that has been shaped by the image*...We can feel the archetype as a charge of energy."[11] Building circles is a way to tap this charge, a way to call together the missing shards of the sacred wholeness that lies within every one of us...and within our forests.

From the megalithic stone circles of Britain to the medicine wheels of Native America, circles have been built throughout history to celebrate our connection to Earth and provide direction in our lives. And no wonder; we live intertwined within a web of circles that support our existence. The biosphere, the geosphere, the hydrosphere, the atmosphere, the sphere of our sun and moon—reminders, all, of the circle's sacred power.

We have traveled full circle in our relationship to trees. We came to a continent draped in virgin forest, and we cut trees relentlessly. It's time

to circle back. It's time for all the diverse forces that have been working to protect our forests to work together to end the destruction and begin the restoration. The ZeroCircles created by activists across the country symbolize the solidarity needed to fulfill the vision of Zero Extraction from our national forests.

Unity Divided by Zero

As the number of ZeroCircles in our National Forests continues to grow, I am hopeful that the educational and media impact of this project will gain momentum. Each ZeroCircle built from found materials is a mandala in its purest form, containing what Tibetan Dzogchen master Longchen-pa says a mandala must contain—"the five excellencies":

- the teacher
- the message
- the audience
- the site
- the time[12]

According to spiritual anthropologist Joan Halifax, "a mandala is a map as well as a protector."[13] Each ZeroCircle maps a different aspect of the condition of our national forests at a particular time and place. Some show the beauty, others the destruction. Linked together, they call attention to the importance of resurrecting our national forests as sanctuaries free from all commercial extraction (which was the original intent of Congress when it established the National Forest system 100 years ago). They also serve as protectors of that vision.

While sharing the ZeroCircles Project around the country, people have often commented on the significance of the zero, and spoken of their awareness of three zeros in the date 2000. I hadn't given much thought to this fact, so I investigated the origin of the zero in one of my favorite books, *The Penguin Dictionary of Symbols*.

"The Maya discovered the concept of the zero at least 1,000 years before anything was known and used in Europe. In the myths of the Popol-Vuh, the sacred book of the Maya, the zero corresponds to the moment when the Hero Maize-god was sacrificed by drowning in the river, and then born again to rise up into Heaven and become the Sun. In the germination process of maize, the zero corresponds to the precise instant which occurs as the seed disintegrates in the soil and before life begins to manifest once more in the form of a tiny emerging maize-sprout."[14] In essence, the great myth of the cycle of rebirth, which is

common to so many cultures, is epitomized by this symbolism of the Mayan zero. In Maya hieroglyphics, zero is represented by the spiral.

Arabs began using the zero as a mathematical placeholder about 900 years ago. They could have chosen a slash, a dash, a dot, a triangle, or any number of symbols to represent "naught." The fact that they chose a circle seems auspicious. Humans have always been guided by symbols, and I can't think of a more significant one at this point in our history than the union of the circle and the zero, hence: ZeroCircles.

When I looked up zero in my fifty-pound *Oxford English Dictionary*, I discovered a quotation by a nineteenth-century mathematician named Carlyle that intrigues me to no end: "Unless my algebra fails me," he said, "Unity itself divided by Zero will give Infinity." After thinking about this for some time, I began to see Carlyle's words as a kind of sustainability equation that might read as follows: Nature (Unity) divided by minimal impacts (Zero) leads to Sustainability (Infinity). Or more simply... "*Living in harmony with nature is infinitely sustainable.*" It may be algebraic, but it doesn't take any knowledge of math to know that this is just plain common sense. I nearly failed algebra in high school, but I smile when I think of how I am applying it now. Finally, just a week ago, my five-and-a-half-year-old added his spin on the equation with a simple question: "Dad, is infinity a circle?"

"You bet it is," I told Nick with a smile.

Recalling the Dead

Troy, Greece, Lebanon, Rome: everywhere civilization has bloomed, deforestation has been its handmaiden. England, Germany, the United States; trees cut for ships, cut for housing, cut to make charcoal, cut for paper, cut for pallets, cut for firewood, cut for diaper stuffing...there is always a reason. South America, Southeast Asia, Siberia—a thread of rationales connects all these regions to the eastern United States, where our once-great forest is making a third attempt at wildness, having been cut to the ground twice before. If ever there was a time to employ the zero-inspired sustainability equation on public lands, it is now.

With this thought in mind, I began the last days of my eastern ZeroCircles tour, heading across Missouri, Illinois, Indiana, Alabama, Georgia, Tennessee, North Carolina, Virginia, Kentucky, Wisconsin, and Minnesota. With 5,000 miles and a dozen presentations behind me, I began to build the final circle of my journey. It would sit on the shore-

line of a circular lake in Minnesota, its purpose to highlight a startling fact I learned while traversing our eastern forests.

We are all accustomed to seeing the green shading of areas called "National Forests" on our maps, and we are used to thinking of these regions as public lands. We take some comfort in this notion. I even feel my body relax a bit when looking over a map and seeing these green areas. But these maps lie. I discovered that less than half of the areas in the east depicted as "National Forests" actually represent land owned by the public. A large percentage of these green-shaded "forests" exist on paper only. They are called *purchase units* and are essentially a Forest Service wish list—lands the USFS would like to buy. Lands within these so-called forests often startled me by turning out to be giant coal mines, small towns, and factory farms. This is all the more reason to press for Zero Extraction in what remains of our recovering eastern forests.

I used wood chips gathered from a Grand Rapids, Minnesota, mill to artfully symbolize the half-owned paper status of much of our national forest land east of the Missouri River. As in most eastern forests, the trees cut from the Minnesota's Chippewa National Forest are demolished, shredded into pieces like those I used to cast my lakeside zero, a circle of chips half on the sand and half floating on the water. The lake was perfectly still that day, and no one was near the boat ramp as I carefully spread the chips in an arc upon the sand. I continued the arc by floating the chips upon the water until they joined the chips on the shoreline, forming a perfect circle. I prayed for the recovery of our eastern forests and watched as the water-borne part of the circle slowly broke apart and began to drift in the direction of two loons that had been observing me from a distance. Whatever it was that bore the chips slowly away—the faint trace of a breeze, or a current—I could not tell. The silence was almost unimaginably complete, on this Sunday at a boat ramp on a lake in Minnesota whose name I cannot recall.

The gradual scattering circle of wood chips, so recently alive in the wholeness of a tree, seemed a slow-motion metaphor for our culture—made visible so it could be understood. Several times I have come across the notion that our modern way might be compared to a flywheel revolving at a speed too fast for its size and construction, coming apart and sailing off in all directions. Metaphors are often quite malleable, and so I decided to give the chips another representation. The expanding pattern of tree shards was an emissary of sorts, a constellation of my need to feel forgiveness. Having been circled and prayed over and photographed, they were no longer simply wood chips. They were wooden shards charged with elegance and grace. As they drifted toward the loons, I felt

charged as well, and challenged to understand the personal significance of what I was witnessing alone at the edge of the lake. What was the oracle of this morning?

Witnessing. Is this the key to receiving some form of forgiveness from nature, a forgiveness that can erase our despair and energize our lives? Every ZeroCircle created in every ravaged forest, as well as the creations that preceded them—the Wheel for Toxic Man, Prairie Shield, Medicine Stump, Beluga Peacemaker—all seemed an artful way of witnessing, a way of acknowledging the pain of Earth and my own hand, however small, in its destruction. In the midst of watching this circle dissipate, I felt something shift inside: a soft blanket of forgiveness seemed to settle over me.

Wilderness activist Mollie Matteson touches on what I was struggling to understand, in her writing about the vanished forests of New England. "What I glimpsed was the soul of place, the spiritual geography that lay underneath everything else. Though I didn't then imagine that any more of this terrain could be retrieved from its long burial, I believe now that this is the mission of ecological restoration. We are recalling the dead, the vanished, the forgotten wilderness. We are both remembering and signaling to that wilderness, asking its return. We are indeed, at some level, asking its forgiveness."[15]

Recalling the dead. Fulfilling the wish list and restoring the forest: this was essentially the prayer I offered that morning to the lakeside circle.

I recalled mystic-scientist Gregg Braden's notion that "we must become the peace we seek."[16] In other words, the way to fortify any experience is to resonate consciously and physically with it as much as possible. With respect to my presence on the shoreline, the word "pray" meant literally: to become, or to be like. I realized suddenly that this was the beauty of ZeroCircles and the art form that I had been practicing. Instead of praying "for" something as if it were not already there, one *becomes* the prayer through one's created circle or mandala. If you want a whole and protected forest, become wholeness in your prayer.

In this praying, I felt something shift inside me. I felt forgiven, the slate cleared, synergized by my participation in the grandeur and wholeness of Mother Gaia.

It was absolutely quiet. Then, the loons crooned their beautiful, ghostly cry. Adrift on a mission of wholeness, the chips were scattered in a wide arc about thirty feet from shore when the birds flew off heavily, inches above the water. They found a new spot several hundred yards away.

Their call seemed a signal for my leaving. I spontaneously answered the loons with a parting yell and my echoing voice returned, ringing along the shores of this small circular lake. The echo reminded me of the

mesmerizing humming tone made by running a wooden stick around a brass Tibetan bowl. It was a beguiling sound, a sound of forgiveness and hope. I yelled with joy again and again, not quite believing this auditory phenomenon to be possible.

"An echo is a sound wave that bounces back, or is reflected from, a large hard surface like the face of a cliff, or the flanks of a mountain, or the interior of a cave," writes Terry Tempest Williams in *An Unspoken Hunger.* "To hear an echo, one must be at least seventeen meters or fifty-six feet away from the reflecting surface. Echoes are real—not imaginary. We call out—and the land calls back. It is our interaction with the ecosystem; the Echo System."[17]

It was the configuration and proximity of the low hills encircling the lake that allowed me to "trade fours with the goddess" and the loons so sweetly.[18] The circular tune played by the lake and I confirmed yet again the charm of the circle and its power as an archetype. I could not have written a more fitting conclusion to my trip. But nature could, and did on the following day.

Pipestone

Cruising down the interstate the next morning in southern Minnesota, I was on the last leg of a circuitous route that had begun three weeks earlier in Kansas City. The fall colors had been dazzling, and I was grateful for the continuous sun and the warm reception I received from all those I was able to share this project with. Everything had gone so well that I felt a strong need to give thanks for it in a special way. I decided to detour a bit in order to visit a place that had always beckoned to me: Pipestone National Monument near the border of Minnesota and South Dakota. To the many Plains Indian tribes, the national monument is perhaps the most sacred site in North America. Why? Because Pipestone is the source of the sacred red stone that they use to create pipes with which to send their highest prayers to the Great Spirit.

The morning fog was dense as I walked along the pathway leading to the quarries from the small visitor center. No one was around. The fog slowly began to lift as I walked, the only sounds a few morning songbirds and the gurgling of a stream that coursed through the area. To the north about a mile away, rising and then disappearing in the fog, a tall three-branched pole appeared to be draped with tattered cloth. Chills ran up my spine, for I knew what it was. It was the Sundance pole, the ritual tree of life that rose from the center of the Lakota's circular arbor.

The Spiritual Geography of Zero

Pipestone is the home of the largest annual Sundance ceremony in the country, and I felt an urge to go to the pole. It was a contrary urge, for the protocol of visiting another culture's sacred setting is cloudy at best. I was both attracted and repelled. I struggled with this conflict as I walked. Then, I came to a waterfall that poured out of a cliff rising unexpectedly from the flat plain. I forgot about my dilemma. I marveled at the beauty of this place, and let my imagination carry me back a few hundred years.

I pictured antelope and buffalo grazing along the prairie stream in safety as warriors worked the nearby quarries. This was sacred land, and all the tribes that came here to collect their stone had rules that forbid hunting in the area.[19]

I wandered along the edge of the cliff, looking down upon the prairie and the tumbling stream. Suddenly a thought popped into my mind and I said, "I humbly ask permission to visit the pole." In the very next instant, a great horned owl burst from an oak tree ahead of me and flew off in the direction of the Sundance circle.

I was astonished. A few hours before I had been listening to a wonderful talking book by fantasy writer George McDonald written over a hundred years ago.[20] He mentioned a technique for tapping the spontaneity of our mind and its connection to nature to aid one in making difficult decisions. Here, it came naturally and unexpectedly. By not fretting continuously over my conflict, by letting it rest and then jump forth unbidden—in tune somehow with the nature of this place—I was given an answer whose validity I could hardly question. Thus I was led to the final circle of my journey.

The Sundance area was not accessible from the quarry, so I drove until I found a gated access road that seemed to lead to it. I parked, lifted my pack onto my shoulders, and began to walk the wet, rutted road toward the central arbor. The sun broke through the fog as I was midway to the pole, setting the landscape aglow. After three weeks of building zeros from found materials and gathering activists together to make circles in the forest, I approached the most sacred circle I could possibly imagine. The large Sundance arbor was surrounded by circular sweat lodges. The sixty-foot tree-of-life pole was stained ochre with bison blood and leaned to the east, blown by prairie winds. The feet of the sundancers had worn a circular path in the earth, and the lines that had recently supported their bodies dangled from the pole with offerings. With feathers and a smoking sage stick in hand, I slowly walked a spiral around the arbor in silent awe. Then, I stood at the foot of the "Tree of Life" and gave thanks for all the blessings of Earth, for the success of this trip, for the recovery of our forests, and for the teachings of the circle.

Chapter 9

The Tree of Life

*"It may be
that some little root of the sacred tree still lives.
Nourish it then
that it may leaf
and bloom
and fill with singing birds!
Hear me,
that the people may once again find the good road
and the shielding tree."*

—Black Elk

n my artistic healing journey, I have often experienced Earth as oracle. Each time I entered a region with the intention of creating some form of healing art, I also harbored a fundamental question in my heart and mind. The shapes, shards, and synchronicities, revealing themselves along the way, guided the creation of an oracular artwork that spoke both to the needs of the land and to my personal issue. In this manner, each place seemed to call forth the creation it desired. In the process, I felt the boundaries between myself and the land dissolve.

In a sense, a landscape would lay before me, like the coins tossed in a consultation with the *I-Ching*. Six tosses to form a specific hexagram: materials found and gathered, shapes and elements absorbed, animals, intuitions, and synchronicities acknowledged—all leading to an earthly hexagram in this consultation with Earth. The "reading" contained within the resulting art form became the story shared here and elsewhere.

What follows is a reading regarding our relationship to a prevalent and ancient myth of origin, that of the Tree of Life. It is a complex reading. The setting ranges from the Mayan ruins of Yatchitlán in Chiapas,

Mexico, to a wall in my Oregon house where a strange painting evolved and transformed over the course of several months. As with any story, there are numerous ways to begin. This one begins with an oracle.

Part One

"Everything in this world has a hidden meaning. Men, animals, trees, stars, they are all hieroglyphics...When you see them, you do not understand them. You think they are really men, animals, trees, stars. It is only later that you understand."

—Nikos Kazantzakis

Oracle

For thousands of years, oracles have served as mediators between heaven and Earth. By using an oracle, we can divine the essence and implication of a given moment. Divination systems such as the casting and reading of bones, tea leaves, animal entrails, stick patterns, and coins have been used throughout history to reveal the various forces and patterns at work in a given moment of one's life. To understand how an oracle works, imagine your life as the trunk of a tree reaching high up into the sky. We constantly flow through this tree, along with everything we perceive. If a cross-section of the tree's trunk were to be removed, it would represent a certain moment of your life and your immediate relationship to all the elements of nature existing around that moment. In light of a particular concern, the relationship contained within this slice of time can be read in the pattern created by the random display of coins, cards, bones, etc. Just as the movements of heavenly bodies mirror the movements of the atom, so one's slice of earthly time resembles, and is a product of, the simultaneous physical forces in the universe that intersect with the oracle at a precise instant. As above, so below. The whole universe is reflected in this moment of divination. The oracle reveals the available forces and compelling tendencies acting upon us within the pattern present in the "slice from our tree."

Occasionally I feel a need to consult an oracle. Usually it's the *I-Ching* but one evening I sought quick counsel from an oracle I had just received

as a gift called the "Lakota Sweat Lodge Medicine Cards." Sitting in a favorite chair with eyes closed, I let my hands sort through the deck. I was seeking counsel regarding confusion in my relationship and while focusing on the issue, my index finger finally rested on one card as something inside said "stop." I turned the card over. It was *The Tree of Life*.

The synchronicity of this reading made me smile. Dr. Carl Jung proposed that divination rests on the concept of synchronicity: the simultaneous occurrence of a pattern of significant events or symbols at a precise moment in time.[1] Not only had I just begun working on this chapter of the book, but also I had begun a large painting on this theme. During the next few months, the wisdom of the oracle's counsel revealed itself strongly as all my archetypes shuffled and danced around the Tree of Life.

The Lightning Oak

Virtually worldwide, the Tree of Life is an archetype representing all spiritual knowledge. Rooted in Earth, the trunk supports the branches, and the branches hold the leaves. Humans are akin to the leaves or the fruit. When we reach a certain stage of ripeness, our bodies return to Earth and we enter the spirit world. Understanding and celebrating this process inspired the painting I began on the south wall of my back room.

It felt odd to have the impulse one night to turn my utility room wall into a canvas. I had never been a painter, yet on that night something was set in motion that would become increasingly strange and magical, as a painted image took life and continually changed form. It was a method of painting inspired by Lori Thompson, my friend and one of the illustrators for this book. I was fascinated by Lori's twelve-month saga and photo documentation of her painting about death. Her process was one of dialog and prayer with images painted into form through intuition, synchronicity, dreams, and feelings. The evolving painting became a guide and guardian of sorts, as Lori traveled, shaman-like, in an intense voyage of self-discovery. For me, the transformative nature of this kind of painting mirrored the moral and ecological imperative of our time—replace our disconnection with nature with a resurrected, sacred view of our place on Earth. Lori's process felt in sync with my own art on the land, and I was moved to try a painting myself.

I cleared a wall space across from my washer and dryer, and began poring through boxes of old photographs looking for a particular one. After spending some time lost in memories, I found what I had been searching for. I put some classical music on my portable stereo, lit some

cedar, and smudged the room. Then, with the photograph in one hand and a pencil in the other, I began to draw the shape of the tree that had been the most important in my life. It was an unusual white oak living atop a hill on the Sleeping Beauty Ranch. Struck by lightning at some point in its long life, the oak had a dramatic shape. The tree *chose* life instead of death. From its burned-out and hollow center, a huge and aberrant branch reached out horizontally, giving the tree a mythical look. Other limbs stretched skyward, in stark defiance of the death blow that had burned down through the trunk's center. This tree's ability to survive beyond catastrophe is a symbol that has always given me hope and power.

With a degree of effort not always manageable, I was sometimes able to climb into this tree by swinging up on a branch that extended barely within my reach. Sitting in the tree, perhaps leaving an offering in the deep, gaping hole at the top of its trunk, was always a sacred thing requiring the sacrifice of intense physical energy. A medicine wheel of stones extended around the tree, and for my years in that beautiful Kansas valley, the lightning oak was my own *Tree of Life*—my refuge, my counsel, my place of power.

Once I completed a likeness of this tree on the wall, I pasted its photograph to the drawing of the immense lateral limb that grew east from the point where the lightning had broken the tree. In pencil, I wrote prayers and spiritual affirmations for the Earth and myself. The writing spiralled out from the center of the tree. Spending time with the Tree of Life, writing and painting in a meditative way, would have a twofold purpose. First, I would retell one of the Earth's oldest stories with a new spin. Second, I would embrace and come to terms with my own emptiness that, with the failure of my marriage a few years before, had been glossed over and covered up.

In the center of the trunk I pasted a picture of myself nestled between the limbs of a giant cottonwood that grew near my old ranch in Kansas. A few days later I darkened the contours of the tree with charcoal, then outlined its edges with black and, later, orange paint. I added a picture of the old, magnificent white oak near my Oregon home that has taken on the role of the lightning oak. It too has a medicine wheel of stones around it. I drew a big, sickly brownish-yellow sun in the corner. At the end of the first week, the painting appeared to show a dead tree. This reflected both my state of mind at the time and the environmental assault taking place everywhere on our planet.

As time went on, thoughts of the painting would often come to mind during the day. My life felt charged in a way I did not recognize. Knowing that this would be an ongoing element of my life for some time, I soon

felt the tree acquire a personality and magic. As the painting grew and changed, I recalled another version of the Tree of Life, created years before on the banks of the Rio Usumacinta that separates Mexico from Guatemala. It was the *Arbol del Mundo* or *World Tree,* based on the foundation myth of the Maya.

Yatchitlán

The Lacandón rain forest in Chiapas, Mexico, is part of the largest remaining tropical rain forest in North America. It is home to the Lacandón Maya who fled to this region when the last Maya strongholds were defeated at the end of the seventeenth century. While some of the remaining Lacandónes still live traditionally, most have been converted to evangelical Christianity. Only about four hundred in number, the Lacandónes were granted a huge forest reserve in 1971. Ostensibly designed to help preserve the traditional Lacandón way of life, the grant also happened to streamline the title search process for timber companies who wanted to log the rain forest. The few Lacandónes who have retained their traditions say that the reign of the God of Creation is over: the supreme god is now the Lord of Foreigners and Commerce.

I felt the influence of this god as I hitched a ride in the back of a truck. The dilapidated red pickup bounced along the dusty, horribly rutted road that wound through mile after mile of what once was rain forest, now turned into cattle pasture (thus providing cheap hamburgers for the foreigners up north). The air rushed past me in waves as I stood over the cab with my hands braced upon the roof. The scent of sawdust from newly cut trees blended with the stench of cow dung, and occasionally, smoke from burning fields. Everything was "wrong side up." This was not Kansas, this was the rain forest—but where was it? The road ended finally at Frontera Echeverria, a tiny outpost on the banks of the Rio Usumacinta and the western edge of the virgin rain forest. Here a *lancha* would be available for the journey upriver to the Mayan ruins of Yatchitlan, which were surrounded still by jungle.

Three Lacandónes, a dog, and a handmade wooden cage holding chickens accompanied me as the boat motored upstream toward Yatchitlan. The Usumacinta's color was a mixture of jade and turquoise, occasionally clouded with silt. The visual contrast with the steep, emerald wall of trees rising alongside the river sparked my imagination. The gruff bark of howler monkeys could be heard above the motor's roar, and colorful flocks of parrots wove in and out of the canopy. This was the real

rain forest. The world's tropical rain forests have been evolving for sixty million years, making them the oldest communities on the planet. Nearly half of all types of living things are found in tropical rain forests, though they cover less than two percent of the globe.

We all know that rain forests around the world are under siege, being cut and burned at an alarming rate. Such facts as "Earth is losing an acre of virgin rain forest every minute" have been accepted by our culture as the way life is at the dawn of the new millennium. We feel powerless under the weight of such information. Yet, the old Mayan adage, "He who cuts the trees as he pleases shortens his own life," echoes our deep, uneasy feelings that are rarely (if ever) acknowledged. We continue on, the thought of our ruinous course an itch we can't quite reach.

I had traveled to this remote region to make an artistic statement about our relationship to the tropical rain forests that would coincide with the 1992 fall equinox. It would be a way both to examine my own relationship to trees and to bear witness to the destruction of our rain forests worldwide. With Earth as an oracle, I wanted to co-invent a story about rewilding the Tree of Life, which everywhere on Earth seemed in a state of rapid decline.

As we rounded a sweeping bend in the river, the approaching temple tops of Yatchitlan rose from the dense *selva,* gleaming brightly in the sun. In the eighth century, the enormous braziers that crowned these temples would likely have been billowing black clouds of copal, and sacrificial victims would perhaps hang from the roof combs. We landed on a wide beach, beside what appeared to be the ruins of an ancient landing. The area seemed almost deserted compared with the more famous ruins to the north. There were a few archaeologists working the ruins and several Mayan families that lived here and served as guides, guards, and cooks. A handful of tourists were there for the day.

I quickly made camp in a private little cove just above the shoreline and began to explore the riverside. I found a large vulture feather and set it afloat in the river's current while appealing to the gods and spirits of this place for guidance and good fortune during my stay. Words rushed forth as the feather made its way downstream through ripples sparkling silver in the sunlight. My prayers ended when the feather disappeared into a spiraling eddy.

Along the river's edge a few hundred yards downstream from camp, the remains of an ancient bridge could be detected. Crumbling towers stood on each side of the shoreline, and two other supports poked above the surface near the middle of the river. Walking through sandy shallows, I tried to imagine how it appeared a thousand years ago—Mayans walk-

ing back and forth with loads and bundles, kids playing in the river—tried to intuit the look and texture of their lives. I came to a rocky area that would have been directly below the bridge. Stones of every shape and size were scattered about, and among them in the mud were several large pottery shards and a stone chisel. Some of the shards had distinctive geometric designs in orange and brown. One, without color, had seven circles side by side. As I held them in my hand, thousands of years began to slip away. I walked on, then stopped abruptly. Protruding from the mud was the ancient, fist-sized head of a clay figurine. Chills spread through my entire body. Carefully, I washed off the dirt, then polished the reddish-brown clay with my fingers. It was a classic Mayan head replete with headdress, ear ornaments, and necklace. I could hardly believe the luck of this find. I closed my eyes and gave thanks. With my fist wrapped tightly around the little head, I felt a kind of authenticity, a timeless belonging to the human community. How I longed to know the deep sense of place, the tribal connectedness and knowing that the owner of the figurine must have experienced.

Walking beside the river, I picked up feathers and pieces of colored cloth lodged in flood debris, half-buried in the sand, and sometimes simply floating in the water. When I got back to my tent it was almost dark. I made a little altar of my findings, with the clay head in the center set upon a large, flat stone. I lit a candle before it, and the shadow of the artifact's contours loomed large upon the orange nylon wall. The head of the broken statuette, circled by feathers, pottery shards, a stone tool, and colored swatches of cloth presented a mesmerizing sight. What was the oracle of these findings, the day's events, this place, this moment? I thought about the devastated forest land I had traveled through, and the Lacandón culture hanging onto its traditions by a thread. What happened to the once-magnificent Mayan civilization and in what ways does it parallel the problems of my society? A book I had brought with me contained some clues. This classic book about the Maya by Linda Schele and David Freidel is called *A Forest of Kings*.

According to Schele and Freidel, in the beginning, the Mayan world was a featureless primordial sea—a place without sun, wind, rain, or the passage of time. Only when the World Tree came into existence was the sky raised up and the underworld depressed. Space was created, within which the sun could begin its rounds. Human time began with the arrival of the World Tree, and the tree is the central myth of the Mayan people. Their glyphic name for the World Tree is *wacah chan*, which means, literally, "raised-up-sky." On public monuments, the oldest and most frequent manner in which a Mayan king was symbolized was in the

guise of the World Tree. In ceremonies, the regalia of the Mayan kings was meant to *literally* convey the kings as The Tree of Life made flesh. The guise worked, as the people they ruled fully supported them in this role.

It was natural that the Maya would choose the tree as a metaphor for human power, for trees were almost their entire world. They were the material for homes and tools, the source of many foods, medicines, dyes, and vital commodities such as paper. They provided fuel for cooking fires and the soil-enriching ash that resulted from burning the forest. Trees were the source of shade in courtyards and the diversity of life teeming in the forest. Much of the Mayan language is a blend of human and tree. Their words for *trunk, bark, branches,* and *fruit* are the same as for *body, skin, arms,* and *face.* The word for *old people* translates as *cracked old bark.* The Mayan *hello* means, "Does your fruit sit well on your ancestor's trunk?" Thus, the "Tree of Life King" was a icon that kept the Mayan rulers in power for nearly a thousand years until growing military competition, overpopulation, and ecological disasters brought them and their civilizations into irreversible decline.

The Tree of Life was a wonderful metaphor for a king to adopt but it could only be sustained, I surmised, as long as the king and his policies stood firmly rooted and embedded within nature. The sounds of the jungle were alive in the night, harmonizing with the sweet melody of the river's rapids as I read and wrote in my journal. The shadow of the bodiless figurine loomed large in the candlelight. Power corrupted the Mayan kings just as it corrupts our leaders today and thus, wasn't the head of the statuette, without its supporting body, a clear metaphor for our culture-wide separation from Earth? Governed by leaders unrooted to nature like the Maya kings near the end of their reign, we live in a society that does little to honor its dependence upon the natural world. Without being firmly united in the supporting web of nature, without the care and sacred appreciation of the *wacah chan,* the life-force that sustains us all, we are headed for collapse as surely as the Maya and their unrooted Tree of Life kings.

The fall equinox would occur in two days, and that night in my tent I decided to create—for the Equinox—my own version of the Tree of Life. I would root myself to it on the banks of the Rio Usumacinta.

Our Indigenous Soul

Recollecting those days in Yatchitlán, I realized there was something missing from the Tree of Life on the wall of my back room. No wonder it

felt dead—it had no roots! During the next two weeks, I carefully added them to the painting which now stood six feet tall. The roots spread throughout the inky-soil darkness beneath the tree, and two snakes wove in and out through them. The snakes entwined their necks just below the beginning of the trunk. Snakes represented a transformation and rebirth I wanted for my own life, because in some ways I felt as separated from nature and the wholeness of my authentic self as the headless figurine.

I had recently participated in a workshop led by a Mayan shaman named Martín Prechtel that had a lot to do with finding this wholeness within, with reclaiming what he called our indigenous or *invisible soul*. After my father died on Earth Day weekend in 1999, my brother sent me a tape of Martín's called "Grief and Praise." I was so taken by the authenticity present throughout his talk and the depth of his own suffering over the decimation of his village in Guatemala during the 1980s that I listened to the tape over and over again. Tears and laughter came in a way I had never experienced before. The mixture was invigorating, and seemed to carry many clues about how to reclaim a lost part of ourselves, and how to process the experience of loss when it occurs within our intimate connections to the human and natural world. When the opportunity came to attend a nearby workshop Martín was giving, I did not hesitate.[2]

In his strikingly beautiful book, *Long Life, Honey in the Heart*, Martín describes with rare eloquence, the thousand year old spiritual traditions of the Mayan Tzutujil village and the role he played as chief, shaman, and initiator of young boys. When these traditions became outlawed and much of his village destroyed, Martín hid out and eventually fled to America with a price on his head. After years of grieving, his mission has become to help modern people recover their "soul's memory of the mysterious and natural humans, animals, plants, earths and deities from which we descend." Martín believes that without our indigenous souls intact, the Land of the Dead (what the Mayans call America) would sink into an oblivion of meaninglessness. His hope is that by sharing the intricate ritual beauty of his village we will be inspired to rebel "against the obliviousness of this age by blessing it with a sincere search for an authentic flowering of our own, an initiation."[3]

At the workshop I attended, participants were told to bring a yard of red cloth, feathers (not owl, vulture, or jay), beads, two gifts that could fit in one's hand, several long willow branches, cornmeal, spring water, string, and flowers. We were to build a *butterfly house* (named for the appearance of two "wings" formed by the structure of the willow-branch

roofs). Through much ritual singing, dancing, chanting, grieving, and praying with our houses, we would set the intention for our creation to call back—once we placed it in a special spot in a wild area near our home—our *invisible soul*. The concept of one having an invisible soul was very curious to me, as I had never heard the term before. According to Martín Prechtel, the Mayan notion was that "if you fall in love before you have been initiated and have incorporated your invisible soul (your naturalness), then you will always be looking to fill yourself up with another."[4]

When I heard his statement, my body and spirit seemed to heave an enormous sigh as if some veil had finally parted after being closed for too long. "No wonder," I thought. "No wonder it is so difficult to find wholeness within. No wonder our divorce rate is so high. No wonder modern culture seeks completion in materialism, entertainment, sex, romance, career, etc." The notion of missing my invisible soul, and living in an uninitiated society with nearly everyone missing theirs, was terribly sad and disturbing. In a culture devoid of any ritualized form of initiation into adulthood, tribe, or community that allows one to bond with the Earth Mother that sustains us, we seek a false completion in a myriad of aberrant ways. We suffer, and the Earth suffers with us.

As a result of the workshop, I was led to some very deep thinking on the meaning of wholeness. I had long held a craving for some "other half," some ideal mate I thought I needed to complete myself. As a spiritual seeker I had learned, of course, and believed, that "wholeness and divinity lay within." Yet with this new revelation about my lost invisible soul, I also knew why this enlightened wholeness had been so elusive. Seeking completion in another, or in the many ways society has devised for us to find it, is a self-defeating proposition.

An enlightening book on this topic is *We: Understanding the Psychology of Romantic Love*. In it, author Robert Johnson speaks directly to the notion of one's invisible soul, even though he never uses the term. Johnson says, "In the instant a man falls 'in love,' he goes beyond love itself and begins the worship of his soul-in-woman."[5] As children growing up, it is often the case that our first sense of the divine takes form when we begin to fall in love. Martín's Mayan village in Guatemala calls it "the holy pollinating illness," and the old people of the community were always on the lookout for telltale signs of this illness. Once observed, the youth would be snatched up by the community and immersed in an age-old initiation process.

How wonderful it would be to live in a community so careful to keep its children from imprinting on unhealthy things during adolescence! Without initiation into nature and community, vulnerable adolescent

souls and psyches of our society imprint on all that advertisers foist upon them: sex, romance, material possessions, computer games, and a whole host of society's glitter and glut. I thought of my daughter Sierra at age ten. She still thought all boys were "dorks," but I knew her clock was ticking and soon the time would be at hand. My plan was to watch for the signs and then at the moment the "illness" began, I would take her with me to India for a month. The plan was a desperate attempt, to be sure, but without a tribe to guide our way, I imagined that the poverty and deeply spiritual nature of India's people would work on her in some way that I would help facilitate when the time came.

The ritual process of building our butterfly houses and setting them out in nature was what Martín called a "corrective ritual"—a way to heal the absence of initiation during such a key time in one's life. We built the structures by dividing our willow branches into thirteen pieces, then lashing them together with hemp twine. Thirteen is a holy number to the Maya, corresponding to the thirteen pulse points, or flowering spots, on the body. We carved designs of spirals, arrows, suns, and the like on our houses, decorated them with flowers and feathers, and set them in a circle. We sang, danced, blessed, and prayed to the little village we had created.

The intensity of the beauty grew as we watched the power of our makeshift village fill with the intentions we set in ceremony. Then we paired off, and each took a turn lying down while our partners covered us with red fabric so we could not see. Martín's face lit up when he saw my red cloth. It was a length of Guatemalan weaving from an old Mayan wall hanging that had been partially burnt in a house fire many years before. He gently caressed it and quietly said with deep sincerity, "This was woven in a village near mine." Each village in the Mayan world has its own pattern, and the presence of this cloth made tears come to his eyes. He did not elaborate.

Perhaps Martín's greatest gift is one of eloquence. He led the group in some of the most beautiful prayers I have ever heard, all of them requests for the homecoming of our invisible souls. Many people broke down and cried. When the prayers were over, our partners lifted the red cloth from us, snapping it overhead as a kind of rebirth enactment for our invisible souls.

The next day, we divided our red fabric in two. We cut half into strips to make cornmeal bundles to tie to our houses. We attached more feathers and decorated the little structures with fresh flowers and beads. Each became unique and alluring. When we put them again into the center, there was not a dry eye among us—for our little village sparked deeply the yearning we all shared for community and tribe, a yearning embedded in our very bones, for something long gone.

"The culture of initiated people has disappeared from view," Martín writes. "It has fled back down the old Hole to the other worlds and is held there in the form of a seed. There its indigenous spiritual DNA lives on, concealed in a mist of amnesia inside every human heart, waiting for a day or a millennium where the climate will be favorable enough to lift the fog and sprout again the old language in new voices, and the old voices in new language."[6] I longed, and everyone in the room longed, (and Martín longed for us) to be one of those new voices in this new millennium.

Then we did something profound. We sat in two lines, facing each other. We took turns staring, without looking away, into the eyes of the one across from us in honor of the grief they have experienced in their lives. Martín led us in more of his beautiful nature-based prayers. Again, many tears. Looking for fifteen minutes without turning away at the man across from me, honoring the grief present in the lines of his face, was one of the hardest things I have ever done. Accepting his honoring of my grief was challenging, as well. Then we took turns silently praising our counterpart in the same manner, as Martín spoke his prayers. There was more ritual dancing and chanting together, each of us blessing our ancestors and each other's chakras and body parts while holding our little houses. We wrote special poems to our invisible souls and placed them inside the dwellings we had created. We exchanged gifts, and attached them as well. Before it was over, we were given instructions on where and how to place our houses when we returned home.

A Gift That Disintegrates

"What *is* that thing, Daddy?" Sierra asked me when she saw it astride the railing near my altar. "It's something called a butterfly house," I said, "to attract our invisible souls. I made it in a workshop last week. It's kind of like a fairy house." She loved fairies and this was something she understood. She'd long ago grown accustomed to seeing bones and feathers and such around our home, and her own world was far too full to question me extensively about such things. "I'll tell her the story of this house," I thought, "when it is time to go to India."

We were instructed to keep our butterfly houses in our homes for seven days, in order to steep in the ambience of the dwelling. I placed mine upstairs beside my bed. Once during the week, I held it over the heads of my sleeping children, blessing them as Martín suggested. After seven days, I packed it along with some cornmeal, a ceramic vessel, the other half of the red Guatemalan weaving, and another poem written for my invisible

soul. I walked north from my home, not knowing exactly where I would place the house. Deer bounded out of my way, twice, before an old moss-covered white oak with a bewitching shape appeared before me.

The look and feel of this tree seemed right somehow, and when a red-tailed hawk flew up from short distance away, I examined the oak more closely. I spied a tattered owl feather half woven into the thick mat of dried green moss on a large lateral branch. I knew this was the spot. I placed the house at the base of the tree with the door facing west, and arranged the cloth and offerings in a pleasing way. "The spirit world feeds on beauty," Martín had told us. "You attract the beings of this world by making beauty. You become visible to the spirits by the gifts you give, and gifts that disintegrate are the most visible to them."

As per our instructions, I tied the red fabric onto a branch above the house and sprinkled freshly ground blue cornmeal into a handmade ceramic container that had been in my possession for a very long time. It was a coffee cup with a protruding sculpted face and a broken handle. In both the Mayan and native American worlds, cornmeal represents sacrifice—the sacrifice of the sweat of the body to cultivate corn. I carefully set my poem by the doorway in the center of the house. Finally, I added two elements of my own to the assemblage. I placed a hawk feather in a crevice in the bark and set a golden eagle skull, a long-held present from a dear friend, on top of the house in a gesture of "finding" my invisible soul and carrying it homeward.

I leaned back against the tree, my creation beside me, listening to the soft, rhythmic drone of the insects and the sonorous calling of a mourning dove behind me to the east. I pondered the meaning and significance of this ritual from a faraway land. Here I was at age forty-eight, making an effort to correct something denied to me by my culture over thirty years ago. I wept for the tribe I would never know, as my emotions swirled from sadness to anger. Was I was fooling myself, thinking that something like this could really make a difference? Yet as Shakespeare said, "Nothing comes from doing nothing." Action is our only salvation, and we must act "as if" our actions matter. I remembered the sense of authenticity so present around the construction of the strange little house, something so lacking in my own culture. What a beautiful ritual this was.

As joy replaced my grief and anger, I picked up a large rock and stood over the butterfly house. I aimed at the clay face cup, yelled loudly, and smashed it to pieces. Then, I walked away. "You will be so tempted to look back on the beautiful thing you created," Martín had cautioned, "but don't—it will spoil everything." As much as I dislike such dogmatic instructions, I did not look back and will never return to that beautiful

spot with a view of neighboring volcanoes shining like white diamonds to the north and south. It is "a way," the Mayan shaman said, "to honor our invisible soul."

Driving into town later that day I realized, with a jolt, that the face cup I had held onto for so many years and just smashed to smithereens had been a present from JoAnn, the first woman I had fallen in love with at eighteen years of age. With the cup now in shards underneath an enchanting oak tree, I felt that some kind of correction had indeed been set in place. A budding confidence grew within me that my invisible soul had begun its journey home to me—that the paradise of wholeness would perhaps be mine one day. I marveled at the parallel of the face cup without a handle and the little Mayan head without a body found beside the river at Yatchitlán. They felt connected in a profound and beautiful way.

Building the Tree

Itchy bug bites and strange dreams made my first night on the shoreline below the ruins of Yatchitlán a restless one. After a breakfast of oatmeal and fruit, I packed all my possessions and headed upriver. My plan was to hike and gather along the shoreline until I found a tree that called out to be "my" Tree of Life. While I picked up feathers and more strips of cloth, brightly colored macaws and flocks of smaller parrots often flew overhead, searching for their favorite fruit-covered trees. I paused once to howl back at a group of boisterous howler monkeys who shouted down at me from their perches high in the trees. After years of exploring various rain forests, I am able to imitate their call (in fact, it is the only animal call I can do well, so I never miss an opportunity).

Eventually, I came to what I had been searching for. It was a beautifully shaped ceiba tree with an exposed root system that ran snake-like down to the river. Several pieces of cloth were tangled in its roots. One piece was black, unlike any I had yet collected. The ceiba's light-brown bark was cool and smooth, almost like skin. I climbed up into the tree feeling it welcome me. A familiar sense of home spread through me, as it often does while I sit in trees I know or am drawn to.

I found a place to pitch my tent and then spread out all that I had gathered along the river: feathers, cloth, pottery shards, a snake skin, lengths of rope and string, and the brown clay head of the figurine. Retrieving a stick of sage from my pack, I smudged the objects and then myself. While I was doing so, a white hawk screeched above me. Its soaring body circled a few times against the bright blue sky—a breathtaking

sight and a wonderful blessing for this endeavor. With the burning sage stick at the base of the ceiba, I sang a song of thanks and welcoming to the four directions, Earth, and sky.

Just as I was ready to begin my sacred jungle art project, a long dugout canoe appeared in the river and stopped abruptly across from me. Two men climbed out and quickly made two spears from the tall bamboo that grew along the riverbank. They walked slowly through the shallow water, spears poised. Looking through binoculars, I could tell they were hunting crayfish. Sitting under the ceiba with the sage smoke wafting in the morning breeze, I watched the hunters collecting their prey.

After a while, I wrote in my journal and considered the odd collection that lay before me. What were the possibilities? With the black cloth found here, the colors of the four races of humankind could now be represented. The most common color was blue. I wondered about the origin of these fabric swatches. Many were of a characteristic size, about four inches by five inches. With these scraps, I decided to decorate the roots of the tree with a design that wound its way up to the base of the trunk. There I would create a symbol for the four races and the four cardinal directions. With the string, I would hang feathers and cloth "flags" from the branches. How the pottery shards and figurine would fit in was still a mystery.

When the hunters paddled off, I felt ready to begin. Carefully spreading the strips of cloth rainbow-like along the largest root, I tied the flags and feathers above them, all the while being showered by the tree's delicate, falling leaves. Then, from swatches of red, black, white, and yellow cloth, I cut four matching ovals and lightly attached them to the base of the trunk with thorns. The colors met and overlapped in the center, forming a starlike pattern. I set the pottery shards, the snake skin, and the little head below the star and contemplated them.

The bodiless Mayan figurine was the most precious thing I had ever found. How could I leave it here in Mexico as a part of this art? I wanted to take it home with me so badly, I searched for reasons to do so. And then, I remembered a dream from many years before. It was so vivid and seemed so important at the time, that when I awoke, I recorded it in the journal I had been keeping:

New Year's Eve Morning, 1989

"I had a dream that feels very prophetic for the approaching decade of the '90s. While thumbing through a section of a *National Geographic* magazine about India, I noticed a picture of a tall marble column with a milky-

green colored vase on top of it. The caption said something like 'a glass vase left by D. Dancer as a sacrifice on top of the holy column.' I knew the vase that was pictured. It was a blown-glass vase that had been a present to me by my wife, Christine. It never really appealed to me much. The color and shape made me uncomfortable. Christine knew it, and it has always been a minor bone of contention between us, in a humorous way.

As dreams go, suddenly I am in India, rummaging through my backpack looking for something else to leave at the temple. I found some soggy sky rockets, in bits and pieces, and began gathering them up as an offering. Suddenly it dawned on me that if I wanted my prayers to be answered I must offer something of true substance. A *real* sacrifice had to be infused with deep personal meaning, and these items, as well the glass vase, meant little to me.

I awoke from this dream with a splitting headache and went downstairs to get some aspirin. With three aspirin in hand I opened the refrigerator and grabbed an almost empty glass pitcher of orange juice. I drained the remains, swallowing the aspirin. It was pitch dark in the kitchen, and being disoriented (remember I was in India only moments ago), I mistakenly set the pitcher on the edge of the counter. Released from my hand, it crashed to the floor, totally shattering the quiet of the night. I had always loved *this* particular glass object. It was an item from my childhood given to me by my mother. It was a real sacrifice!

This dream seems symbolic of the work confronting the human species. We live in an unprecedented time. Human evolution has led us to the brink of a precipice. We must do as any animal does when it comes to the edge of a cliff—ponder the view, turn around, and take a step forward, for to continue on as we have is most likely suicidal. The frills and seductions of modern society that are eating up the Earth are the offerings of substance we must leave at the temple. Turning around is the sacrifice we must make as a species."

With the memory of this dream I realized that the precious head of the statuette must be a part of this Tree of Life. I climbed into the tree and found a circular, altar-like spot below two large, upward-extending branches. I precisely positioned a square of emerald green cloth, circled it with the snake skin, tied owl feathers onto a branch above, and gently released the ancient artifact from my hands into the center. Raising a flute to my lips, I played sweetly to the figurine, attached now to its rooted body—completed in the ceiba. Blending with birdsong and the chirping of insects, my flute song was a melody of thanksgiving and a musical prayer that the Tree of Life blossom anew in the hearts of humankind and inspire us to make the needed sacrifice.

Sacrifice of Shards

On the day I was writing this part of the chapter, a very curious event took place in my home. I had decided to paint the head of the figurine into the crotch of the Tree on my wall. I prepared a small area of the design by painting white over the blue sky, so the artifact's color could be depicted accurately. While the paint dried, I began to get things ready for an afternoon trip with my kids to Squally Point, a nearby beach on the Columbia River. I wanted to experiment on the dunes, setting up a mandala to potentially photograph. On a bench near the painting there was a coffee mug filled with colored glass shards that I intended to use in the mandala. The cup was a long-retired favorite cup purchased in Monument Valley from the Navajo woman who made it. It was a work of beauty, with an enchanting desert scene painted in black and white. I grabbed it, carried it into the kitchen, and set it down—I thought—on the counter. My beautiful, precious cup crashed to the floor, like the glass pitcher that I had just written about. I had missed the counter!

Dumbfounded by the event's synchronicity, I stood wondering at the shattered cup and shards that sparkled below me on the floor. The cup broke into four pieces, two large and two small. While gathering up the glass shards and cup pieces, I considered how they reflected my own life at the time. With the sudden recent failure of a relationship that appeared to hold great promise, I was feeling disoriented and fragmented like these scattered shards before me. Some were pieces of mirror, and these bore portions of my reflection as I picked them up one by one. I realized how precious and fragile this life is that we have been given and what a struggle it can be, at times, to maintain our wholeness. A cherished possession, a favorite place in nature, or a beloved relationship— we never know what sacrifice we will be called upon to make, or when. We may search for meaning, but if one can be found at all, it is often only when looking back from a future perspective. The invisible economies of the Great Mystery protect us from knowledge when we desire it, the better for us to gain wisdom, compassion, and acceptance. Yet always, our losses remind us of the impermanence of all life. Contained within each beginning is the seed of an ending. Ultimately, we have only the peace and sanity of the present moment, and it is sacred.

Within the traditions of most indigenous cultures and in our personal lives as well, moments of change are often marked by giveaway and sacrifice. As is often the case, the truth of the idea is rooted in the word itself: *sacrifice* comes from the Latin, *sacri-ficium,* which means "making sacred." The greater the sacrifice, the greater—and perhaps more

sacred—the change. It seems that if one can muster the courage to lean into loss, embracing what must be relinquished as a gift to the spirit world, perhaps even attaching special significance or dedication to it, then one can strengthen one's life force and perhaps further one's luck. Humanity's greatest triumphs are filled with such tales.

Its two large pieces glued back together, the repaired cup sits on top of my computer as I write this story. I added the cup's two small fragments to my collection of shards, then walked into the back room to paint the head of the Mayan figurine into my Tree of Life. The moment felt highly charged. Recalling the figurine head sitting in the ceiba tree, and the face cup that I intentionally smashed in front of the butterfly house more recently, I realized that at this moment I was again inviting my invisible soul homeward, painting and connecting the shards of my life into wholeness. Each stroke of the brush completed the body of the figurine by rooting her, uniting her and in the process, myself, to our larger body, the Earth. I stood back and examined her there, firmly set upon the large limb that extended eastward from the trunk. A current of warmth passed through me as I remembered my last look at the figurine joined to the ceiba tree on the banks of the Rio Usumacinta ten years before. In reminiscence of that sight etched forever in my mind, I painted a thin white spiral emanating from her mouth upward through the branches of the still barren tree, into the turquoise sky.

Part Two

"A star falls when a tree is cut."
—Chan K'in Viego, Lacandón elder

One Leaf, One Being

It rained lightly all night at my shoreline camp beside the ceiba tree. At daybreak, I was awakened by raucous bird and animal calls of the jungle. Today was the fall equinox. The air was clean and pure after the night's shower, and the Tree of Life glistened silver in the wetness. I climbed up to gaze upon the altar. The clay head sat regally in a shallow pool of water that stood in a small hollow formed at the union of the

tree's main limbs. The little pool reflected the ceiba's leaves and branches, and the blue sky above. Connected to Earth and sky, the little head seemed to float on the emerald-colored cloth with the snake skin like an exotic gown around her. It was a magnificent sight to behold, and I was content for it to be my last of her.

As the sun rose over the tree canopy, I sat on a rock beside the river, eating nuts and dried fruit. I wrote in my journal. Then, an urge suddenly came over me. The air was getting hot, and near the base of the tree was a long pile of pale green and yellow leaves that the wind had blown into a hollow beside the embankment. I lay down in them and began to spread the leaves over my body. When completely covered by their moist and peaceful coolness, I relaxed and imagined my body as part of the tree above—one being, one leaf on the Great Tree of Life which carries within it the blueprint of all trees and all life. I realized that the sap of the tree runs through every leaf, including me, connecting us all together as One.

I felt the roots of the tree extend into the dark, fertile soil below me, uniting with the roots of other plants and trees, all of them holding the entire fabric of Earth together. With each breath I drew in the scent of the leaves, the river, and the jungle. The moist sustenance of Earth's nutrients journeyed upward, conveyed through the trunk by the tree's immense beating heart, into me, into each leaf and branch in an unspeakable longing to help us reach sunlight and sky. My leaf being was a bridge between Earth and sky, gathering sunlight to create the life blood that nourishes and sustains the Tree of Life.

The wind rustled and shook me, as I became infused with a deep sense of communion with all creation. Tiny insects scurried across me. Birds sang sweet melodies beside me. Hummingbirds sucked nectar from the flowers that surrounded me. And then, like other leaves occasionally falling from the tree, I fell to the ground slowly, sailing in the light breeze to a place of rest to relinquish my life and nourish the earth from which I had come. Facilitated by rain, sunlight, and insects, my leaf form dissolved into millions of molecules that fed the soil. Absorbed by the tiny rootlets of the tree overhead, I journeyed up through the trunk to become, again, a part of it all in the grand, miraculous tree-dance of life.

Overjoyed, and itching like hell, I sprang from the leaves and made a beeline for the river. Hundreds of yellow butterflies were flitting about, intermittently resting on the wet sand. They were disturbed in my path and burst up around me as I dove into the cool, green water. When I surfaced, they were fluttering here and there above me and on the shoreline, dazzling nature angels blessing this day. With several butterflies perched

on my head and my shoulders as I stood, dripping, in the shallows, I gave thanks for the blessing of the equinox, this peace, this tree, this still-wild forest, and all life.

I lazed about in river bliss and butterflies for half the day, then packed my gear and headed back toward the pyramids. A thunderstorm was brewing, and I was excited by the possibility of watching nature's display from the highest temple.

The *Wacah Chan*

I hastily reestablished my original campsite in the quiet cove by the river, then headed for the ruins with anticipation. It was late in the day, and no tourists or archaeologists were about. A sleepy guard sat beside the entrance, and I wondered about the protocol of exploring these seldom-visited ruins. Being alone here felt important, and my desire was strong. Approaching the guard, I explained that I wanted to photograph the approaching storm from one of the temples. I tipped him handsomely and had the impression that he was making an exception as he looked around cautiously, smiled, and let me pass.

Wandering alone through the lichen-"painted" ruins of Yatchitlán to the rumble of distant thunder, I felt the enchantment and intrigue of a visitor to a lost world. The towering trees that surrounded the ancient temples and ruined buildings were shrouded in a verdant diversity of orchids, bromeliads, and liana vines, all competing for light. The increasing wind charged the scene with magic, and two thousand years slid away before me. It felt as though a Mayan king might slip out of a shadowy doorway at any moment.

The ancient city ascended from the river in a series of broad, massive terraces built against the face of the forest-covered hills, thus creating a jungle citadel. The tallest bluffs supported the temples, giving the lords of Yatchitlán a commanding view of the low-lying rain forest that swept from the far side of the river south around to the northeast horizon. As the storm gathered energy in the northern sky, I climbed to the roof ledge of Shield-Jaguar's palatial observatory, the oldest surviving structure at Yatchitlán.

Mayan buildings functioned as metaphors—pyramids as mountains, and temples as caves leading to the Underworld, with doorways carved in the image of gaping monster mouths. They served as setting and stage for the ritual pageantry that continually reinforced the power of the kings. On August 2, 320 c.e., Yat-Balam ("Penis of the Jaguar," or more

delicately put, "Progenitor-Jaguar") founded the dynasty that ruled Yatchitlán throughout its recorded history. The ruling descent of this line was unbroken until the city was abandoned 500 years later. The most famous of Yat-Balam's many descendants were Shield-Jaguar and Bird-Jaguar, a father and son who collectively ruled the kingdom for more than ninety years.[7] Their likeness is carved throughout the ruins, and I imagined them ascending the temple with me to perform a ceremony before the storm.

When I reached the top, I scanned the horizon in each direction. To the south and east, range after range of serrated hills telescoped into the hazy, unbroken rain forest as far as the eye could see. This was the Petén, Guatemala's wild and mostly protected portion of the rain forest. To the north and west, the rain forest was increasingly fragmented by roads and cut-over land. The wind blew fiercely, as a rolling line of gray clouds moved slowly south over the darkened forest toward the temple. Thunder and lightning grew closer and closer together. Smiling like a fool, I watched the sky as the wind grew stronger and rain began to fall. I stretched my arms up, feeling myself as the tallest being for scores of miles in all directions, in love with the wildness and connection to the Mystery so present here. Then I scrambled part-way back down the temple, into a large doorway I had noticed on my way up.

Lightning struck several times in the forest nearby, as I huddled within the stone enclosure. I pulled my flute from my pack, and as I began to play, the notes resonated richly in the chamber. The walls, carved with hieroglyphics, seemed to dance eerily in the lightning flashes. I played to the *chacs* and *balams,* the Mayan gods of sky and forest that were so alive, connected, and in evidence that evening.

When the storm passed, I climbed back to the top of the pyramid in time to see the sun burst through clouds just above the horizon, casting all of the forest in a warm, glowing light. Time felt suspended at the still point of the world, and I imagined myself a "Tree of Life King," Bird-Jaguar perhaps, 1,500 years before, bowing to *Ka,* the sun, as it slipped into the forest. Mayan kings were the conduit of communication between the supernatural world and the human world. The realm of humankind was connected to the Otherworld along the *wacah chan* axis, the World Tree, which ran through the center of existence. This axis had no single location in the earthly realm—rather, it could be made manifest through ritual at any point in the natural and human-made landscape. In the rapture of bloodletting rituals, the King brought the great World Tree into existence for all the populace to experience, through the middle of the temple which opened the awesome doorway into the Otherworld. Mayan

astronomers who were able to predict heavenly events such as equinoxes, solstices, and occasional eclipses were employed by the kings, and with the skies seemingly at their command during massive, meticulously-timed public ceremonies, the kings held their power for many hundreds of years.[8]

Las Plumas

The light was all but gone and night closed in around me as I made my way back through the tree-shrouded ruins. Ghosts and spirits felt uncomfortably close, and my heart beat uncontrollably. The stone-strangling vines of the jungle seemed about to reach out to pull me back to the ancient past. The rational mind has little defense against the imagination during such times, and the compelling need is to hurry back quickly to the familiarity of one's time, one's world, one's tent. It was completely dark when I reached the river and found my camp. Exhausted and joyful with the day's events, I quickly drifted to sleep.

I broke camp the next morning. While waiting for the boat that would take me back to Frontera Echeverria, I walked downstream to the site of the ancient bridge. Along the way, I saw a woman emerge from a dugout canoe and head into some bushes carrying a large scrap of blue cloth. In an instant, the source of all the cloth I had gathered along the river became clear. They were Mayan butt wipes! I sat down, chagrined, and wondered how to tie this piece of information into the oracular "reading" of this place.

Laughing to myself, I immediately thought of the Mayan community linked together in this region by the rain forest and the river. Each scrap of cloth had been steeped in the flow of the river's floods and seasons. Spread out along the roots of my Tree of Life and underneath the figurine itself, these very human colored tatters were a fine way to represent the hope and community of our species. To think of them as litter, or as something unsanitary, would be missing the point. The Mayans that used them live very simply along the river and produce minute amounts of waste compared to some of us. No one farms the rain forest more efficiently than the Lacandón people do. Using ancient Mayan techniques, they create in their fields a partial replica of the forest's complexity with its layers and mixtures of plants and animals—exactly the opposite of modern agriculture. Farming their *milpas*, fishing in the river, and trading with their neighbors, Mayans exist mostly on a subsistence level with little need for money. Compared to the waste produced

by our money-driven world, the cloth swatches found along the river are something entirely different. Ironically, the Lacandón word for money, *T'ak'in,* means literally "the excrement of God."[9]

As is true for indigenous cultures across the globe (and perhaps for others as well), it is this "excrement of God" and what it buys that continuously erodes the integrity of their way of life. Ancestors of the modern Lacandón retained their freedom by forsaking their civilization, fleeing into the forest. They abandoned their jaguar skins and temples. They forgot the calendar and hieroglyphic books. What they retained was the lore of nature: knowledge of seasons, herbs, and wild animals, worship of sun, moon, and natural forces. They distilled Mayan culture to its essentials, to the very foundation upon which their civilization had originated more than three thousand years before. Surviving in the jungle by mobility and the simplicity of their needs, the Lacandón resisted outside forces until the twentieth century when they became indoctrinated and slowly domesticated by Christian missionaries in search of "heathen" souls. *Lacandónes,* a term given by the Spaniards to any unconquered Maya, means literally "those who worship stone images." A few traditionals still make regular offerings in the ruined temples of Yatchitlán and Bonampak.

I had encountered some Lacandónes a week earlier, outside the famous and heavily touristed ruins of Palenque. They were not traditionals, although they worked hard to have that look. Rather, they were the epitome of a culture in the throes of ruin by *T'ak'in.*

Dressed in clean white smocks, with manes of long, wavy black hair hanging nearly to their waists, they presented quite a sight assembled in groups of two or three, selling bows and quivers of arrows to passing tourists. I had seen these bows and arrows in city curio stores. Here, however, they were displayed under a giant ceiba tree, the literal representation of the World Tree. It was a surreal scene. What struck me the most was the arresting beauty of the arrows themselves. Each shaft was tipped with a flint head and fledged with multi-colored feathers. The feathers were almost mesmerizing in their beauty and apparent authenticity. For an hour or so I watched, as the tourists and the Lacandón Indians conducted business. The rapt look on the faces of the mostly middle-aged and elderly tourists as they approached the Indians and their wares fascinated me. They looked at them transfixed with wonder, and fingered the arrows as if they were sacred objects. Repeatedly, money and goods changed hands. Agape with the enchantment of the forest and the token of rare authenticity they were able to actually carry home with them, the tourists entered their buses unaware of the depth of their bargain. "Did they ever wonder," I

thought, "where those feathers came from?" Certainly not from chickens. And—if they knew, would it make a difference?

I had recently hiked into Bonampak, a protected Lacandón forest reserve around ruins that contain what many consider to be the best preserved murals in Maya land. It was a two-hour walk through the forest to the ruins, and during my trek, birds and bird calls were conspicuously absent. At the time, I wondered why. As I sat on a bench in the Palenque parking lot watching the natives sell their wares, I recalled my walk through the forest and the answer became clear. I decided to ask one of the vendors.

Holding an arrow in my hand and touching the pretty feathers I asked, "Donde es la origination de las plumas?" He and two others seemed not to understand me. I asked a younger lad, standing alone in front of his display, about the origin of the arrow's feathers. Perhaps he had not been cautioned about such questions and answered *"aves de la selva"*—"birds from the jungle."

An anthropologist in Yatchitlán had told me that many of the homes in the Lacandón villages of Naha and Lachanha have televisions and washing machines, even though as yet they have no electricity. Apparently, many of these "unconquered ones" have now been seduced by the glitz of the modern world.

To the modern world I reluctantly returned, as the long dugout canoe motored back toward roads and wires. I again watched the colorful flocks of parrots fly among the trees and was glad for the isolation of this place but also knew how fragile it was, and how close by lay the juggernaut of civilization. How long would the tropical birds last, feeding the western world's dreams and cravings for a lost authenticity?

The fragile Lacandón forest is only the western extreme of North America's last rain forest. The vast emerald canopy extends north throughout Quintana Roo, down eastern Campeche in Mexico, and south into Central America, covering much of Belize and Guatemala's Petén region. Flying above, several years before while working as an aerial photographer for Lighthawk, it had seemed an untouched wilderness. However, the population of the Petén alone has soared from 20,000 to 400,000 in the last four decades, as petroleum speculators, logging operators, cattle ranchers, and landless peasants exploit this abundant frontier. Ninety percent of the good farmland is owned by ten percent of the people in a region where the per capita income is about three hundred dollars per year. Population pressures have forced families to leave their homes and form colonies in the jungle. They follow the logging roads to a

clearing in the forest where the largest trees have been cut, then burn the remaining vegetation to create cornfields. When the soil becomes depleted in a few years, the land is sold to cattle ranchers, leaving the people homeless once more.[10] In an effort to protect their mutual rain forest, the governments of Mexico, Belize, and Guatemala have set aside ten million acres as reserves and national parks. Much of this land, however, is protected on paper only. Given the current rate of destruction, experts predict the forest may be gone by 2010. We must trust and pray that the Maya, and others living in buffer zones along the protected area, will realize that their future—as well as their past—lies within the forest.

The Love of an Oak

The Great Tree of Life, whose branches and roots are withered and dying in much of the world, still clings to life because of wild places like the Lacandón rain forest. I looked at my painting in the back room. Except for the two snakes coiling up from the roots below, it was lifeless and looked dead. I knew it was time to breathe life into it, but how?

I remembered a picture my friend Lori Thompson had sent me of the stump of a once immense, triple-trunked oak tree she had dearly loved. While Lori lived in a nearby townhouse, this tree and the grove that sheltered it became a place of refuge and peace for her and her son. Somehow, the city of Buffalo, New York, had grown around this forgotten twenty-acre wildness, which lay between a football stadium, an apartment complex, a highway, and a subdivision. Out of place like a magic land, the sparkling creek that flowed through the grove spoke softly of the animal abundance and native connection of an earlier time.

Lori and ten-year-old Jaymes constructed a medicine wheel of stone and carefully built an earth lodge near the oak at the edge of a little bluff above the meandering creek. In the midst of streets and cars, houses and wires, it was a sacred place in a way only the last of something can be. Even after she moved to the country, this place remained a sanctuary in Lori's life and she returned whenever possible. Getting to know this land in intimate ways attuned her to this island of wildness and in a sense, she became a part of it. However, it was not until later that she discovered the true meaning and depth of her connection to the grove.

In January 2000, Jaymes was in need of surgery to correct a sixty-degree bend in his spine. This severe scoliosis resulted from a spinal cord tumor he had at birth. For several weeks, Lori felt uneasy and was drawn

to return to the oak trees she loved. But the details of healthcare prevented her from making time to visit the trees, and she kept telling herself she would get there as soon as she could. A month passed, and finally her son was home from the hospital. Lori was exhausted emotionally and physically, and decided to head for the sanctuary of her stone wheel among the oaks. There is no way she could have been prepared for what she found. Bushes, grasses, and flowers had been torn up and trampled. Tracks of machines and men were everywhere. All the giant oaks were cut down. Their big straight pieces had been hauled away. Everything else remained as it fell—hacked, twisted, broken.

She recalls: "As I walked along the path, my eyes witnessed a great violation—a great wounding—as if all of the world's pain, for a moment, lay bare before me. I felt numb in disbelief. Sadness and anger of indescribable magnitude flooded my body. I ran through the woods, heading for my earth lodge. The path was invisible beneath broken branches, limbs, and tears. All the pain felt by Mother Nature at the hands of man seemed focused right here at this moment. The grief was so great I could barely hold it and fell down upon the Earth crying in anguish, asking for forgiveness, for we know not what we do.

"Somehow I felt responsible. Could I have protected them? How could something so vital and so elegant be taken with such disregard? I made my way to the medicine wheel and stood before the furthest oak that had been cut down. It was the triple-trunk oak, and it lay only a foot or so from my medicine wheel—reaching almost—as if crying out for help in its final moments. Had the trees been calling me?

"I sat down in my circle shaking, afraid to move as all the emotions swirled around me. I tried to imagine a worse feeling and thought about people who had witnessed the violent death of a loved one. I could not imagine the pain of such a violation but I knew in my heart then that our wars against each other and against nature have created so much cultural grief that we are all suffering to some degree from post-traumatic stress disorders. It is a grief so great that we bury it beneath the rush and distractions of our modern world and so it grows, to what end I shudder to know. I went and lay down across the stump of what I considered the grandmother of the oaks...the triple trunk surrounded by a tight circle of stones placed there by someone many years ago. Some of them were almost embedded in the base of the trunk. I wept. I asked for some kind of understanding and guidance. Why had this happened? Why did I witness it, and why now? Who were these people who sold these trees? What did they love and what have they lost? These great oaks, hundreds of years old...gone. Gone. I felt hopeless and paralyzed. What was I sup-

posed to do now? I had to do something."[11]

It was through the sacrifice of this grove that Lori and I became acquainted, for the day after her discovery, she frantically got on the Internet, typed "trees" into a search engine, and eventually, through a series of synchronicities, found my ZeroCircles website and me. "When I read Daniel's words on the screen late that night," she remembers, "about the violation of our planet and our need to heal and resurrect our sacred connections, tears streamed down my face in recognition. Perhaps one other soul understood, and perhaps there were more."

Feeling aligned with the ZeroCircles idea and the healing power of Earth art in general, she wrote to me. We discovered many things in common—she, too, is an environmental artist and we connected on many levels. Eventually, we came to agree that Lori should be an illustrator for this book. When I visited her in New York to discuss the project, she took me into the grove and shared the depth of her pain. Seeing her there, standing in silence with her head bowed beside the stump of the slaughtered tree she had loved, was like witnessing the spiritual devastation of someone who had just lost their house and belongings to a fire. But it was even more than that, for a house is not a living thing.

Lori lit a bowl full of sage and blew smoke over the stump, while I sang a Native American death chant I had learned many years before. It was given to me by a medicine woman with the admonition: "Use it only in the presence of death." When I first heard the chant, I gave it a tune to help me always remember the words. I have used it many times since then, in encounters with the death of trees and animals. Few things I have heard in this lifetime carry the power and healing of this chant. My father died of leukemia on Earth Day weekend in 1999, and the memory of singing the chant among family who stood in a circle around his body in the hospital room became sharp in my mind as we stood before the stump.

> *Never the Spirit was born*
> *The Spirit shall cease to be, never*
> *Never was time—It was not*
> *Endings and beginnings are dreams*
> *Birthless and deathless and changeless*
> *remain the Spirit forever*
> *Death has not touched him at all*
> *Dead though the house of him seems*

The Tree of Life

When we allow ourselves to bond in a sacred way with a particular tree, or a special wild place, the Earth spirit begins to flow into us. The place we love gradually becomes a part of our very being. Falling in love with a tree or a wild place is a natural thing. It is our birthright as conscious beings on Earth. It should be a safe thing, for what tree, what wildness would ever desert us? Through the love of nature we can find our wholeness, for indeed Nature is the very residence and essence of our invisible souls. Yet, because nature is everywhere in retreat from us, and wild, protected places are generally far away (only four percent of our nation's land is protected), fewer and fewer people know the beauty and power of truly bonding with a living part of wild nature. Without these bonds, our species-wide disregard and disconnection from nature grows ever deeper and as a result, we may be in danger of losing our souls.

Perhaps it is foolish to fall in love with a tree, if the tree happens to be growing in an unprotected urban area. Yet, isn't this the kind of emotion that has always inspired the protection of wild places? It takes great courage to risk our love for something that is fragile, that may be gone next year or next week. Isn't that the truth, however, for anything or anyone we choose to love? Indeed, we must love the wild nature we find nearby that clings to life. I can think of nothing more important than *declaring sacred ground* in the unprotected wild areas near our homes. Through the love of these places, we can retrieve much of what has been lost to us—perhaps even our invisible souls. If we have ears to hear, these places are speaking to us now as individuals, for it is from individual loving acts that we keep the Tree of Life beating in our hearts and souls and on Earth. To ignore the sounds of Earth crying out to us is to ignore the *wacah chan*, the life force that sustains us all.

If there is a lesson from Lori's experience, it is to learn the issues around the fragile wildness you decide to bring close to your heart. First, assume it is in danger because indeed it is. Who owns the land and what is planned? Be diligent, work quietly and quickly, for there may be a way to protect it via a Land Trust, conservation easement, or purchase by the city or by friends who feel as you do. Be prepared to defend it as much as you love it, for if it is ripped senselessly away, your grief will be immense and long-lasting. And if there is simply no way to save the wildness you have found, consider loving it anyway, bearing witness to its passing. Such acts carry great blessing.

Resurrection

I have photographed hundreds of clearcuts and the devastations of industrial man all over the world, but I don't think I have ever been so touched by the destruction of a place and its impact on one soul as I was by the loss of Lori's oak grove. And so, it was on her photograph of the ghost-like stump of the sacred triple-trunked tree that I knew I would begin to paint the resurrection and blossoming of life. I pasted the photo onto the base of my Tree of Life. The sacrifice of this wild oak tree then became a symbol for every clearcut in our national forests and every acre of rain forest burned into pastures. It stood for every river dammed and each endangered species lost forever. It became a metaphor for modern society's severed connection to nature and the vital need for its resurrection. And most of all, it stood for every lost, bulldozed, logged, and developed place of beauty and wildness ever cherished and loved by a child, a man, a woman, or a community, and the lakes of tears shed throughout history by the witnesses of nature's retreat in the name of progress.

Dipping my brush into brilliant orange, I painted over the exposed cut section of the oak stump and imagined a healing taking place, a completion and the beginning of something new. Then I painted a tall trunk rising up, connecting to the trunk in a photograph pasted above it of a beautifully shaped favorite oak tree in full foliage. I painted yellow and orange fruit into the oak and then painted a large limb branching out through the side of the trunk, sprouting a fruit-covered branch. Recalling the lightning-struck oak tree in Kansas from which this tree took its likeness, and the days I would sit for hours in silence (hoping for wildlife to approach or pass overhead), I painted a deer to the west of the trunk and a red-tailed hawk flying from the east.

In the teachings of the medicine wheel, west is the place of transformation. As the deer took shape in my painting, it was empowered by each stroke to resurrect things lost in my life and the life of our species, to transform that which separates us from our wholeness. The hawk flew up from the east as the Phoenix from the forsaken land coming to reclaim and rewild the Earth so future generations can live here in balance. The east is the place of illumination and enlightenment, and I directed the bird to find and lead my invisible soul homeward. The bountiful life-generating forces that were beginning to flow through my tree are universal in human mythology. While the symbolism is mostly forgotten in our society, our Christmas trees function as the Tree of Life each winter when we decorate them with "fruit and animals." By candlelight, I played guitar and improvised songs to the tree, wondering what to paint next.

The Tree of Life

Ode to Joy

In nearly all contemporary and historic religions, the Tree of Life survives as an archetype from one of the oldest forms of religious experience—shamanism. Woven through these traditions are three worlds linked by a Tree. The tree brings these realms together, reaching down into the fecund, primordial void and skyward toward the boundless mystery of the universe. The roots stand for the *lower world,* home to unseen creative forces that unleash their magic and synchronicity. Here lie our collective unconscious, our memories, our karma, and the archaic past.

The Tree's trunk symbolizes the *middle world.* It serves as a bridge between matter and spirit, with its ever-expanding growth rings an expression of the eternal present. The Tree of Life is often depicted with a spring emerging from the base of the trunk, bringing forth the waters of life. And so, on the second night of my painting's emerging life, I painted a small, cave-like opening and spring into the base of the oak stump in the center of the Tree. With turquoise paint, I filled this entrance to the tree with rushing water, just above the two entwined snakes poised in the black soil below. As an offering to the world I wanted to access through this "doorway," I tacked above the opening a tiny cloth bundle filled with fragments of mirror and glass swept up from the day I missed the counter with my cup of shards.

The *upper world* consists of the Tree's branches, leaves, flowers, and fruit.[12] It is the realm of luminous vision, where sky-beings breathe winds of inspiration and creativity down upon us. It is the kingdom of mystical ecstatic union, a land where the Great Spirit can beam visions, and the fire of illumination, into our souls.

Taken as a whole, the descending roots and extending foliage of the Tree of Life are metaphors for enlightenment, a way of raising, channeling, and focusing the energies locked within us for spiritual transformation.

I decided that the third day of painting life into the Tree would mark the beginning of the Great Blooming. Knowing it would be important to enlist serious help in this effort, I dropped one of the Mayan clay shards I had brought home with me from Yatchitlán, breaking it on the tile floor beneath the tree. I ground up one of the pieces in a small bowl, lit some sage and several candles, put a CD of Beethoven's Ninth Symphony into my portable stereo, and went to work. As I dipped the paintbrush into black and then into the ancient shard powder, the snake body began moving through the spring up into the Tree. Its head emerged out of the large hole in the top half of the trunk just above a photograph I had taken of the Tree. Dipping my brush in the shard powder each time—returning, in

a way, the pottery pieces to their place of origin—I painted three white birds emerging from the snake's open mouth. They carried a special prayer to each of the three worlds. This took a long time to get right, and I finished in silence long after Beethoven's symphony had ended.

I replayed the finale, *Ode To Joy,* and cranked up the volume. In the candlelight I sat down and contemplated the Tree of Life before me. I was quickly overcome with emotion in the union and love for the oak trees in my life, for my invisible soul growing ever closer, for the sacrifices I had made, and for all the blessings of my life. I recalled the ceiba tree on the Usumacinta River in Mexico and the figurine's head I had left there ten years before. Things grow fast in the rain forest, and by now it surely had been absorbed by the growing limbs...at one with the tree. With that memory and the dramatic look and feel of the Tree of Life before me, I felt a ripening, a sense of Home and completion I had rarely known. I wept tears of joy and release.

I knew that my painting had only just begun, that until there was not an inch of bare wall left, I would continue to paint life into it. And when there was no longer any space, perhaps new trees would sprout on the side walls of my utility room and the beauties of nature observed each day—the little synchronicities, songs, and joys of life—would become the fruit upon it.

I set a single candle below the painting and spread my favorite rug out beside it. In the silence, I laid my body down to begin a new journey, knowing that the Tree of Life glowing magically above me would be a neverending ceremony to *wacah chan,* the life force. It would become a Forest of Life.

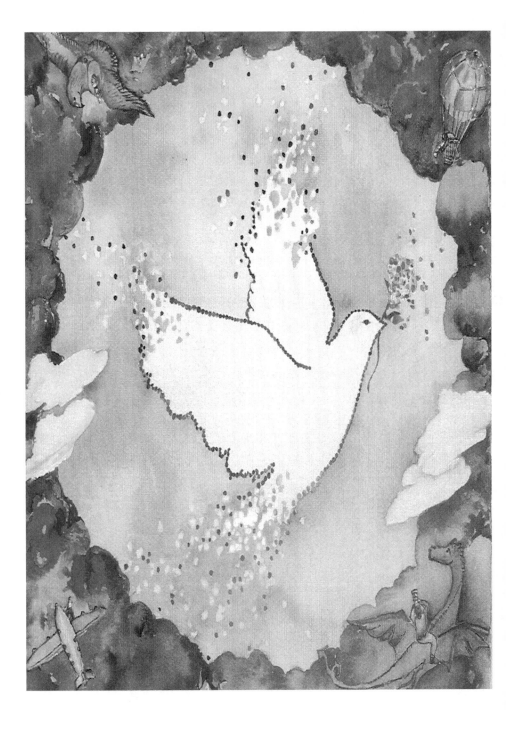

Chapter 10

From Earth to Sky:
Art For the Great Mystery

"From this hour I ordain myself loos'd of limits and imaginary lines."
-Walt Whitman

hen we look back on our lives we can identify the watershed events, the special random occurrences that had they not happened, our lives would be very different. I could not have anticipated that a simple visit to an old neighbor in Kansas would inspire much of my path ahead.

Around the time I was finishing this book I paid a visit to my old friend, Joe Malone. Joe had been a struggling family farmer down the road from the Sleeping Beauty Ranch and also worked as a part-time prison guard. He had helped me once on collaborative project with my friend Stan Herd, the now semi-famous "crop artist." Stan uses a tractor as a paintbrush and crops for color on giant images that only make sense from high in the sky. Back in the fall of 1990, Joe let us use one of his fields and his tractor for the creation of a 25-acre image of the head of an Indian warrior. It was called *The Native American*. To add more color to the image, I invited the entire elementary school in the nearby town of Oskaloosa to all dress in red and blue and become beads on the headband of the giant field figure. Eight busses brought them out and I photographed the scene from a helicopter, one of the most spectacular sites I have ever seen from the sky. Nearly 20 years later, sitting beside Joe on his front porch over looking the Big Slough River valley and the ripening cornfield across the road, we recalled the

213

magical event. He told me something startling which was to set the course of my work for years to come. His son Johnny, now fully grown, had been one of the beads on the headband and it had been a transformative experience for him.

"The whole thing seemed like chaos on the ground," Johnny told his father years after the event. "But when I saw the picture taken from high above and how beautiful it was I realized over time, how important it is to hold a "big picture" view of life, how it helps us to better make sense of our lives, to see how everything fits together. I think it was the most important thing I did in school and it's what I remember most."

That bit of information was like pollen to a flower. The solo work contained in this book had often led me to thinking about how I might bring the fruits of what I had learned into the hearts and minds of many, especially children. Johnny's words about his experience and my own desire to reach out to greater numbers of people inspired my current path of leading artist in residencies in schools and communities called *Art For the Sky*. What began with Stan using crops for color in many-acred living works of art led me to "paint" literally using people as color in the creation of giant living paintings on soccer fields, parks and in wild landscapes. In a way similar to the solo works contained in this book, the sky art formed by the bodies of hundreds of participants (often including leaves, cast off clothing and recyclables) can be seen as both prayer put into form and celebration directed to the Great Mystery that holds us all.

Pilgrimage to The Lines

Stan wasn't the first to create art on a scale most appreciable to eagles and clouds. There was a mysterious race of ancient artists in the Nazca Desert of Peru about 3000 years ago who, through the concentrated work of many generations, left art upon the earth seemly created by giants with impossibly large rulers. Thousands of lines, some as long as 3 miles, immense geometric figures and animal shapes lay scattered across the immense desert silence. Many are concentrated in an extensive plain near the town of Nazca but some are still being found to this day, so remote and far stretching is this region. I was in my teens when I first heard of the Nazca Lines and they have held me in their spell ever since. At the beginning of my venture into actually trying to make a living doing "art for the sky" I knew I had to make a pilgrimage to The Lines.

When my bus from Lima entered the Nazca Desert, I was unprepared for the vast wastelands that met my eyes as we rolled on for hundreds of miles on our way to the remote town of Nazca. This is the driest place on

earth and it was summertime. I drank water constantly to stay hydrated and the people I encountered in small villages along the way were the dirtiest I had ever encountered anywhere. Obviously water was precious. Only when entering one of the occasional and very seasonal river valleys did I see the color green.

In my pack I had a bag full of beanie babies my daughter had gleaned for me, before I left, from her vast collection . . . "gifts for the trail" she said . . . and I gave them to the shy and grubby urchins I encountered on my bus ride through the desolate and heat baked region. Their wide smiles of appreciation were as big as my wonder as to how anyone could eke out a living in this land. From time to time the bus would stop at some small outpost to deposit or pick up a dust-coated passenger or two. As I would soon discover as my trip in Peru continued, there seemed to be a practice acceptable on bus rides whereby a unique kind of salesman, entertainer or proselytizer, would climb on board and try to engage the entire bus load with all sorts of antics, gyrations and enticing language to sell everything from Jesus, books and knives, to a salve from the Amazon called *Una de Gato*, which, judging by the way the young man pointed to every conceivable part of his body and spoke on and on tirelessly with a very doctorly expression, it seemed this rare and special product available for a pittance, could heal just about anything from hemorrhoids to arthritis. He distributed a boxful of the gold, medallion-sized canisters throughout the bus and sold most all of them it seemed to me, judging by the number of coins that came his way. I bought one myself and when I googled it later at home, it turned out to be "cats claw", a potent immune booster from the Peruvian Amazon. Between the likes of medicine man , the beanie-baby-giving and an unusually clean fellow who came on board sporting a monkey on a leash with diapers, the bus ride, hot and dry as it was, was quite enjoyable.

When I finally arrived in Nazca I was somewhat shocked as to what a tourist attraction The Lines had become. Emblazoned on everything from hotel signs to t-shirts, earrings and playing cards were the popular animal figures that lay on the desert floor for all these many years. Hummingbird, lizard, monkey, spider, tree . . . I encountered them everywhere. I had no idea The Lines appealed to so many. But then why not? They are intriguing, mysterious and beautiful. I bought two blankets sporting the hummingbird design, which cover my bed and my son's bed these days.

When I flew over The Lines the next morning in a hired plane, there they were below me, those very same figures emblazoned on everything imaginable in the town of Nazca. In the midst of lines on top of lines, amongst geometric shapes stretching to the far points of the compass, the

figures met my eyes through the plane's front passenger window from the lofty angle they surely were designed to be seen. As I photographed them one by one I wondered what in God's name were these people up to, creating art that only made sense from way up here? Hundreds of people fly over the lines most every day with the same question surely ringing in there minds. There are many theories about the lines but most are based on insufficient evidence. Some key elements, like the beak of the hummingbird for instance, predict celestial events such as the winter solstice. Probably these ancient artists were trying to appeal to the Gods, to say something about water in gratitude and celebration, for they were totally dependent on the flowing of seasonal rivers carrying snowmelt form the Andes mountains. It is likely they will always remain a mystery though, for try as we might, it's impossible to know with certainty how a desert dweller thought 3000 years ago.

It was on the ground the next day however, up close and intimate, that the true majesty of the lines took hold of me. I hired a taxi to take me out to the 70-foot observation tower 15 km from town on the Pan American Highway, and climbed the ladder to the top where I could see a tree of life figure about 150 feet-long and what looked like a hand in the distance about half that length. Though well before noon, the desert sun was already blazing and waves of heat shimmered across the horizon. A few tourists came and went, photographing one another with the lines and endless desert in the background. For a distance of about 200 feet, graffiti in various colors was painted upon the highway asphalt in front of the tower, some of it emulating the lines in miniature— a pale compliment to the ancients, I suppose.

My plan was to walk down the highway a ways and then strike out in to the desert at a point where a line intersected the road. After a mile or so, when the road curved around a hill and the tower disappeared from view, I found what I was looking for— a three-foot-wide, eight-inch-deep line angling off towards a long burnt orange mountain in the middle distance. I walked beside it in the increasing heat, my sand-colored shirt wrapped around my head as I had stupidly forgotten my hat. I wore desert colors as technically, one was not supposed to walk amongst the lines and I did not want to be seen from the air. I didn't worry much about that however, as the area of the main concentration of lines and figures is about 200 square miles.

As I walked beside the line it was easy to see why they stood out so clearly. The surface of the desert floor was a mat of brown and black rocks of many shades and sizes. Underneath them lay white sand which, when exposed, created the kind of contrast artists need. I picked up big dark rocks

along the way that had tumbled into the lines and moved them off to the side . . . a bit of repair work I surmised, to help justify my illegal walk. I paused to take a few pictures and a swig from the last of my two water bottles. I thought about my days working with Stan Herd long ago and how important it was when photographing his giant paintings from the sky, that the lines be freshly plowed to reveal that important contrast which begins fading as soon as the newly turned and dark soil is exposed to the sun. Not so here, in a land where a 1/2-inch of rain a year is a deluge and the "soil" is dark rock. Who knows, their art may outlast our own civilization. Or maybe climate change will wash them all away. At any rate, they had already lasted a few thousand years and I kept wondering as I walked along this one single line, one of many hundreds of miles of them, what compelled these intrepid people to work so hard in the adverse conditions of this desert wasteland. What were they up to? If only stones could talk!

After walking nearly a mile, the line ended abruptly at the edge of an arroyo. When I climbed a low hill for vantage, I could see that it continued on the other side. A few hundred yards or so to the north I spotted what appeared to be a spiral on a small plain tilted towards me and parallel with the line I had been walking along. Thirsty, with my bottle almost empty, I decided to head for the welcome curve of the shape ahead and then back to the highway to catch a ride back to Nazca. Thankfully, some high clouds began to shade the sun as I approached the outer ring of what indeed was a spiral. I paused beside a small cairn at the entrance to the opening and offered a few precious drops of water and then walked in slowly, replacing a few rocks that had fallen into the line as I moved along, circling round and round, towards the center. I sat down beside a large tumbled cairn at the heart of the spiral knowing that this was the culmination of my pilgrimage to The Lines. I closed my eyes and reflected on all the things I had to be grateful for, said a few prayers, and asked that the work of these ancient mystery artists infuse my own budding work of a similar, though far less permanent nature. I took a drink from my water bottle, swirled it around in my mouth, and then spat it upon the rocks recalling that such a gesture in the famous book *Dune*, was the highest compliment that one could pay another in a land without water. I heard the drone of a plane overhead and remained motionless. When the sound faded, I retraced my steps along the spiral and considered the meaning of this symbol etched by ancients everywhere around the world on everything from canyon walls and desert floors to pottery and our very skin. One might consider the spiral the very grain of the Universe so emblematic it's place in Nature. From the twisted double-helix DNA in genes and the great currents of oceans, whirlpools and hurricanes, to

the rotary form of galaxies, shells, pinecones and our own family tree, the spiral theme is ever present.

I imagined the flattened spiral in which I walked to be stretched upwards by an invisible hand from the sky giving it spring or hourglass shape. As I moved along, the past funneled behind me and the future uncoiled ahead. And thus, I was not exiting the way I came in but rather entering a new time, a portal to a way of meeting the world suffused with the ancient beginnings of this beguiling art form that had beckoned me since I was a teen.

Impermanence Rocks

"Okay, boys and girls, say the word *im-per-man-nence*." Without hesitating (they know the drill) 50 bright-eyed first grade faces repeat back in unison, "im-per-ma-nence."

"Okay, once more, louder this time" I ask them.

"IM-PER-MA-NENCE" they echo back with enthusiasm.

"And again, once more" I repeat wondering if such a concept can really be taught at this early age. I mean, I still struggle with it at age 50. And yet, I didn't begin to take it fully into my consciousnesses until I began reading Buddhist texts in my late twenties. What if we began coming to terms with our temporary existence and the fleeting nature of all things when we are five?

Physically experiencing the concept of impermanence in the body is one of the core teachings of the week-long Art For the Sky experience. Each residency culminates with the entire school taking the form of a giant living and breathing piece of art by becoming human "drops of paint" on an image drawn upon their playing field: a 200-foot-wide dove, salmon, bear, bighorn sheep, etc. The huge images only make sense when seen from high above and this is a central point of this art. Immanuel Kant said that "for peace to reign on Earth humans must evolve into new beings who have learned to see the whole *first*."[1] As Johnny suggested, we can best make sense of our world by using our imaginations to rise above it. From this vantage we can see how everything is connected, how everything fits together. Sure, we know this intellectually but we haven't yet learned how to truly see this connection, this whole, first. I call this way of seeing our "sky-sight" and believe this ability lies dormant in our brain, ready to activate our highest creative potential. Our very survival as a species may be dependent upon its awakening as it is readily apparent that we are not able to solve the critical problems of the world on the same level in which they were created.

From Earth to Sky

"IM-PER-MA-NENCE" the children repeat back a third time. This is the first day of my residency at the Bishop Elementary School in Bishop, California, the first day students begin to learn about art on a scale they had never imagined. Creating art that is directed heavenward and is so big that it makes no sense on the human scale, connects us somehow to an ineffable something much greater than ourselves. Call it The Creator, God, The Great Mystery . . . however we choose to name It, after our intentions have been set and the art is completed all feel like something very rare has been accomplished, something unspeakable . . . and just maybe, in some- way we can barely imagine and probably will never know of, there will be a response. Perhaps the ancients felt something of the same and the thrill of it was the source of the tremendous amount of energy and collaboration it must have taken to create such an abundance of art on the parched desert floor of Peru.

Perhaps they had mastered the ability to fly in their dreams and viewed their creations in this way. In my experience with various audiences I have found that about one-third of people have flying dreams and children and teachers love to share the many ways they fly. Flying like superman, a statue, swimming, hovering, turning into eagles and horses, and being pulled up by balloons or umbrellas are just some of the more common ways in which people fly in their dreams. The fact that we sometimes dream in this manner suggests that in a way, we already know how to "fly", that we have a predilection for it. We only need to learn how to bring it into our con-scious minds or, using computer lingo, on to our "desktops."

With the help of selected older students, I measure and mark the 140-foot image of an endangered Sierra bighorn sheep on the athletic field with non-toxic latex paint. There it lies mysteriously for a few days with chil-dren running and kicking soccer balls across it, occasionally stopping to try to figure out where the head and feet are. The day and hour of the big event finally arrives and then suddenly, as children and teachers pour out on to the field to fill the design, the bighorn is overflowing with joy, excite-ment and managed chaos. In the process of tweaking these designs, first on the ground, then with a megaphone from high above in the "man-bas-ket" of a crane, or in the bucket of a fire or utility truck, there comes a moment when everyone reaches the height of collaboration and the image seems to take on a life of its own.

The power of collaboration is one of the central teachings of sky art. Without it, this way of art is impossible. Each individual paint drop is like a cell in the body. When all our body's cells collaborate as a team, we are healthy. When things get thrown out of balance, when we don't have

enough of one kind of cell or too much of another (cancer), we get sick. Nature works this same way of course. We need all the pieces or things begin to fall apart. Art for the Sky is also a metaphor for how change happens and how life begins. When all the participants align in the shape of a salmon, a bear, a loon or a bighorn, a critical mass arises suddenly and the living image fully comes into being. Each individual is absolutely vital to the whole. It's the same way an atom becomes an atom. A certain amount of electrons have to arise out of chaos and align together and when that critical mass occurs, an atom is formed. One electron less and there would be no "birth" of an atom. Physicists call this moment, "phase transition". The Buddha might have called it, "becoming." Everyone kneeling on the Earth in the shape of a figure formed in gratitude as a gift from Earth to Sky creates a field of energy that all can sense. That energy is called *love*.

When everything is properly balanced in the living painting, a charged and special "ah ha" moment of perfection often occurs, a still point almost, that I can sense from up above and reportedly, many on the ground can as well. And then after being held for a short while in the tension of the created whole, form dissolves back into chaos and then into silence . . . coming from nowhere, returning to nowhere.

"Form is emptiness . . . emptiness is form." I first tripped over this slippery koan at the heart of Buddhism back in my twenties. Ever since, deciphering it has been like trying to spin around fast enough to catch a glimpse of my backside or grab a hold of my shadow.

Sometimes when we do art for the sky in mid-afternoon, shadows can be a big problem, like spilling black paint all over the picture. Asking everyone to squat down low with hands upon the Earth can help and yet sometimes the extra blackness adds depth to the image. When a cloud passes overhead and shadows disappear, I feel the play of form and emptiness. (In the Portland, Oregon *Dove In* depicted in this chapter's drawing, shadows lent a spooky look to the flying white dove carrying a rose in its mouth made from 40 bags of Goodwill clothing. 92 year old activist, Granny D, and my son Nick formed the eye of the dove in this event held at the beginning of the war with Iraq.)

Wings to Fly

After photographs are taken with everyone still in position kneeled down with hands upon the Earth, I speak to them with a megaphone from the top of the bucket truck or, if I am lucky, from a hot air balloon. "On the count of three, everyone say *Thank You Great Mystery!*'" Then in unison, the image erupts in joy as hundreds of voices rise to the sky in thankfulness, a

gift from Earth to sky in gratitude for all the blessings and bounty of life on Earth. As our version of the endangered big horn dissolved into a joyous chaos of children dashing to the four directions, I chose to believe that a deep teaching was distilled bodily in the hearts and souls of each participant.

The next morning the entire school gathered for the closing assembly. After giving thanks for their wonderful performance, I come back again to the subject of impermanence: "Impermanence is a natural phenomenon at the very heart of life. Extinction of a species is something entirely different, however. To erase an entire lineage of fellow beings which have been traveling with us for four billion years of evolution, is not acceptable. When you and all your schoolmates were part of the bighorn, in that moment you saw through the eyes of bighorns everywhere. I bet you wanted to live and evolve, didn't you?"

"Yes!" the students roar.

"You craved habitat and wildness, didn't you?"

"Yes!" they roar again.

"To protect bighorns and all species, we must take good care of the mountains, the rivers, the forest, and the sky. When we learn to see through the eyes of all beings, we understand how important it is to respect nature and care for Earth. We understand that Wild is the Way and we must dedicate ourselves to protect that way."

Next, I invite everyone to sing along with me on the chorus of the song I wrote which they learned during the week called "Wings To Fly". The song is a teaching about awakening our skysight. The chorus goes like this:

<div align="center">

I just close my eyes

And go up to where the eagles glide

Where you can't hide a lie

No mater how you try

I go up into the sky

Where I can see with my red-tail eyes

Yes I've got the wings to fly

So high . . . high, high, high.

</div>

This final singing is a powerful part of each residency as everyone in the entire school raises their voices together loudly and with heart before the images of their creation are revealed. When the song is over, the energy in the gymnasium is supercharged almost like the climax of a sporting event, as everyone anticipates the view from the sky . . . the result of their wondrous collaboration. When the first image of the bighorn is pro-

jected large on the wall, a joyous cacophony rises up and threatens to lift off the roof. Children laugh. Teachers cry. What seemed like chaos on the ground was beauty after all.

Onward

My goal with Art For the Sky is to create a web of animals and endangered species across North America. As of the summer of 2006, 30 sky art creations have taken place in 9 states and Canada and many more are in the works as this way of art takes wing. All can be viewed in the virtual Sky Gallery at www.artforthesky.com.

There are some that particularly stand out like the *Sky Griz* with the Blackfeet tribe in Montana on sacred land where the US Forest Service wanted to drill for gas and oil. An infant in the arms of her mother and several elders over 80 were a part of a gathering of 450 native students on wild land, who kneeled down upon the Earth in cold, 30 mph winds to form a giant grizzly bear. Four tipis perched above the image in an arc. Soon afterwards the USFS withdrew their plans to drill stating, "more study was needed." Indeed!

A hummingbird took shape one stormy afternoon in Gadsden, Alabama with 80 black, inner-city junior high kids, a van load of thrift shop clothing and a beak made of recycled cans. The long beak pointed at the mayor's office demanding that the promise of recycling made many years before, be honored. A leaping cougar framed against the sun came into being with 950 students and teachers in Des Moines, Iowa in freezing cold weather with a wind chill of 10 degrees. The "animal" was "running" towards the capitol building with a message of prairie protection. 1000 students and teachers from two schools in Hood River, Oregon formed the shape of Mt. Hood in an image called *Wy'East Dreaming* (Wy'East is the mountain's native name). First graders dressed in red as hot lava and led a human eruption out the top of the mountain followed by all the interior colors, a sight of profound beauty from above. During a week of 10 inches of rain, *Honu o ka Lani* (turtle from heaven) was formed heading out to sea in Hilo, Hawaii. At the precise moment "Thank You Great Mystery" was shouted upwards by the 300 participants, a warm deluge began lasting an hour in which everyone got joyously soaked . . . a special blessing from the Gods an elder Hawaiian told us latter.

As I complete this chapter I am returning from the creation of *Loon-Sky-Lake* with a 750-student school in Burlington, Ontario. This was the first time habitat was created to go with an animal . . . a 1200 square-foot "lake" made mostly with blue jeans from the local Goodwill. We named it

"Goodwill Lake" and the image of the loon floating upon it with a spiral made of kindergartners emerging from its beak depicting it's wild, beautiful call is one of my favorites thus far. After the final presentation the principal stated excitedly that the school was going to get an Earth-flag for each room and adopt "the pledge of allegiance to the Earth" as a morning ritual! I teach this to every school and have them recite it in mass during the final assembly in the hopes that in America, it can replace the tired "pledge to the flag."

I pledge allegiance to the Earth and the wild web of life upon it,
One planet in our care, irreplaceable, with peace, justice and beauty for all.

Each time another project is completed and the words "Thank You Great Mystery" are joyfully shouted to the sky by hundreds of children and teachers, my trust deepens that just maybe we will find a way to come into right relationship with the world at last, a relationship of respect, love and gratitude. And just maybe these many rising voices will be heard and echoed back to us in some way which we cannot know, a way that may help nudge us a little bit closer to balance and harmony with Earth and one another.

+ + + +

As I watch the joyous dissolution of each image, another metaphor always emerges, the metaphor of my own death. A day like this one will arrive when I too will dissolve into the great continuum from which I came, for our bodies don't belong to us, they belong to nature. I like to think my last words will be beautiful like those murmured by a Blackfoot Indian Chief named Isapwo Muksika Crowfoot in 1890: "A little while and I will be gone from you—whither I cannot tell . . . From nowhere we come, into nowhere we go. What is life? It is the flash of a firefly in the night. It is the breath of a buffalo in the wintertime. It is the little shadow that runs across the grass and loses itself in the sunset." [2]

*Art For the Sky is a project of the Charitable Partnership Fund, a 501-c3 non-profit organization based in Portland, Oregon. To learn more about this residency and how it can come to a community or event near you, please visit www.artforthesky.com. Passionate teachers are usually the ones that mentor these projects inward so if you know one please tell them about this work!

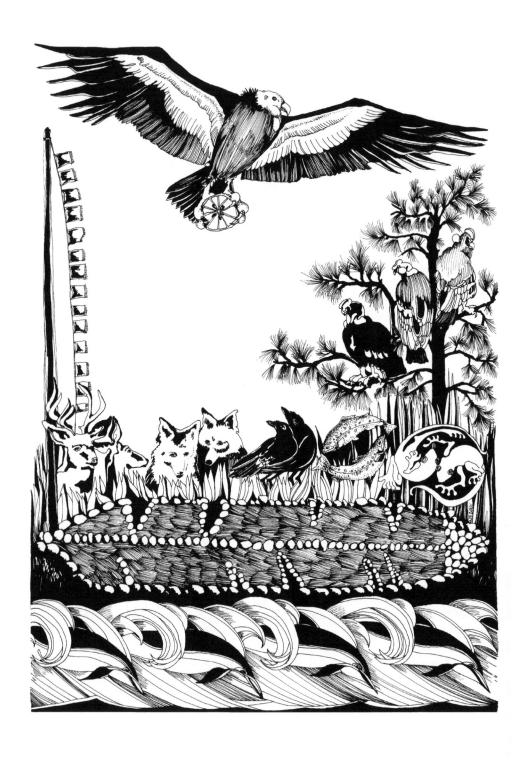

Chapter 11

Skyland

"Hope is the thing with feathers."
—Emily Dickenson

his, the last chapter, was my first adventure with the art form explored in these pages. I debated whether the book's narrative should appear in chronological sequence. Extraordinary events—once in a lifetime events—occurred on this odyssey, and because of them and their continuing impact on my life, I have saved what came first, for last. It is a way to honor the experience that precipitated so much change and awareness in my life. It is a way to complete this circle of stories.

"Condors," he said, pointing upward. I could not understand why we had driven so far to see black specks floating high in the sky. I was only six, and the word *condor* had no meaning. Rare and endangered were tough concepts for a youngster, and my father's explanations failed to excite me. I left to play in the rocks with my brother while Dad, rapt with wonder, fixed his long, black binoculars to the heavens. Many years later, these great birds reappeared and altered the course of my life. I am forever thankful, and honor them with this story.

It was the fall of 1988 in Kansas. I had just completed four years of work with field artist Stan Herd, aerially documenting his unique earthworks. Painting with his tractor, Herd planted, plowed, and mowed field artworks twenty-five to eighty acres each that made sense only from the point of view of angels and eagles. Stan's art intrigued me because it was anti-consumption. It was art that could not be collected, purchased, or locked up in museums and galleries. Impermanent, it was simply for the

sky. Something shifted within me during the years I peered down upon these intriguing designs from airplanes and helicopters. Art upon the body of Earth, art that was not about money or adornment: these notions challenged my beliefs about the role of the artist at this critical point in history.

My work with Stan culminated in a traveling photography exhibit called "Art for the Sky," which toured the nation 1984–90. My other photography work, documenting the wild spaces of Kansas, also reached its conclusion with the publication of *The Four Seasons of Kansas* in 1988. Wrapping up these efforts, I felt a readiness for something new and important to enter my life.

I met Gigi Coyle at the 1989 Interspecies Communication conference, which she organized. Gigi directs the Ojai Foundation in California, an education and retreat center dedicated to the stewardship of Earth and the honoring of spiritual practices of all traditions. After seeing my images of Stan's field art, Gigi challenged me to become an artist in residence at the Foundation at Ojai and begin an Earth art project of my own. It was a kind, and somewhat frightening, offer. I had never really considered myself an "artist." After all, I had no formal training in drawing, painting, sculpting, or any traditional art forms. I had no idea whether I could produce a quality earthwork. Yet inside, I felt I could. Meanwhile, my four-year relationship with Christine was in turmoil after a winter breakup of several months and then a tentative reunion. A month-long retreat at Ojai felt like a powerful thing to do.

So began, in the summer of 1989, a one-month tenure as "artist in residence" at the Ojai Foundation. In addition, I became one of five students in a course called Person, Family, Planet and would help direct our group in an Earth art project. My idea was to construct an eighty-foot-long condor feather prayer stick. This vision was born on a walking meditation during my first visit to the forty-acre Ojai Foundation sanctuary that spring. As I passed in silence across a neglected area of land near the Foundation entrance, two paths diverged. I noticed that the ground between the paths was reminiscent of a giant feather. Since this region was the last refuge for the California condor, a work to honor this great bird seemed to be calling for creation. The class and the community favored the idea and we decided we would call it "The Feather Bridge." The notion for the name was that all four elements would be bridged in the building of the feather—earth, air, fire, and water. In tribute not only to the California condor, but all endangered species, the Earth sculpture might become a ceremonial site that would signify the planetary healing intent of the foundation community.

On Condor Time

We began our project at the oceanside. As a way to help purify our intentions, we smudged ourselves with sage smoke on a cliff above the sea. We then began cruising the coastline hunting for just the right rocks with which to form the feather's outline. We knew we had found the site when we spied four dolphins swimming a short distance beyond the wave line (a rather rare sight in this area). We waded out to greet them, chanting a Chumash song suggested by Gigi. The Chumash Indians were native to the region and to them the condor was grandfather to the eagle, a being of the highest importance. As the dolphins swam closer we honored them with a flower bouquet gathered from the feather site. When they swam away, we collected rocks until the truck was full. Wrapped in wonder and smiles, we carried a special presence away with us.

An actual condor tail feather provided the model for the Feather Bridge design. The feather came from Topatopa, a condor captured in 1967 in Matilija Canyon, near Ojai. Amid intense controversy, Topatopa was the first condor collected by the Condor Research Unit to begin a zoo breeding program at the Los Angeles Zoo. Until about 10,000 years ago, the California condor—nearly fifty inches long, with black body feathers, white wing linings, and a naked orange head—roamed widely across what is now the southern United States, feeding on the remains of mammoths and other Pleistocene megafauna. As those animals succumbed to pre-Columbian hunters, the condor's territory became concentrated in a coastal strip from British Columbia to Baja, California. In the early twentieth century, condor numbers were still high in central California. While ever-increasing numbers of trigger-happy locals found them enticing targets, it was eventually a combination of habitat depletion and lead poisoning (from eating contaminated kills) that drastically reduced the condor population to around sixty by the late 1950s.

In 1967, the Endangered Species Act granted the condors legal protection. After many concentrated attempts by the National Audubon Society and others to solve the condor's problems, it became apparent in the mid 1980s, with barely twenty birds remaining, that California's environment—law-breaking hunters, an expanding network of utility lines, and a plethora of lead bullet-riddled deer, coyotes, and other mammals—had doomed wild condors. The U.S. Department of Fish and Wildlife concluded that to be rescued from extinction, the remaining birds must be removed from their natural home which could no longer support them safely. They would have to wait in zoo breeding programs in the hope that their habitat could be healed and they could one day live again in natural splendor.

As we edged the Feather Bridge with boulders gathered from alongside the Pacific Ocean, I pondered what I have come to think of as *"condor time."* For millions of modern people crowded in cities like Los Angeles, the condor has become a wilderness symbol representing a heritage of vast spaces and unbroken stretches of time. "The condor *is* habitat," was a common refrain heard among conservationists during the last days of the wild birds. What better a metaphor for our species than the California condor? Its fate seems to foreshadow our own, a signal for the difficult work that lies ahead. Will Earth grow too toxic to support us? Must we retreat into increasingly artificial environments to survive? The answers lie in our ability to recognize the message carried by wild animals in their struggle for existence on a planet suffering from the weight of humanity. As conservationists work valiantly to preserve and restore biodiversity hot spots and sensitive species like the California condor, some now speak of "hospice ecology"—taking care of species while their last individuals inevitably slip through our hands, into extinction. In light of what's happening, one can't help but wonder...are we ourselves living on condor time?

Pilgrimage

In two weeks our Feather Bridge rock work was complete. To honor our creation, we decided to make a pilgrimage to the 46,500-acre Sespe Condor Sanctuary. Of course, no California condors lived in the sanctuary—they had all been captured and placed in captive breeding programs in the San Diego and Los Angeles zoos. Still, a pilgrimage to their last habitat seemed important. Throughout time, people have made pilgrimages as a way to prove their faith and find answers to their deepest questions. To make a pilgrimage is to invite synchronicity and wonder into our lives, to reaffirm the mystery that surrounds us. I wondered what magic awaited me in this region where the condors so recently reigned in the skies.

The six of us began trekking along a ridge trail. After hiking for a few hours, I left the others on Pine Mountain. They spread out and began making offerings and sitting in silence. Here they would stay for a twenty-four-hour fast. I continued east for another hour, to the top of a slightly taller peak along the ridge. I found a point that protruded from pink and orange cliffs, which fell abruptly into space. I could easily visualize the condors that once enjoyed this very place. I removed my clothes, spread them upon a blanket of pine needles, and lay down for a nap in the sun. I awoke later to stare at the rapidly passing clouds overhead and

something else in motion—a pair of swifts, spiraling down toward me, united in courtship. Over and over they would dive down in unison, and then fly back up. Eventually, they separated and disappeared among their brethren. A few minutes later, two lizards began circling on the rock in front of me, the male mounting the female repeatedly. I puzzled over the possible meaning of these heavenly and terrestrial animal matings during such a significant time for me.

A primary reason I came to Ojai was to try to resolve my relationship with Christine. She wanted marriage and children. I, with a long history of "commitment-phobia," wasn't sure what exactly I wanted but knew I could not stay in the safety of ambivalence much longer. Was there a message in the mating displays of these creatures? When the lizards disappeared into a crack I walked, naked, to the abyss and playfully flapped my arms, condor style. Condors use cliffs like these to launch their heavy bodies and nine-foot wingspans into the air, a task quite tedious from flat ground. I pushed up on my toes and imagined myself one of them, leaping lightly into flight. I said a prayer for the glorious flyers who once graced this range with their wild shadows as they scanned the terrain for sustenance. I felt a deep loneliness for them, and sadly recalled an earlier time when I chose to play in the rocks instead of joining my father to watch condors soar high upon the thermals. Were they the last of their kind? I prayed at length for Earth healing and the condor's recovery of a place in the wild. Where the cliff protruded most precipitously into space, I left a half an orange as an offering.

In The Between

I put on my clothes and began my descent from the peak in a very calm state. After a few moments on the trail, I was surprised to see two ravens in a tree about one hundred feet in front of me on the path. I watched them preening each other for a moment before they saw me. Squawking, they flew off, leaving me standing open-mouthed and amazed at this mountain's abundant animal romance. Most beliefs surrounding the raven depict this bird as a messenger of the gods or a harbinger of magic. I gazed in the direction to which the birds had flown and noticed, with disbelief, some impossibly large gray-feathery shapes barely visible through the trees. I couldn't imagine any birds this big. They could not be turkey vultures, whose wings are black. Those of golden eagles are brown, not gray. I was thoroughly mystified and began to feel light-headed. Was I seeing an apparition?

Desperate Prayers

I dropped down on all fours and began stalking toward the sight, using the shadow of a tall Ponderosa as cover. I reached the protection of a large boulder, and carefully peered over it. Nothing. I felt like I had entered a mythic territory, a kind of dreamtime. It was, as environmental philosopher David Abram writes, "a kind of time out of time, a time hidden beyond or even within the evident, manifest presence of the land."[1] I had entered the *between*. Often functioning as a threshold for initiation, the mysterious between world of Celtic spirituality is the shoreline between land and sea, or as psychotherapist David Richo writes in *Unexpected Miracles*, "the destiny between effort and grace, the synchronicity between cause and effect."[2] I had entered this territory and it was a landscape that continues to echo its impact upon my life.

I walked around the rock feeling disoriented, still seeing no birds, wondering at the trickery of my mind. Then suddenly, I saw them. They were at the crest of a twisted old pine that jutted up just above the incline. What struck me first was their impressive size and a huge, red "5" fastened to a wing. Filled with wonder, I felt as if the world had stopped turning. They were condors!

They were not California condors, however, but their South American relatives. I discovered later that these were two of the three female Andean condors that had been released into the Sespe Condor Sanctuary by the Los Angeles Zoo and U.S. Fish and Wildlife Service biologists. This action was part of an innovative effort to perfect release techniques, and to identify environmental threats, before California condors were reintroduced into the wild. It was an endeavor that would perhaps culminate in the future re-establishment of these great birds to their former range.

I crouched not even fifty feet away, watching them preen one another as the ravens had done moments before. I noticed "6" on the other bird, red tags fastened to each wing by researchers. The wings also supported delicate antennae. I quickly realized they had no concern for my presence and began to photograph them. I clapped my hands to encourage them to fly. They did, and so began a magical time of observing them take off and soar over the cliffs as they had for thousands of years, and then glide to a landing back on their tree.

Condors are aerial masters. They can stay aloft for more than an hour without flapping their wings—a well-adapted talent, since they roam over six million acres. "My" condors were very intent on staying at their roost. It was nearly sunset and they consistently returned after a few minutes of flight. While waiting for "5" to glide into photographic position in the west, my immediate surroundings were suddenly blackened by an immense shadow that passed over me from the east. Words cannot

describe the kind of charge I felt pass through my body, but I remember it. I looked up and saw the third Andean condor. It was a beautiful sight against the blue sky, ablaze with yellow "1" tags on each wing. It was bearing something orange in its mouth.

Before landing on the old tree, the third condor dropped what it had been carrying. Barely ten feet away from where I stood lay the perfectly shaped, dry, weathered shell of half an orange! I picked it up and held it reverently in my palm. My prayers of less than an hour before and the half-an-orange-offering I left at the cliff's edge were fresh in my mind. This was not the orange I had left at the cliff, but the desiccated, totally-pecked-clean shell of another from somewhere beyond. Chills of recognition passed through my body and I sat down on the talus slope in disbelief. I was stunned. How could this be? The synchronicity was beyond belief. In fact, who would ever believe this story? Looking back on this event, I have come to view it as a kind of initiation into a world, a way of being, where human and nature can collaborate in important ways.

I put the old shell of the orange in the pocket of my vest to add to the feather back at Ojai, and began to head back to the area where the others were camped. Feeling joyful and very light, I selected three rocks from under the condor roost to also add to the Feather Bridge. As I hiked down the trail I clapped the rocks together. The sound produced by striking one from one hand against two held in the other was penetrating and vibrant, an ancient sound. In high spirits and in a peace I had never felt before, I was startled by a whooshing sound above me. I looked up just as two condors, "5" and "6," flew barely twenty feet overhead. They were wing tip to wing tip above the trail beneath the forest canopy. The sound

of the rocks must have stimulated their curiosity. I felt completely blessed by their farewell. It was the last I saw of them, but the memory of their formation above me will remain etched on my spirit for all the days of my life.

Synchronicity Deciphered

Although I knew of them, I never imagined the possibility of actually seeing the Andean condors. They were loose in an area of thousands of square miles. The chance seemed too remote to even consider. When I returned and called the condor research unit they told me that remarkably, I must have stumbled upon the birds' roosting site, a place the team had been searching for. It was the furthest point they had been sighted since their release six months earlier. In fact, the team had lost track of their whereabouts as the condors had disappeared out of range.

All the way down the trail and all through the night I speculated on the meaning of what I had seen. Signs, omens, and synchronicity had always played a part in my cosmology so I felt an incredible power in this uncanny condor connection. I knew I had been given a life vision, a vision I must now interpret. I felt like an excited brave on his way home to the medicine man.

I was born on the fifth of July and thus the number five had always been my favorite. The number six had always been special to Christine. So what was number one? This was the condor bearing the desiccated half-an-orange, clearly a match and answer to my offering at the abyss. According to *The Penguin Dictionary of Symbols:* "like all fruit containing a mass of seeds or pips, oranges are a fertility symbol." I did not fail to notice, as well, that all the numbers added up to twelve—the number of months in a year, the number of signs in the zodiac, essentially, according to *The Penguin Dictionary,* the number representing fulfillment and completion. As if this were not enough, I had a scar between the thumb and forefinger of my left hand, from a two-week-old abrasion. The shape of the red scar could not have been a more perfect copy of a condor in flight! Destiny, dreamtime, and synchronicity felt blended in a strange and beautiful way.

Noted psychologist F. David Peat thoroughly researched the notion of synchronicity in his book, *Synchronicity: the Bridge Between Matter and Mind.* Concluding from the works of Carl Jung and others, he beautifully articulates something very difficult to make sense of, let alone describe: "...a bridge can indeed be built between interior and exterior

worlds and synchronicity provides us with a starting point, for it represents a tiny flaw in the fabric of all that we have hitherto taken for reality. Synchronicities give us a glimpse beyond our conventional notions of time and causality into the immense patterns of nature, the underlying dance which connects all things and the mirror which is suspended between inner and outer universes. With synchronicity as our starting point, it becomes possible to begin the construction of a bridge that spans the worlds of mind and matter, physics and psyche."[3] A *bridge* indeed! Apparently, creating our own "feather bridge" activated this mirror, and the appearance of the condors, the orange dropped from the sky, and what was to follow quite literally connected the inner and outer universe.

Peat believes that synchronicities reveal the absence of division between the material world and our inner psychological reality. The relative paucity of synchronous events in our lives portrays the degree to which we have fragmented ourselves from the infinite and dazzling potential of consciousness and reality. According to Peat, what we are really experiencing within a synchronicity "is the human mind operating, for a moment, in its true order and extending throughout society and nature, moving through orders of increasing subtlety, reaching past the source of mind and matter into creativity itself."[4]

The Third Condor

Back on Ojai land, everyone was excited by the story. It seemed to validate the power of creating healing earth art, and the mindfulness with which it was constructed. Some of us were practicing this mindfulness for the first time. It seemed to call forth the power of a partnership society; of group decision making, the importance of setting our intentions in both prayer and practice. All of this, we felt, created an opening for the condors to appear and bless our work. For me personally, the appearance of these magnificent flyers affirmed the importance of the kind of art I was trying to articulate. When ever I lose faith in the ability of this art form to function as a tool to teach others about what is happening to our planet and our very selves, I need only recall my blessing by the condors. And I was soon to see, their appearance had an additional meaning for me.

To complete the Feather Bridge, we stood a tall pine pole at the end of the feather's shaft. Not wanting to cut a live tree, we searched hard and finally discovered this fifteen-foot-long pole, lodged between rocks to form a bridge across a mountain stream. Standing it at the base of the feather transformed the work into a gigantic prayer stick (something

often used among indigenous groups, albeit in normal proportions, to commit their prayers to the Earth). To this pole we strung hand-painted prayer flags written with our blessings for the Earth. On my flag I wrote an old Navajo prayer: "May my body be a prayer stick for the Earth."

On a clear morning, we filled the feather with brush gathered from fire clearings, old straw, and other dry, organic refuse. As the community circled around, we set the brush afire while we offered thanks and prayers. We sang and beat the drum as a few of us sprinted joyfully through the center of the burning, smoking feather. That afternoon we added earth to the sculpture and wetted it down, thus bringing in all the elements and turning the Feather Bridge a rich charcoal, the color of condor plumage.

After photographing the feather from a plane I reflected on the many bands of California Indians who considered the condor sacred, capable of granting supernatural powers and providing communication with the otherworld. One tribe, the North Fork Mono people, believed the great bird was able to carry those who slept out in the open up into the skies. The condor would set them free in "skyland"—a notion that held a key for my unraveling the message carried by the third condor.

The meaning of the third condor bearing the "1" on its wings and carrying the orange arrived with a beautiful precision. Jack Zimmerman, his wife Jackie, and Gigi led our group in a workshop on relationship during my concluding week at Ojai. Jack was particularly attuned to Native American thought and had done a great deal of work interpreting dreams. He suggested that the third of something represents the divine element, that which results from the unification of heaven and earth. My *Dictionary of Symbols* corroborates this and further elaborates about the number one: "One is the symbol of *homo erectus*. Human beings are the only species to walk upright and there are anthropologists who see in this their distinguishing characteristic, a characteristic more profound even than their powers of reasoning. It is also the symbol of revelation, the intercessor which raises mankind through knowledge to a higher plane of being. One is the mystic center, too, from which the Spirit radiates like the Sun."[5]

The teachers offered that my task was to bring the divine element into my relationship back home. On that note, I left Ojai. My homecoming initiated the beginning of an emotional tornado that was to last for several months. Christine and I seemed caught in a vortex of indecision. Just when we decided finally to break up on congenial terms, she discovered that she was pregnant. Like a warm wave breaking over us we were quickly swept away with the meaning of the third condor. The

divine element had swiftly entered our relationship and it was to come in the form of a baby!

Once I finally accepted what was happening, I was able to break the chains of illusion that were blocking my ability to commit to a woman I truly loved. Attachments to my youth, perfection, and freedom were exposed in the naked light of truth. There was a new life that was important now, and a new relationship. I had reached a time when I realized that my ego did not hold the answer. In surrendering to the unconscious and flowing with the currents of Earth, I felt myself glide into an entirely new region of being. It was a wise and beautiful terrain, ruled not by reason but by dreaming, instinct, and the poetic. In a word, perhaps, it was *Skyland*.

The supreme task of our age, I believe, is the recovery of this divine terrain. We can find it by renewing our intimacy with nature. Our very survival may depend on our ability to do so. In this sense, the story of the condors may serve as a cultural metaphor. It is time to dream back our primordial bond with the Earth; it is time *"to sleep out in the open and invite the condor."*

Amazing Grace

On March 17, 1990, Sierra Sky Dancer was born at home on the Sleeping Beauty Ranch, in Kansas. She is the most willful spirit I have yet to encounter in this life. I often wonder if somehow, on some level, she engineered the whole story presented here. She is sixteen now, and next year it will have been seventeen years since the creation of the Feather Bridge. Christine and I, though now divorced, believe that we came together to produce two beautiful children and learn some valuable lessons. We deeply honor this truth.

On my last trip to Chile I shared the condor story with a naturalist who became a good friend. Not long after I returned home, I received a package from him. It contained a long, tattered flight feather of an Andean condor, and in a note he explained that it had been used for years as a "talking stick" in his work with children's groups. He felt that it was time to retire it and that I would know what to do with it. I did. During my next visit to Ojai I placed it under the largest rock along the shaft of the Feather Bridge. It was the same spot where years before I had placed the dried half-orange carried by the third condor during my day on the mountain.

A pine tree has been planted at the base of the feather and now rises green and tall. New buildings and much redesign has taken place at the

Ojai Foundation but the community is committed to maintaining the feather as a permanent ceremonial site.

Celebration is certainly due, as there are now over 150 wild California condors flying again in Arizona and California with talk of releases in the Columbia Gorge, near where I live. Additionally, 112 designated breeders and youngsters are awaiting release or are in breeding programs, bringing the total world population to almost 300 California condors. The lead problem, which has been so devastating to condors, no longer seems completely intractable. A Colorado metallurgist has developed lead-free ammunition that will not poison non-target animals. Wild condors may yet have a chance to recover.

During the spring of 2000, I traveled to the Ojai Foundation for a workshop and to spruce up the feather a bit with the addition of black cinder rock to its interior. I also planned to spend a few days looking for California condors in the wild. The day I headed out to find them was, ironically, the same day that three condors were going to be released in the Sespe Condor Sanctuary. Among them was AC #8, the last wild female captured and the first of the original wild birds to be released. She was over thirty years old.

I was excited. It seemed there was a good chance to see many of the newly freed wild condors near a community on the edge of the Chumash Wilderness called Pine Mountain Club. The big, A-framed roofs of these vacation homes provide convenient perches that overlook the deep, thermal-producing canyons. I found the birds circling above a favorite hillside snag where I was told they often roosted. What a sight it was! Six condors rode the thermals overhead, as they had done for thousands of years, in countless places. Tears welled up in my eyes as I stared, disbelieving, at the grace of their flight. The elongated white triangular patches under their wings gave them the elegant appearance of kings and queens.

I searched underneath the tree and found three long, beautiful feathers. No object ever evoked more magic, more trust, and more promise than these.

Feeling blessed and ecstatic, I held the feathers aloft and saluted the birds above me. I wished them well on their journey into their newfound twenty-first-century wildness. I stayed with them as the evening descended and watched as they landed one by one in the large ponderosa pine. When the birds had all found their evening roosts, I sat below them with my back against the trunk of the tree and played bar after bar of "Amazing Grace" on my harmonica.

Just before this book went to press, I received word that biologists found the "first intact condor eggs in the wild" since the recovery program began. My new friend David comes to visit sometimes. He is working on his phD

and for his dissertation he is searching for past evidence of California condors in the Columbia Gorge region where I live. Not far from my house there is a cliffy, canyon area pocketed with little crevices and caves that would have made nice condor nest sites. If he finds evidence of them here or elsewhere in the Gorge it will help make the case for those who want to target this region as the next point for the great bird. To welcome them in advance, I carved and painted a life size version of a condor into the adobe retaining wall near the entrance to my home."

Epilogue

"Be joyful though you have considered all the facts.
Expect the end of the world. Laugh.
Practice Resurrection."

—Wendell Berry

 welve years have passed since my artistic odyssey into spirit and ecology began with the creation of the Feather Bridge in California. I have learned much in this time. I am convinced that Earth will collaborate with us in an artful way to her own and our own higher ends. I have learned to conquer my despair over all that is being lost by recalling The Golden Prairie, believing that the impacts of humans are much like a passing ice age upon Mother Gaia.

There is an upwelling of new mythology and revisioning alive within our species that I trust will carry us (in very reduced numbers, most likely) beyond the end of history. Much of what is lost will be resurrected, from protected seeds and from pockets of wildness that persist thanks to the deep conviction of those who have declared them sacred. There are people—myself included—who are willing to die for wild places they consider holy. Such knowledge keeps my heart strong.

I try to smile often, and to create art upon Earth's body as it feels important to do so. I continue to tell stories, and to live by the basics: reduce, reuse, recycle, grow organic food, write letters, vote green, and support my local environmental groups. I breathe faith and trust in the Uknown into my children, and try to instill in them a sense of the sacred wild. Many times daily, I give thanks for all the blessings bestowed upon me by this beautiful Earth. For me, the signs are everywhere: The Tree of Life is hanging on and will blossom once again if we each uncover the unique gift we have been given to offer Earth at this time and with it, nurture the wildness that survives around us.

And what if our worst fears are true? What if indeed we are some of the last humans to be alive on this planet? Sometimes this belief might settle in the cells of our body after reading another dreary newspaper headline, or in the aftermath of a dream. Maybe it is already held somehow within our DNA. What if we are accomplices, witnesses, human "ghostbears" in the final years before the curtain falls?

How should one behave in light of this belief? With integrity, with soul, with beauty; in radical alignment with all threatened and endangered forms, which of course includes most life on Earth. There is no room for complacency at such a time. We must carefully consider our every action. We can bring our loving presence to the members of a wild species—to special trees and places that become dear to us—so that they can be whole and strong for as long as possible. In this way we show our gratitude and apologize to Earth for the history of which we have been a part.[1]

Falling in love with all beings that are about to leave, with every form of wildness we encounter, and blessing them with grace and awe, is a calling worthy of ancestral honor. It is wise to put "shards into circles" in as many ways as we can, to bow in a ceremonial way, offering our deep thanks and reverence for the great gift that we have been given—life on Earth.

And, if we *are* destined to continue as a species, how should we act? Exactly the same way!

Sleeping Beauty Pilgrimage

On a full-moon night in autumn 2000, I walked through the prairie on a pilgrimage to visit the "Tree of Life" on the hilltop of my old Sleeping Beauty Ranch in northeast Kansas. A thousand sunrises and as many night watches had burned the power and feel of this valley into every synapse of my body. Familiar smells floated on the still October air, and prairie grasses crunched softly beneath me as I wove my way through them toward the distant hills. The hill-shapes hinted at the form of a woman lying on her side. I was pleased to see how many patches of native Tallgrass Prairie had begun to reclaim the old brome pasture. Twin packs of coyotes echoed from the west and east sides of the valley, creating the unique and haunting concert I had grown to love when I lived here. How I missed these animals! Their wild and wonderful welcome released a flood of memories.

Climbing the rock fence to enter the hardwood forest, I recalled what the new owners of the ranch had told me—that, strangely, they had never explored this particular forty acres of the property. My old path

was gone. I felt disoriented as I picked my way through the vine-filled woods, the trees noticeably thick and tall about me.

Eventually I reached the hilltop clearing and found the old oak. My jaw dropped. The tree had again been hit by lightning, and all the upper branches had fallen. The biggest of them leaned against the trunk. All that remained was the giant horizontal branch which seemed to defy gravity as it reached south and then rose, golden-leafed, to the sky. The mystical countenance of the oak was of two golden hands clasped together in prayer extending toward the moon from a figure about to tip over.

By the condition of the fallen branches I could tell that the lightning strike had occurred a couple of months earlier. I doubted the tree would survive another winter in this condition—the strain of snow, rain, and sheer gravity would most likely be too great for its hollow, damaged trunk to bear. I knew what I must do. The next day two neighbor kids and I carried a pair of telephone poles up the hill to the tree. We placed large, flat rocks on the ground beneath the massive limb and cut the heavy poles to stand upon them, bracing the branch in two places. As we secured them into place, the three of us shared an eerie sensation of the tree breathing a sigh of relief and gratitude.

The next day I cut all the dead branches and burned them in two piles. I had found a road-killed owl on my way to the ranch and I placed it on the pyre, offering prayers to the Tree of Life as the flames consumed the owl's body.

While the fires burned I began to excavate my medicine wheel, which lay invisible beneath a mat of grass and a tangle of small vines and brush. With clippers and trowel I slowly uncovered the rocks set in place so many years before. How strange, I mused, as I brushed them off with my hands, to be an archaeologist of sorts, uncovering my own past. As the white rock of the wheel emerged, I recalled the times I had sat in the circle with my back against the tree's gnarled trunk seeking counsel. My marriage had begun in a ceremony around the oak and now, like the tree's burning branches, had transformed into something new. I thought of the day I placed my baby girl in the wheel and walked far away to sit and watch, letting her bond on her own with the wild spirit so present there. I recalled the many offerings left in the tree's darkened center and the thrill of deer and coyotes passing nearby, and of orioles landing beside me while I lay quietly on the long horizontal limb. Uncovering the wheel brought me to the very root and foundation of who I was, the heart of everything I believed in.

Carefully shoring up the last limb of the lightning oak and tying owl feathers to its two supporting posts felt as natural as if the oak were my

own father. I have experienced no greater honor than to be able to extend this tree's life. It felt symbolic of the situation humankind is challenged to embrace at this point in history. In the wake of modern civilization, precious niches of plants and animals everywhere are saying goodbye to their time on Earth. As Gaian citizens during the Age of Toxic Man, we can do no more noble thing, perhaps, than to engage in a kind of *hospice ecology* for Earth's dwindling wildness and witness the passing of its creatures and landscapes in as beautiful and sacred way as we can. This work and the stories and blessings we gather in the process will empower us to protect and rewild the places that stand a chance of surviving the "human ice age." With the wisdom such care instills in us, we may be able to build a bridge beyond the end of history.

Wild is the Way

Was there not a time in the lives of us all where we touched, for a moment, life's shining vibrant core, a moment where we felt the oneness of our heartbeat with wild Earth? Do we not all have something that needs to be uncovered and resupported, something we can do that will reconnect us to our wild core and in the process, to the unique gift we have to offer this time? There is much joy, healing, and power in this gift which awaits us in our personal corner of "the garden."

It is true. The Tree of Life lives in our own back yard. We must only remember. There is a place calling to us now, awaiting our embrace. It is ground zero of our authentic selves, sacred ground from which our gift to the world can spring forth. We must find this place and when we do, nurture it and hold on to it for dear life. We must let its wildness grow into us and reclaim us. It is true north on the compass of our soul, our link to the entire universe. It points homeward and confirms the course: *wild is the way.*

So...let nature lead you, as an excellent dance partner would, to the earthly music all around us. Follow the wild step and you will move through life in harmony with your spirit and soul and the desires of the Universe. Listen to the wind singing in the trees outside your door. Watch the animals and look to the sky. Notice what lies in your path. Stay centered...be bold...follow the signs...

Endnotes

Preface

[1] Mark Twain, *The Diaires of Adam and Eve* (Fair Oaks Press, 2002). I listened to excerpts of this on a talking book while stuck in a Portland traffic jam headed for my home in the Gorge. How I wished he was beside me to muse away the time with remarkably clever insights like those that fill this book!

Introduction

[2] Gary Snyder, *Practice of the Wild* (San Francisco: North Point Press, 1990). If I had to pick one book to help someone develop or deepen his or her environmental ethic, this might be the one. Our minds have been shaped by the wild and thus we do indeed have a "native mind" coded with nature. Snyder puts it well: "There has been no wilderness without some kind of human presence for several hundred thousand years. Nature is not a place to visit, it is home."

[3] Paul Sheppard, *Nature and Madness* (San Francisco: Sierra Club Books, 1982). This excellent book describes the problems of civilization amounting to Western man being stuck in an adolescent phase of development.

[4] Derrick Jensen, *A Language Older Than Words* (New York, Context Books, 2000). Not for the faint of heart, this work is an explicit and deeply felt rant against the nightmare of modern civilization and what we are truly up against.

[5] Laura Sewall, *Sight and Sensibility: The Ecopsychology of Perception* (New York: Penguin-Putnam, Inc., 1999).

[6] Joanna Macy, *World as Lover, World as Self* (Berkeley, CA: Parallax Press, 1991). All Joanna Macy's books are inoculations of spirit and sanity to help us conquer the despair that is part and parcel of being alive in

these times, and reap the power that comes with making the effort.

[7] Sister Miriam MacGillis, "The Fate of the Earth." Taped lecture. When I first heard this sentence, I stopped and rewound the tape to hear it again. It was perhaps the greatest affirmation of my work that I had encountered.

[8] Judith Cornell, *Mandala: Luminous Symbols of Healing* (Wheaton, IL: Quest Books, 1994). A wonderful project that brings mandala-making into schools can be found at: www.mandalaproject.org.

[9] Marilyn Bridges, *Markings: Aerial Views of Sacred Landscapes* (New York: Aperture, 1986). Encountering this book early on my path as a photographer made me look at Earth from above in a brand new way and inspired hundreds of hours of aerial photography from Kansas to Chile.

[10] Mircea Eliade, *The Sacred and the Profane* (New York: Harcourt, Brace and World, 1959).

[11] Fydor Dostoyevski, *Crime and Punishment* (New York: Dodd & Mead, 1963)

[12] Bodanis quoted in Annie Dillard, *For The Time Being* (New York: Vintage Books, 2000). This book is a tribute to the current of impermanence that flows through all life. I have read few writings that have helped me see the godliness of each moment more than this gem has.

[13] Stephen Mitchell, *Tao te Ching* (New York: Harper & Row, 1988)

[14] John G. Neihardt, *Black Elk Speaks* (Lincoln: University of Nebraska Press, 1979). I visited Harney Peak in the Black Hills of South Dakota where Black Elk is said to have had his vision. Ironically, there is a square, hand-built stone lookout tower on top.

Chapter 1

[1] Laura Sewall, *Sight and Sensibility: The Ecopsychology of Perception* (New York: Penguin Putnam, Inc., 1999).

[2] Lewis Mumford, *The Transformations of Man* (New York: Harcourt, Brace and World, Inc., 1956).

³ Kris Freeman, "We're Choking the Ocean With Plastics," *National Fisherman* (January 1987).

⁴ James E. Lovelock, *Gaia: A New Look at Life on Earth* (New York: Oxford University Press, 1979).

⁵ Ibid.

⁶ Alan Metrick, "Homesteading, Yucatan Style," *The Amicus Journal* (Summer 2000). Richard Sowa turned a personal vision into community action. Enlisting the help of friends, neighbors, and school children in the town of Puerto Aventuras, Mexico, Sowa gathered 100,000 plastic bottles that had washed up on the town's beach. Wrapped with fishing nets, they serve as a floating base for Sowa's new home. Local authorities, who gave the artist permission to build his island as a community project, consider it Mexican soil. Nevertheless, Sowa's plan is to add to the island in ever-growing spirals, until it reaches what he says will be an ocean-worthy size of about 80 yards across. He'd like to take it around the world.

⁷ Laura Sewall, *Sight and Sensibility: The Ecopsychology of Perception.*

⁸ Christopher Reed, "Down To Earth," *Dharma Gaia: A Harvest of Essays in Buddhism and Ecology* (Berkeley, CA: Parallax Press, 1990).

⁹ Diane Harvey, *The Golden Road To Unlimited Totalitarianism.* Unpublished manuscript, www.surfingtheapocalypse.com. Nobody else I have encountered writes with quite this mixture of terror, beauty, and sacredness. Harvey's point of view is that of one who has cast off society—she lives a hermit's life in the desert, writing prolifically and producing amazing art. Her website is a must-read for a parting of the veils into what is at stake for the human race.

¹⁰ Union of Concerned Scientists brochure. "The World Scientists' Warning to Humanity," issued November 18, 1992. See: www.ucsusa.org for the organization. For the report: www.earthportals.com/Portal_Messenger/ucs.html

¹¹ Steven McFadden, *Profiles in Wisdom* (Santa Fe: Bear and Company, 1991). Through all time, I wonder how many millions of humans have looked to the sun for help? When I was young, I thought that if there was a god, it must be the sun. I recently saw the Omni Max film *SolarMax,* which features minute-long views of the erupting, pulsating, storming

sun filmed from the Hubble Space Telescope. I could have stared at it for days, so glorious was the sight. Nothing I have ever seen in a film remotely compared with the awe and magnitude of this view. It was like looking at God.

Chapter 2

[1] Scott Russel Sanders, "Telling The Holy," *Orion Nature Quarterly*, Vol. 12, No. 1 (Winter 1993).

[2] Will Baker, *Backward: An Essay on Indians, Time and Photography* (Berkeley, CA: North Atlantic Books, 1983). This is an astonishing book that forever changed my relationship to my camera and travels to foreign lands. Baker's travels as an anthropologist and photographer in Peru should be read by all who long to visit unspoiled cultures. . .not that there are any left.

[3] Jim Nollman, "When the Whales Disappear," *The Animal's Agenda* (September 1990). Sierra Club Books is in the process of publishing Jim's account of our trip to the Arctic entitled *The Wild Heart*. For more information on Jim Nollman and Interspecies, visit his website: www.interspecies.com.

[4] Gail Tuchman, *Through the Eye of the Feather* (Layton, UT: Peregrine Smith Books, 1994).

[5] The origins of the word "thrill" refer to the vibration an arrow makes when it hits its target. Whether in art or in our daily lives, if we remember the meaning of the word "thrill" we can delight in the completion of our own perfect moments. All artists must feel a true thrill whenever they step back and realize that they hit the mark especially well.

[6] Thich Nhat Hanh, *The Heart of the Buddha's Teaching* (New York: Broadway Books, 1999).

[7] Barry Lopez, *Arctic Dreams* (New York: Bantam, 1987).

[8] Paul Sheppard, *Nature and Madness* (San Francisco: Sierra Club Books, 1982).

[9] Will Baker, *Backward: An Essay on Indians, Time and Photography*.

[10] Jim Nollman, "When the Whales Disappear."

[11] Ibid.

[12] Ibid.

[13] Brenda Peterson, *Living by Water: True Stories of Nature and Spirit* (New York: Ballantine, 1994).

[14] Jim Nollman, *The Beluga Café* (San Francisco: Sierra Club Books, 2002).

Chapter 3

[1] Conversation with Lance Burr, environmental attorney, Lawrence, KS. Lance claims that this story originated from Wes Jackson. . .where he got it I do not know.

[2] James Lovelock, *Gaia: A New Look At Life On Earth* (New York: Oxford University Press, 1979). I remember seeing Mr. Lovelock speak at the University of Kansas. Afterwards someone asked him, "If you could change one thing on this planet to give humankind a greater chance for survival, what would it be?" Without a moment's hesitation he said, "Eliminate cattle."

[3] Evan Eisenberg, *The Ecology of Eden* (New York: Alfred A. Knopf, 1998).

[4] Ibid.

[5] Derrick Jensen, *A Language Older Than Words* (New York: Context Books, 2000). Jensen goes on to say, "Once we've recognized the destructiveness of our civilization we've no choice, unless we wish to sign our own and our children's death warrants, but to fight for all we're worth and in every way we can to change it. There is nothing else to do."

[6] Diane Harvey, *The Golden Road to Unlimited Totalitarianism.* Unpublished manuscript. http://www.surfingtheapocalypse.com.

[7] R.L. Wing, *The I Ching Workbook* (New York: Doubleday, 1979).

[8] Ibid.

Endnotes

[9] Diane Harvey, *The Golden Road to Unlimited Totalitarianism.*

[10] Annie Dillard, *Pilgrim at Tinker Creek* (Toronto: Bantam, 1974). Alongside Aldo Leopold's *Sand County Almanac,* this is one of the great nature books of our time.

[11] Wes Jackson, *Becoming Native to this Place* (Lexington: University of Kentucky Press, 1994). Wes Jackson received a Swedish foundation's Right Livelihood Award in 1999 that is often referred to as "The Alternative Nobel Prize."

[12] John Madsen, *Tall Grass Prairie* (New York: Falcon Press, 1993).

[13] Ibid.

[14] Ibid.

[15] "The M1, Best and Worst Weapons," *U.S. News & World Report* (July 10, 1989).

Chapter 4

*Terry Tempest Williams wrote a book called *Desert Quartet: An Erotic Landscape* which was published in 1997. In an entirely different manner, her book also reflected on the four elements. Synchronistically, I had not heard of her book until after I had named this chapter and finished doing the artwork related to the first three elements discussed. Hearing of her work of the same title was a pleasant surprise and synchronicity, as I am deeply moved by her work.

[1] Greenpeace Action pamphlet.

[2] Jim Corbett, *Goatwalking* (New York: Viking, 1991). Jim Corbett is a Quaker who went into the desert wilds with his goats, living a life of "errantry" subsisting on milk and wild foods. As he puts it, "Society provides most of the make-believe that prevents one's hells from surfacing into full consciousness. No matter how dissatisfied, one can always find distractions with society." Going "feral" led him to some powerful truths, which fill this unusual book. When he surfaces he tells those who must meet him at airports to "look for Don Quixote with glasses." They spot him immediately. His path, while certainly not for everyone, is one of the

most inspiring I have encountered. "Any productive member of a society at war with man or nature can also be sure that he is one of its soldiers, no matter how considerately he lives. To serve life, technocracy's conscripts must go beyond simplicity and do more than desert; they must gather into basic communities that open an exodus."

3 Scott Russel Sanders, "Homeplace," *Orion Nature Quarterly* (Winter 1992).

4 Henry David Thoreau, *Walden* and *On Civil Disobedience* (New York: Harper and Row, 1965).

5 Jerry Mander, *In the Absence of the Sacred* (San Francisco: Sierra Club Books, 1991). Paul Ehrlich's book *New World, New Mind* deals with this topic at length. His thesis is that our environmental problems stem from being equipped with a brain that does not know how to think long term; that primarily is still mostly concerned with the present moment, like keeping the bear out of the cave and finding food for dinner.

6 Wendell Berry, *The Unsettling of America* (San Francisco: Sierra Club Books, 1977).

7 Thomas Handloser, "An Interview with Godfrey Reggio," *THE* Magazine, Vol. 1, No. 3 (September 1992). Godfrey Reggio filmed, produced, and directed one of the most remarkable movies of our time, *Koyaanisqatsi*. (The Hopi word means "world out of balance.")

8 *The Box: Remembering the Gift* (Santa Fe: Terma Company, 1992). *The Box* was a collaborative effort by a group of artists, educators, and deep ecologists dedicated to the exploration of Spirit and Nature. After more than two decades of studying teachings from around the world and years of individual hands-on service, *The Box* was assembled to provide a self-guiding and self-enabling process with which to share the wisdom critical to the well-being of Life on Earth. The Terma Company and its network of guides offer courses and trainings for individuals, schools, and corporations. Contact the Ojai Foundation, 9739 Santa Paula Rd., Ojai, CA 93023.

9 Robert A. Johnson, *Owning Your Own Shadow* (New York: Harper Collins, 1991).

10 Helena Norberg-Hodge, "Economics, Engagement and Exploitation in Ladakh," *Tricycle: The Buddhist Review* (Winter 2000).

Endnotes

[11] Terry Tempest Williams, *An Unspoken Hunger* (New York: Random House, 1994).

[12] Ibid.

[13] Robert Michael Pyle, *Wintergreen: Rambles in a Ravaged Land* (Seattle: Sasquatch Books, 2001). In the last chapter of this book, Pyle delves deeply into the meaning of the popular bumper sticker "Nature Bats Last." It was my father's favorite environmental chapter, and is one of mine as well.

[14] Evan Eisenberg, *The Ecology of Eden* (New York: Alfred A. Knopf, 1998).

[15] Chellis Glendinning, *My Name is Chellis and I'm in Recovery from Western Civilization* (Boston: Shambhala Publications, 1994).

[16] Diane Harvey, *The Golden Road to Unlimited Totalitarianism.* Unpublished manuscript. See: www.surfingtheapocalypse.com.

[17] Stan Steiner, *The Vanishing White Man* (Norman, OK: University of Oklahoma Press, 1976).

[18] David Brower, lecture, University of California at Berkeley, March 1994.

[19] Allen D. Kanner and Mary E. Gomes, "The All Consuming Self." And now in 2001, President George W. Bush is echoing his father's statement in his anti-environmental policies and desire to drill in the Arctic National Wildlife Refuge.

[20] Paul Wachtel, *The Poverty of Affluence* (North Kingston, RI: New Society Publishers, Limited, 1988).

[21] Wes Jackson, *Becoming Native to This Place* (Lexington: University of Kentucky Press, 1994).

[22] Jay Letto, "1872 Mining Law: Meet 1993 Reform," *E* Magazine (Sept/Oct 1993).

[23] Robert Michael Pyle, *Wintergreen: Rambles in a Ravaged Land.*

[24] Laura Sewall, *Sight and Sensibility: The Ecopsychology of Perception.* (New York: Penguin Putnam, Inc., 1999).

[25] Vicki Robin, "A Deeper Shade of Green (non) Consuming," *The Greenmoney Journal*, Vol. 3, No. 2 (Winter 1994/95).

[26] Helena Norberg-Hodge, "Economics, Engagement and Exploitation in Ladakh."

Just before this book went to press, the events of September 11, 2001 shook the world and became indelibly etched into the American psyche. The immense mound of rubble created from the fallen World Trade Center towers led me to recollect the creation of the Restoration Mound and the issues that inspired it. I began to wonder how we could most highly honor those that sacrificed their lives in this tragedy.

Extraordinary sacrifice calls for extraordinary response. After an initial surge of blind patriotism and anger that saw flag and gun sales skyrocket, there appears to be a real willingness to look more deeply at why America generates the depth of hatred it does among much of the world's poor and disenfranchised people. Can it be as simple as the fact that we are only four percent of the world's population and use twenty-five percent of its resources? Did we think the rest of the world wouldn't notice or care? New York's catastrophic events beckon us to examine closely the cycle of greed and poverty, selfishness and envy, over-consumption and hunger, riches and exploitation, and the resentment and wars these inequities feed. We may never again have the opening we do now to awaken internally as a nation and to lead the way out of a cycle that has led civilization from war to war to war.

As individuals, we must make every effort to move from fear to love, to embody in our actions, speech and thought, the world we envision, a world of peace, equality, and ecological health.

Chapter 5

[1] Kathleen Dean Moore, *Holdfast: At Home in the Natural World* (New York: The Lyon's Press, 1999). She goes on to write: "Maybe something ancient in my mind seeks meaning from the lay of the land, the way a newborn rejoices in the landscape of a familiar face."

[2] Evan Eisenberg, *The Ecology of Eden* (New York: Alfred A. Knopf, 1998).

[3] Redwood Summer film. Produced by Stuart Rickey/Redwood Summer Partners. www.bullfrogfilms.com/catalog/168.html

Endnotes

[4] Merlo quoted in Derrick Jensen, *A Language Older Than Words* (New York: Context Books, 2000).

[5] Evan Eisenberg, *The Ecology of Eden.*

[6] Ibid.

[7] Gail Tuchman, *Through The Eye Of The Feather* (Salt Lake City: Gibbs-Smith, 1994).

[8] Carolyn North, *Synchronicity: The Anatomy of Coincidence* (Berkeley, CA: Regent Press, 1994). Another great book about synchronicity is *Unexpected Miracles: The Gift of Synchronicity and How to Open It* by David Richo. "Synchronicity erases the line between us and nature. It blurs the line between human and the divine. It underlines the entry of eternity into time."

[9] Brian Swimme, *The Hidden Heart of the Cosmos* (Maryknoll, NY: Orbis Books, 1996).

[10] Scott Russel Sanders, *Staying Put: Making a Home in a Restless World* (Boston: Beacon Press, 1994).

[11] Joan Halifax, *The Fruitful Darkness: Reconnecting with the Body of the Earth* (San Francisco: Harper-Collins, 1994).

[12] Ken Wilcox, *Chile's Native Forests: A Conservation Legacy* (San Francisco: NW Wild Books, 1996).

[13] Ancient Forest International (www.ancientforests.org). Since 1989, Ancient Forest International (AFI) has been instrumental in the protection of primary forests around the world. With the help of its international ancient forest network, AFI develops opportunities for wildlands philanthropists and communities to work together to acquire and protect strategic and invaluable forestlands. AFI has helped coordinate the purchase of nearly one million acres of ecologically critical forested land, primarily along the Pacific coast of North and South America.

[14] This is the term I use to describe the beams of light that sometimes appear in the morning when there is just enough humidity in the air (or, light fog) to be made visible by the sun as its rays stream through the forest.

[15] Francois-Rene de Chateaubriand, *The Martyrs* (New York: Howard Fertig Incorporated, 1996).

¹⁶ Evan Eisenberg, *The Ecology of Eden.*

¹⁷ Parque Nacional Pumalin. The Foundation for Education, Science and Ecology (EDUCEC), directed by seven highly respected Chileans in the fields of conservation, science, and law, was established to receive title to the 270,000-hectare fjordal sanctuary known as "Parque Pumalin." This sanctuary has been hailed as one of the most ambitious privately funded wilderness preservation efforts. The Foundation and the park were created by San Francisco businessman Doug Tompkins, founder of Esprit and The North Face, as well as the Foundation for Deep Ecology. This pioneering conservation effort came about after several international expeditions in the northern fjords of Chilean Patagonia, organized by CODEFF, Bosque Antiguo and AFI. Tompkins was already impressed with the diversity and biomass of Chilean rainforests. In addition to land acquisition, the Foundation advocates for wildland preservation to ensure the long-term viability of all native forest ecosystems, and promotes ecotourism development as an alternative to conventional forest exploitation.

Chapter 6

¹ David Bohm, *Wholeness and the Implicate Order* (Boston: Routledge & Kegan Paul, 1980).

² Louise Callen, *The Education of the Heart.* Edited by Thomas Moore (New York: HarperCollins Publishers Inc., 1996).

³ Scott Russel Sanders, *Staying Put* (Boston: Beacon Press, 1994).

⁴ Lewis Hyde, *The Gift: Imagination and the Erotic Life of Property* (New York: Random House, Inc., 1979). In this remarkable book, Hyde begins with the premise that a work of art is a gift and not a commodity. It sheds a bright light upon the problems of the artist in a predominantly materialistic society. It is an encyclopedic compilation of myths, stories, and cross-cultural accounts of gifting relationships. A common thread that runs throughout these stories is "the gift must always keep moving." When we hoard things we are likely to "burst or stagnate."

⁵ Bernard DeVoto (ed.), *The Journals of Lewis and Clark* (Cambridge: The Riverside Press, 1953).

Endnotes

[6] Craig Lesley, *Winterkill* (New York: Dell Publishing, 1984). When I first moved to the Columbia Gorge I read this book and its sequel, *Riversong*, which both depict many of the characters and places I later came to know in the Gorge.

[7] Timothy Egan, *The Good Rain* (New York: Vintage Books, 1991).

[8] David James Duncan, "How to Hope Like A Coho," *Cascadia Times* (February 1997). This phrase has become our rallying cry in an effort to remove Condit Dam, a 90-year-old impediment to salmon on the White Salmon River.

[9] Derrick Jensen, *"Beyond Hope"* (Orion Magazine, June 2006).

[10] Planck quoted in Jim Nollman, *Interspecies Communication Quarterly* (Winter 1995).

[11] Michael Parfit, "The Floods That Carved the West," *Smithsonian* (April, 1995).

[12] Joanna Macy, *World As Lover, World As Self* (Berkeley, CA: Parallax Press, 1991).

[13] Lois Gould, *A Sea-Change* (New York: Farrar, Straus & Giroux, LLC, 1988).

[14] Renee Weber, *Dialogues with Scientists and Sages: The Search for Unity* (London: Routledge & Kegan Paul Ltd., 1986).

Chapter 7

[1] Susan Sontag, *On Photography* (New York: Dell Publishing, 1978). Unfortunately, this book is out of print; I have found few books on the impacts of photography to be as relevant today as this one is.

[2] Bill McKibben, *The Age of Missing Information* (New York: Random House, 1995).

[3] Susan Sontag, *On Photography*.

[4] Kenneth Brower, *Photography in the Age of Falcification, The Atlantic*

Monthly (May 1998). In 1991 LaBudde won a Goldman Prize for his work on the tuna-dolphin issue. The Goldman Prize is annually awarded to six people, one from each continent except Antarctica, for "grassroots efforts to preserve and enhance the environment." With the statuette comes an award of $160,000. LaBudde says he contributed much of his award money to a variety of causes: the Alliance for the Wild Rockies, the Southeast Alaska Conservation Council, the Shawneel Defense Fund, and the Leonard Peltier Defense Fund. With the rest of the money he established the Endangered Species Project at the Earth Island Institute and began buying video cameras to send to other activists to enable them to document threats to endangered species.

[5] Ibid.

[6] John Daniel, "Toward Wild Heartlands," *Audubon* (Sept-Oct. 1994).

[7] Arne Naess, *Ecology, Community & Lifestyle* (New York: Cambridge University Press, 1990). Naess, a Norwegian, is considered to be the father of the Deep Ecology movement.

[8] Susan Sontag, *On Photography*.

[9] *Nature Photography's Code of Practices*. See: www.reflectiveimages.com/CodeofEthics.htm and www.tpwd.state.tx.us/adv/nphoto/photoeth.htm.

[10] Many professional photographers are represented by stock agencies. These businesses buy a wide variety of photographs, catalog and package them, and then market them to advertisers, media, and publishing houses. Generally, the entities that buy these images can use them however they choose. There are a few stock agencies, like Still Pictures in the UK, who supply only environmental images and have strict screens on how they can be used. I have some of my own images filed with them. See: www.stillpictures.com.

[11] Alice Walker, "A Thousand Words," *Living by the Word* (New York: Harcourt Brace Jovanovich, 1988).

[12] Susan Sontag, *On Photography*.

[13] Wendell Berry, *The Unsettling of America* (New York: Morrow/Avon, 1978).

Endnotes

[14] John Lane, *A Snake's Tail Full of Ants: Art, Ecology and Consciousness* (Devon, England: Green Books LTD), 1996.

[15] Virginia MacDonnell, "The Natural Value of Art." www.eco-art.com/ecoart/articles/gini.htm

[16] John Perreault, editorial, *Design Spirit* (Winter/Spring 1990).

[17] Wolfgang Sachs, *Global Ecology* (London: Zed Books, Limited, 1993).

Chapter 8

[1] Staunch visionary for the forest, Tim Hermach, came up with the original idea of Zero-Cut. The group he founded, The Native Forest Council, is always on the leading edge of protecting our public lands. Their website is a beautifully designed guide to what is happening to our public lands and what we need to do about it: www.forestcouncil.org.

[2] The Index of Environmental Trends was a project of the National Center for Economic and Security Alternatives. It can be ordered on the web for $10. www.ncesa.org/html/publications.

[3] George Wuerthner, "The Myths We Live By," *Wild Earth,* Vol. 29 (Spring 1998). The quarterly journal *Wild Earth* works to foster a culture of conservation, helping to communicate and shape the latest thinking in conservation science, philosophy, politics, and activism. www.wild-earth.org.

[4] Barry Lopez, *Crow and Weasel* (San Francisco: North Point Press, 1990).

[5] U.S. Forest Service Forest Products Lab, Madison, WI, 1997. The figure has been reduced to 2% as of January 2001.

[6] Iowa Representative Jim Leach, quoted in 1997 *Des Moines Register* editorial.

[7] The National Forest Protection and Restoration Act . . . (H.R. 1494 in the 107th Congress). A bill summary: To save taxpayers money, reduce the deficit, cut corporate welfare, protect communities from wildfires, and protect and restore America's natural heritage by eliminating the

fiscally wasteful and ecologically destructive commercial logging program on Federal public lands, restoring native biodiversity in our Federal public forests, and facilitating the economic recovery and diversification of communities affected by the Federal logging program. The National Forest Protection Alliance is a good place to track the current status of any zero-cut bill in Congress. NFPA is a national alliance of citizens and organizations dedicated to protecting public lands from commercial exploitation, and in particular, ending commercial logging on federal public lands. You can access a copy of this bill on the NFPA website and also take action by writing your representatives in Congress: www.forestadvocate.org

[8] Laura Sewall, *Sight and Sensibility: The Ecopsychology of Perception* (New York: Penguin Putnam, Inc., 1999).

[9] James Hillman, *The Thought of the Heart and the Soul of the World* (Dallas: Spring Publications, 1981).

[10] Robert Johnson, *We: Understanding the Psychology of Romantic Love* (San Francisco: Harper and Row, 1983). This book is required reading for anyone growing up in our culture. It is profound, illuminating, and extremely relevant in a society weaned on Disney fairytales and indoctrinated by their adult equivalent in film. Ohhhh, to have read this book when I was eighteen!

[11] Tibetan Dzogchen master Longchen-pa from Bailey Cunningham's wonderful website about her Mandala Project, www.mandalaproject.org.

[12] Joan Halifax, *The Fruitful Darkness: Reconnecting with the Body of the Earth* (San Francisco: Harper-Collins, 1994).

[13] Jean Chevalier and Alain Gheerbrant, *The Penguin Dictionary of Symbols* (London: Penguin Books, 1994). This book is an invaluable and comprehensive guide to all things symbolic. It is always within easy reach and used very frequently by me and my children.

[14] Mollie Matteson, "A Vision of Wilderness: Re-Calling the Sacred." Talk delivered at the Forest Reform Rally, September 13, 1998, Lake Ossipee, New Hampshire.

[15] Doreen Virtue, Gregg Braden, James Twyman, *The Great Experiment: A Psychologist, a Scientist, & a Mystic Remember the Future* (New York: Hay House, Inc., 1999).

Endnotes

[16] Terry Tempest Williams, *An Unspoken Hunger* (New York: Pantheon Books, 1994).

[17] Evan Eisenberg, *The Ecology of Eden* (New York: Alfred A. Knopf, 1998). My musical collaboration with Gaia on the lake reminded me of the metaphor Evan Eisenberg, an accomplished musician, calls "earth jazz." He uses this term to help describe how to collaborate most highly with Gaia in our daily lives. "You improvise. You are flexible and responsive. You work on a small scale, and are ready to change direction at the drop of a hat. You encourage diversity, giving each player—human or nonhuman—as much room as possible to stretch out. You trade fours with the goddess: play four bars, listen to her response, respond, listen, respond." Another reference to music that speaks to the same feeling: "Ditch your notated score—whether ascribed to nature or yourself— learn to improvise. Respond as flexibly to nature as nature responds to you. Accept nature's freedom as the premise of your own; accept that both are grounded in a deeper necessity. Relax your rigid beat and learn to follow nature's rhythms—in other words, to swing."

[18] Pipestone Visitor's Center information panel.

[19] George McDonald, *Phantastes: An Adult Fairy Tale* (Whitethorn: Johannesen Printing & Publishing, 1998). George McDonald was the acknowledged inspiration for all of C.S. Lewis's popular books. On a cross-country drive in the late 1990s I listened to a tape of this rare and enchanting book several times, and will never forget it.

As of this writing, more than seventy ZeroCircles have been created in fifty National Forests and twenty-five states. I am hopeful that this effort will continue to inspire others to create and document forest circles on public lands across the country. A dynamic website tells the story: www.zerocircles.com. The site displays all the ZeroCircle artworks that have been created, provides updated information about the status of legislation to achieve zero-cut, as well as information about each National Forest. Via the Internet, both the media and the public can follow the progress of the ZeroCircles campaign, send letters to their representatives, and network with regional conservation groups working on this and related issues. Translating the circles into action to protect our forests is the goal, and I am committed to maintaining this site until we achieve zero extraction on public lands.

Will we reach this goal? I am certainly hopeful. As bleak as things look for nature, the story is far from finished. All who love, cherish, and work to protect Earth hold some strong cards, and whether we call it "magic" or just "artful activism," I firmly believe that efforts like ZeroCircles, when played in concert with others, will help birth a new relationship with our forests. Each circle is a link in a chain connecting all of our forests; a chain symbolizing the unification of all those fighting to protect the forests as whole, living systems vital to our survival on this planet.

How to Participate

First...don't be intimidated by the word "artist." In an earlier time, art was not something others did for us to view, or to purchase for display on walls and tables of our homes. We all were artists, and doing art was simply a part of life. Art empowered us. It gave meaning to our lives and connected us to the whole. You won't find the kind of art displayed on the ZeroCircles website, or described in this book, for sale in shops or galleries. It is art of an entirely different nature. I invite you to rediscover the connection this art of old once provided.

The ZeroCircle you create in the forest with your own hands out of earth-found materials is a symbol, a physical mantra that helps connect you to all life. It is personal medicine for your soul and for Earth.

While building your circle, remember that these are your forests. You have every right to be an artist here. Highlight something that disturbs or delights you, and build a circle from things you find on or near the site (check the ZeroCircles website for ideas and photo tips). Send a photo of your work to the project, along with a paragraph or two describing the situation. The photograph will be added to the ZeroCircles website. If enough circles are built, the story will activate the media on a new level and the word will get out in a brand new way that it's time to end commercial extraction of all kinds on public lands. The zero, ancient symbol of rebirth, can guide us in the resurrection of our forests if we choose it to be so.

Send a print or slide of your circle with a descriptive paragraph to:
 ZeroCircles
 POB 693
 Mosier, OR 97040

Endnotes

Chapter 9

[1] Carl Jung, *Man and His Symbols*. Edited by Aniele Jaffe. (New York: Doubleday & Company, Inc., 1964). "According to the Chinese sages," writes F. David Peat in his book *Synchronicity: The Bridge Between Matter and Mind,* "an act of divination enfolds a moment that contains the essence of the present and the seeds of the future. Divination is therefore the microcosm that reflects the whole of nature and society and includes, within it, the observer."

[2] Martín Prechtel, workshop at the Ojai Foundation, March, 2000. See Martín's website, www.floweringmountain.com for information about his workshops which are life-changing events to be sure!

[3] Martín Prechtel, *Long Life, Honey in the Heart* (New York. Penguin Putnam, Inc., 1999). This singular book makes one long for one◊s lost tribe like nothing I have ever read. So many cultures have been dismantled and scrambled that the beautiful intricacies that protect our youth by proper initiation into adulthood are all but lost. We are lucky to have someone like Martín to help us see what is missing and shows us ways to recover the seeds of what we have lost. Here he reflects on his own youth growing up on an Indian reservation in the Southwestern United States, a reflection that led him to the Mayan world of Guatemala: "My fanatical teenage search for what was real and original was more than a personal code of aesthetics. For me it had been a life-or-death quest for the survival of my soul in the face of the modern world that was being forced on us in New Mexico."

[4] Ibid.

[5] Robert Johnson, *We: Understand the Psychology of Romantic Love* (San Francisco: Harper and Row), 1983.

[6] Martín Prechtel, *Long Life, Honey in the Heart* (New York. Penguin Putnam, Inc., 1999) Until the time Martín talks about arrives, we must "to try to repay the debt we owe (from wrecking the world) by giving gifts of beauty and praise to the sacred, to the invisible world that gives us life."

[7] Linda Schele, David Freidel, *A Forest of Kings: The Untold Story of the Ancient Maya* (New York: HarperTrade, 1992).

[8] Ibid.

[9] Christopher Shaw, *Sacred Monkey River: A Canoe Trip with the Gods* (New York: W. W. Norton & Company, Inc., 2000).

[10] Derek Denniston, *Defending the Land with Maps* (Washington: World Watch, 1994). Despite the situation in the modern Mayan world, today's forest may be healthier than it was at the height of the classic Maya empire. With the cities so close together, much of the region would have been a domesticated landscape of cornfields, plantations of food trees, terraced slopes, artificial reservoirs, and networks of canals. However, what threatens to make things far worse than they are currently is the expected doubling of the Central American population to 60 million people within the next 25 years. With no uninhabited arable land remaining, the only way for peasants to find new land to log, ranch, or farm is to grab it from those not powerful enough to defend it. "Conflicts over land rights have become the most incendiary and deadly issue in Central America, and by far the biggest threat to the cultural survival of its indigenous peoples," says Mac Chapin, director of the Arlington, Virginia-based Native Lands, a program of the Tides Foundation that works to secure indigenous land rights. Fortunately, help may be on the way. In the last few years, international conservation groups have begun to realize that their best hopes for preserving the scarce remnants of the tropical rain forests lie squarely with supporting their inhabitants. Since it is impossible for conservationists to make informed decisions about which rain forests to save until knowing who lives there and how they are using the forest, mapping efforts are the logical first step. "Maps by Indians are the first cut on creating effective strategies to preserve indigenous homelands and their biodiversity," says Chapin.

[11] Personal journal (June 2000). For information about Lori Thompson's drawings, sculptures, and classes, write: Sacred Images, PO Box 1284, Orchard Park, NY 14127.

[12] Book of Reconciliation. *The Box: Remembering the Gift* (Santa Fe: Terma Company, 1992)

Chapter 10

[1]Immanuel Kant, *Perpetual Peace* (Indianapolis: Hackett Publishing Company, 2004) I discovered Kant's "see the whole first" quote a few years after I began conducing Art For the Sky programs. I was ecstatic as this summed up the importance of sky art more than anything I had come across. I heard the traveling "eco-evangelist", Michael Dowd refer to it in one of his fascinating presentations on *The Great Story*. He and his science-writer wife, Connie Barlow, live permanently on the road doing what they call "the great work", delivering the most powerful presentations of our time I believe, in person, to community after community. See: www.thegreatstory.org.

[2]Guy Merchie, *The Seven Mysteries of Life* (Houghton Mifflin Company, Boston, 1978)

Chapter 11

[1] David Abrams, *The Spell of the Sensuous: Perception and Language in a More-Than-Human World* (New York: Pantheon Books, 1996). There may be some real truth to this feeling. I went back ten years later to hike to the point where I saw the condors and give thanks for the experience. There was a recent spring snow and I barely made it to the trailhead in my rental car. I tried very hard to find the place. Everything seemed very different. Perhaps the snag that they had perched in had fallen, perhaps it was the snow that disoriented me. At any rate, I got myself into a dangerous position searching until sunset—as the light began to wane, I could not find the trail back among the cliffs and woods covered in light snow. The temperature dropped rapidly, and I became very cold in my sweaty cotton clothes. I nearly panicked, realizing what a dangerous predicament I was in. At the last possible moment before hypothermia

set in, I found my footprints and (by the flame of a lighter) was able to follow them slowly back to my car.

2 David Richo, *Unexpected Miracles: The Gift of Synchronicity and How to Open It.* (New York: The Crossroad Publishing Company, 1999.) Richo encourages us to embrace every moment, for "by synchronicity, every moment stands on the the threshold between time and eternity—and lets us stand there too." When, through synchronicity, we enter "the between" we engage "the transcendent function of the psyche that produces the healing third when we honor opposites."

3 David F. Peat, *Synchronicity: The Bridge Between Matter and Mind* (New York: Bantam Books, 1987). "Within a synchronicity the meaning and potentialities of nature, mind, and society can be displayed. Moreover the perception of this moment by the individual may give rise to the release of formative energy that can be used to creatively change the future and even transform consciousness." Poet Rainier Maria Rilke puts it another way, "To transform itself in us, the future enters into us long before it happens." The synchronicity of the condors was the wellspring for this book.

4 Ibid.

5 *The Penguin Dictionary of Symbols.* Jean Chevalier and Alain Gheerbrant, The Penguin Dictionary of Symbols. (London: Penguin Books, 1994).

Epilogue

1 This section was partly inspired by Anne Herbert's article, "Handy Tips on How to Behave at the Death of the World," *Whole Earth Review* (Spring 1995).

Illustrators' Words

Jocelyn Slack

As I read each chapter, Daniel's words illicited images that floated to the surface and caught my attention. These became the building materials for each drawing. At the heart of each drawing is the piece he created in the environment. Deer, coyote, rocks, bones, feathers, trees, rainbow, prayer flags, etc. are ingredients I used to illustrate the piece. Other images of the landscape were woven in—weather, geology, stories within stories.

After a certain point, each drawing took on a life of its own. I lived with the drawing and the writing behind it and they almost literally began to "grow." Each line revealed the next line. There is a wonderful process that occurs while drawing for me, like a memory map. Everything that is going on around me while I am working is recorded, weather, time of day, season, events, emotions. This is the style for much of the artwork I do.

Jocelyn Slack – POB 924 Wilson, Wyoming 83014
jjlwasson@hotmail.com

Lori Thompson

The Earth's beauty and complexity is awe-inspiring. I have grown up with the knowing that this planet breathes and lives. Life is sacred. Nature has healed my soul on more occasions than I can count. Therefore, it is in gratitude and love that I worked in creating the illustrations for this book. It is only a small token of my appreciation and a symbol of my hope that all people open to the creative power, beauty and grace within themselves and in nature's gifts. In seeing the sacred in all things perhaps we will protect and care for ourselves and the earth in compassionate and sustainable ways. The illustrations in this book are dedicated to a 150 year old triple trunked oak tree lost to a lumber yard in 2000 - and to my son, Jaymes who loves trees as much as I do.

Lori's personal artwork includes earth-centered clay sculptures, pen and ink, pastel work, acrylic texture paintings, and mixed media work under the name of Sacred Images Studio. She also lectures, teaches and conducts workshops on healing art, relaxation and wellness, and contemporary earth centered ritual and creative expression.

Lori Rothfus (Thompson) 2799 Bentley Ave, Jamestown, NY 14701
Lori@creativewisdoms.com
www.creativewisdoms.com

Illustrations

About the Author

Daniel Dancer's work as a conceptual artist, activist and educator has been shaped by his travels worldwide in search of styles of being that engender happiness, sustainability and connection to Earth. After getting his MA degree in psychology at the University of Kansas, he left the academic world to pursue a career as an outdoor photographer. His striking images of beauty and destruction have been published in hundreds of publications worldwide. It is precisely this interface between wild nature and devastation that most greatly informs his work as an art activist. While this book documents his work as a solo artist in the wilds, his current work includes entire schools and communities. Called *Art For the Sky*, Dancer conducts week-long residencies where hundreds of people form giant living paintings of images that only make sense from the sky. His unusual work teaches participants about the importance of collaboration, living in gratitude and the power of awakening our *sky sight*—a way of seeing which enables us to hold a big picture view of our lives and access our highest creativity.

On the Oregon side of the Columbia River Gorge, Dancer founded a model environmental community called *Rowena Wilds* where he lives in an earth-sheltered home made from recycled materials. He is available for presentations, residencies and workshops. For more information about his work and projects visit, www.inconcertwithnature.com. You may contact him personally at POB 693, Mosier, Oregon. 97040. e-mail: daniel@inconcertwithnature.com.